GW00536115

(UP)RISING SONZ!

Booth-Clibborn Edditions

Authors: Mark Felt, Scott Kinsey
Designers: Scott Kinsey - GOODFEAR Inc.
Introduction © 2008 Claude Grunitzky
Photography © 2008 Mark Felt, Scott Kinsey

Room For Living Publishing
An Imprint of Booth-Clibborn Editions

First published in 2008 by Booth-Clibborn Editions
in the United Kingdom
HYPERLINK "http://www.booth-clibborn.com" www.booth-clibborn.com

© 2008 Booth-Clibborn Editions

All rights reserved. No part of this publication may be reproduced or transmitted in any form or by any means, or stored in
any retrieval system of any nature without prior written permission of the copyright holders, except for permitted fair
dealing under the Copyright, Designs and Patents Act 1988.

The information in this book is based on material supplied to Booth-Clibborn Editions by the authors and participants.
While every effort has been made to ensure accuracy, Booth-Clibborn Editions does not under any circumstances accept
responsibility for any errors or omissions.

A cataloging-in-publication record for this book is available from the publisher

ISBN 978-1-86154-301-1
Printed and bound in Hong Kong

(UP)RISING
SONZ!

conceived by
mark felt, scott kinsey

creative direction and design by
goodfear inc.

copy editing by
claude grunitzky

foreward by
i manifest

photography by
mark felt, scott kinsey

skateboarding by
grant fukuda, bennett harada, matt lemond, kyle yanagimoto *and many more...*

INK = "FINGERS"!!

54

FOREWORD

THIS *ART FORM* × × ×
ALLOWS YOU *ACCESS* × *INTO* THE MANY
× × × OF *ONE'S* *OWN* × × ×
× IMAGINATION, ENVIRONMENT, SELF
CREATIVITY, AND ~ *TIVITY* ×

A KEY TO INFINATE *POSSIBILITIES* ;
TO *CREATING* , OUR OWN *REALITIES* ×
SOMETHING, LIKE A DOORWAY, OR A
FROM *WITHIN* ×

THE ART OF SKATING × × × IS A LANGUAG~

UNLIKE , THE SPOKEN LANGUAGE × × × BUT

VERY CLEARLY , WITHIN EACH SKATER'S LIVE

ON MANY LEVELS ×

INTERNATIONALLY , SKATERS SESSION TOGET~

BUT , IT'S A PERSONAL THING FOR EACH o~

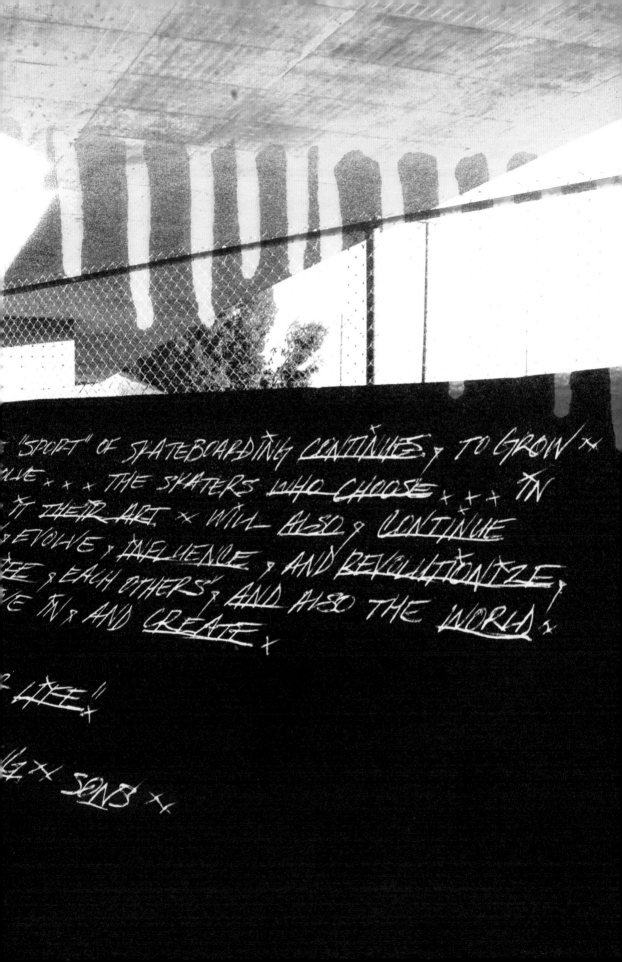

"SPORT" OF SKATEBOARDING CONTINUES, TO GROW
VE... THE SKATERS WHO CHOOSE... IN
IT THEIR ART... WILL ALSO, CONTINUE
EVOLVE, INFLUENCE, AND REVOLUTIONIZE,
EE & EACH OTHERS, AND ALSO THE WORLD!
VE IN, AND CREATE.

LIFE"

SONS

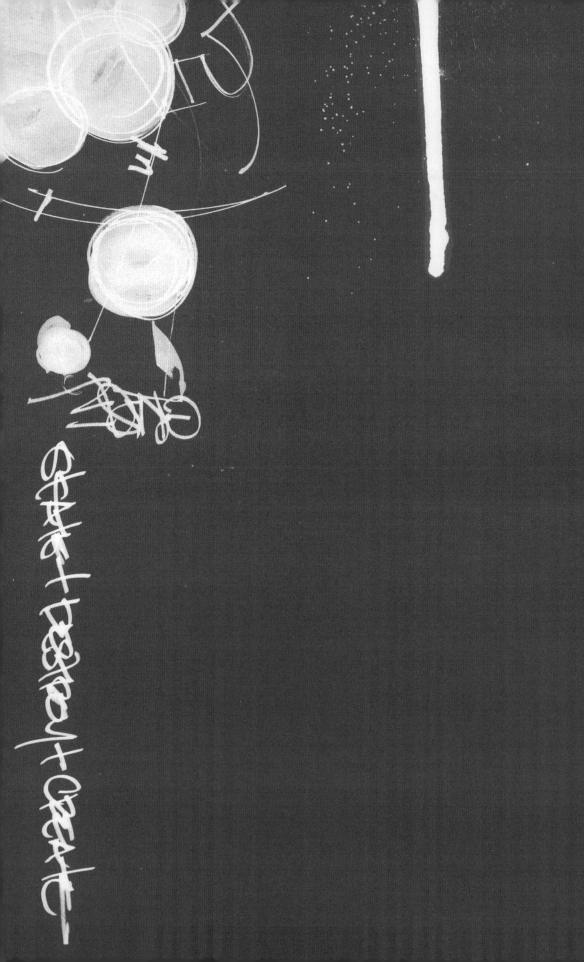

INTRODUCTION

The Sun sets and the Sun rises in each and every city. In between, these shades of grey, there are colorful and inspirational people that drive sub and pop cultures by following their passions. (UP)Rising Sonz! is an homage to these creative individuals. The common language is creativity and the thread that ties them together is skateboarding.

(UP)Rising Sonz! is the introduction of a unique creative community from Japan's landscape to a world-wide audience, while highlighting the cultural impact and continuing reciprocal influences of skateboarding from East to West.

These original skateboarders embody style and attitude to the umpteenth degree. They travel through Japan skating, meeting strangers in the streets, sharing personal stories while experiencing various facets of culture with like-minded trendsetters.

This pictorial travel diary explores how skating has acted as a catalyst for stylistic experimentation for these artists. They manage to transcend boundaries, language barriers, cultural differences and physical distance to explore the nexus where skateboarding meets art, fashion and other elements of Asian youth culture. They represent the full spectrum of generations that have influenced skate style, fashion and street attitude.

They're taste-makers that draw inspiration from the urban sprawl's soul and intertwines that spirituality into their everyday life. They are one of the main sources that serve as the creative essence of city's youth.

Along the way, we explore a range of cultural aspects related to skateboarding's influence on modern Japanese society, by documenting their travels and interactions through Japan. The skaters shown here are multi-disciplinary artists with a strong DIY ethic. They thrive on a mindset where rules are made to be broken and nothing is impossible. Even though their styles may sometimes clash with current trends, they've followed their own path and found alternative avenues of communication and innovative distribution channels to share their work. The growing popularity of skateboarding has allowed their influence to reach far deeper into the worlds of fashion, literature, film, and art.

"(UP)Rising Sonz!" is a celebration and an exploration of their astounding creativity on and off the skateboard, spotlighting the lifestyles of unique individuals who have had a major influence on the direction of skateboarding and youth culture as a whole.

水谷慶子

MIZU TANI

KEI KO

QUADROPHENIA

QUADROPHENIA

BOONDOCK SAINTS

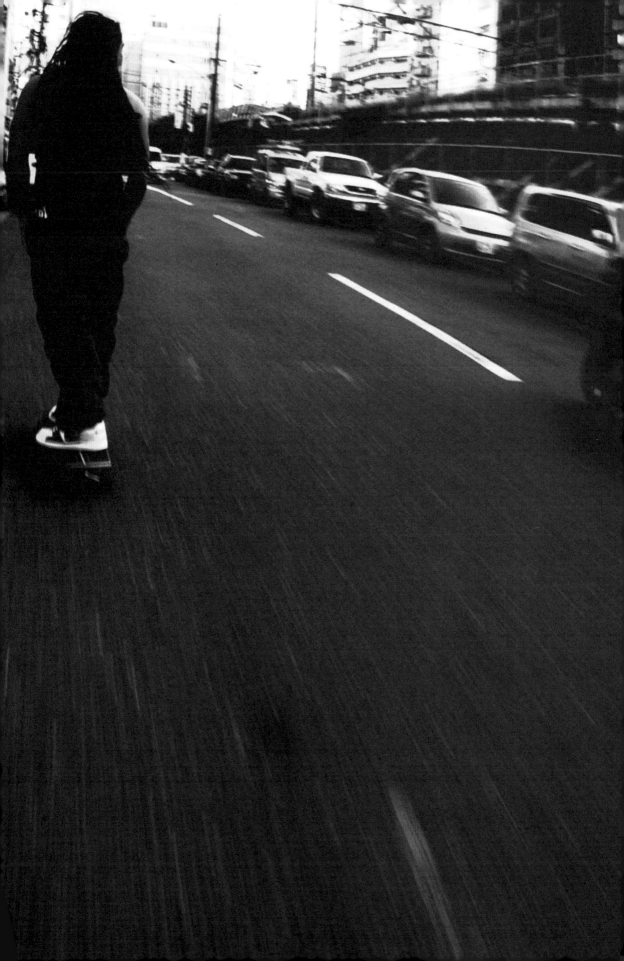

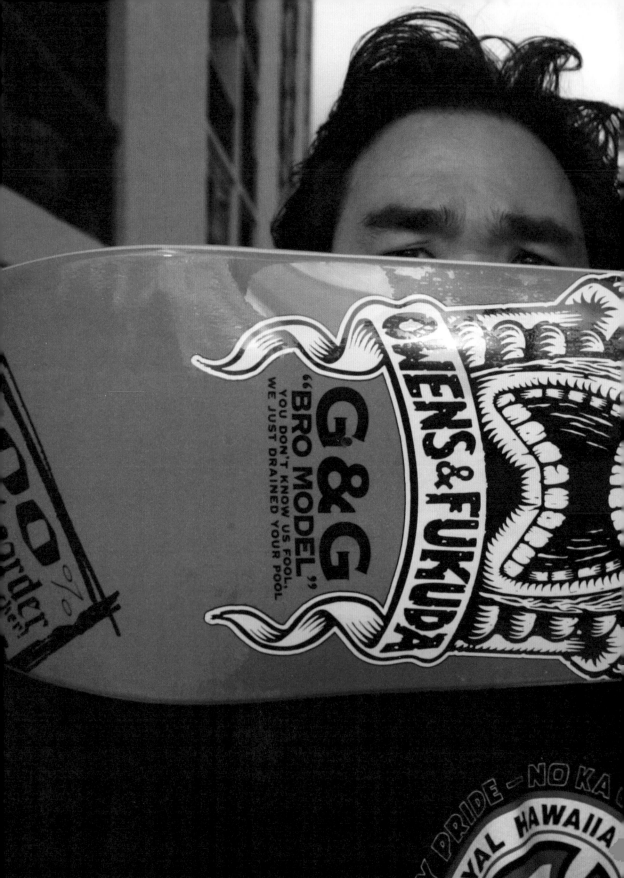

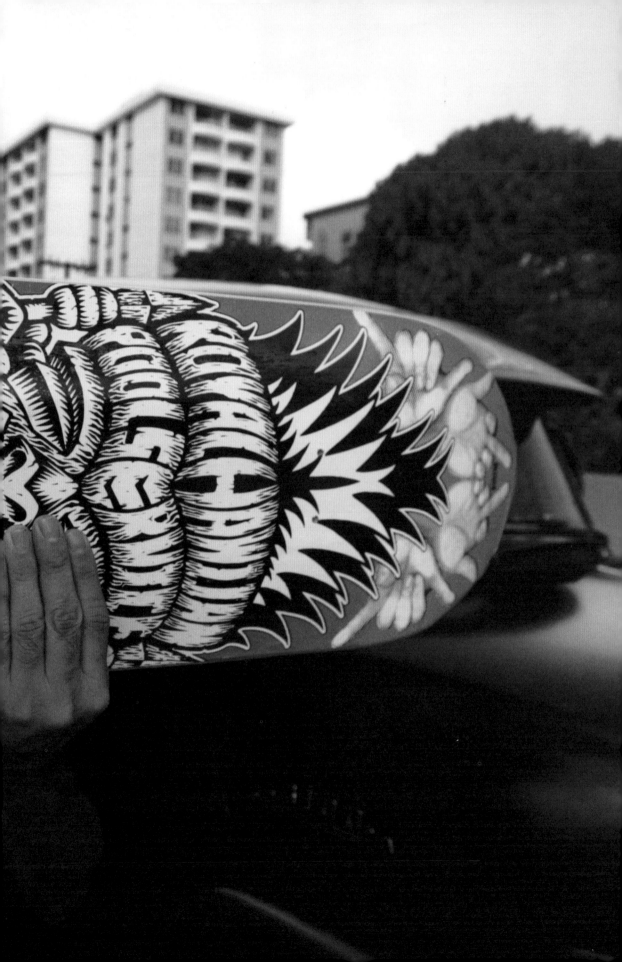

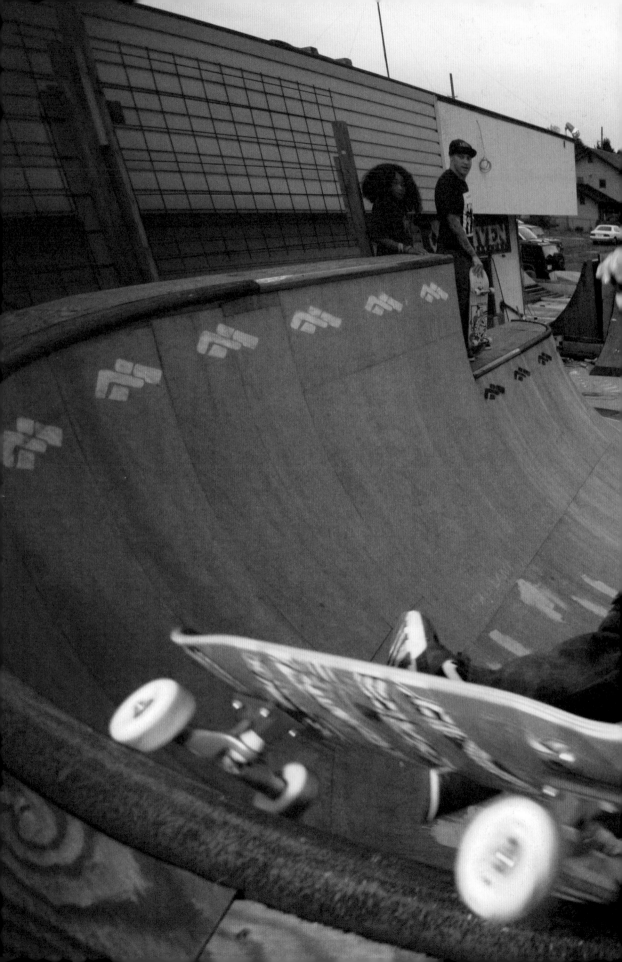

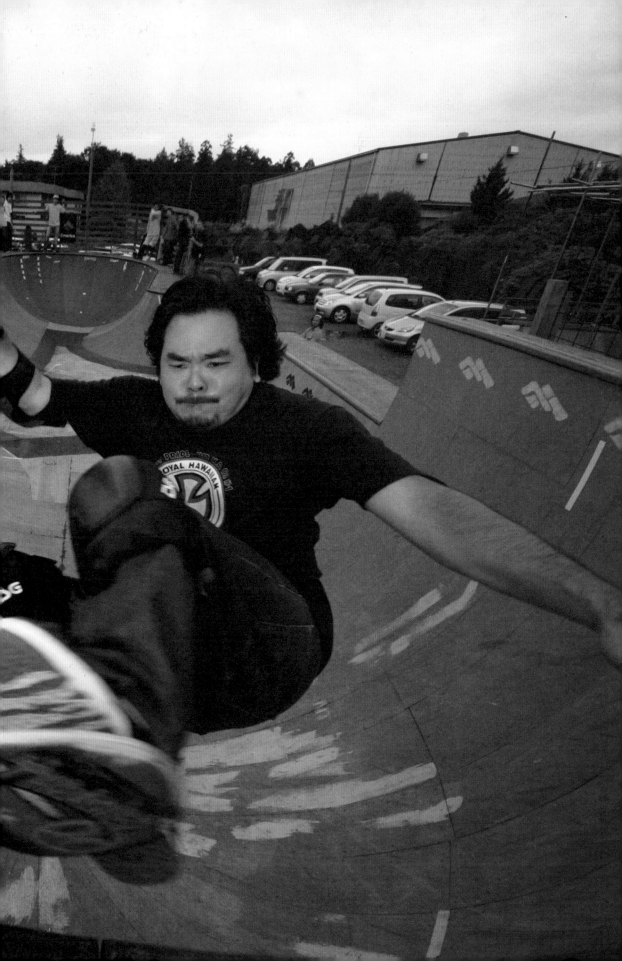

KYLE YANAGIMOTO

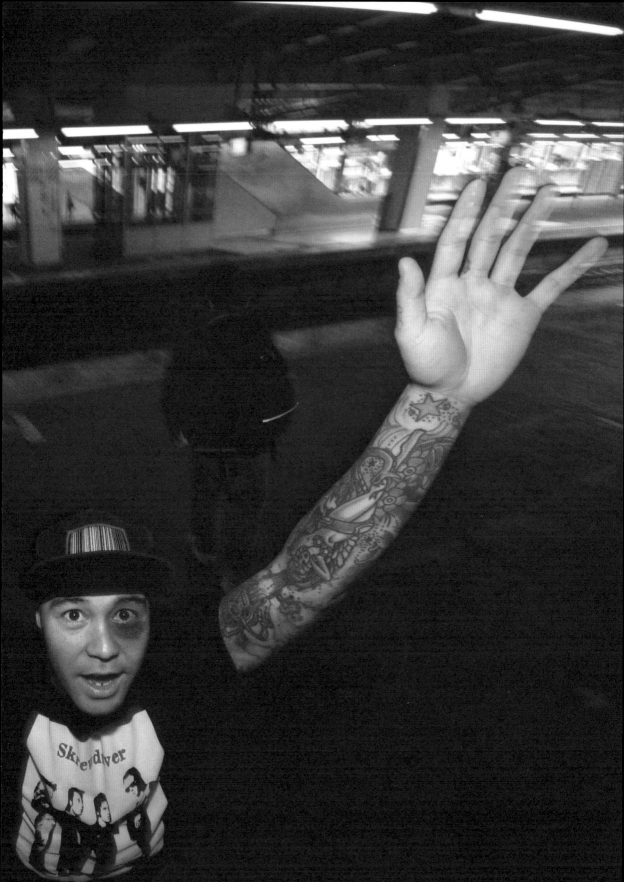

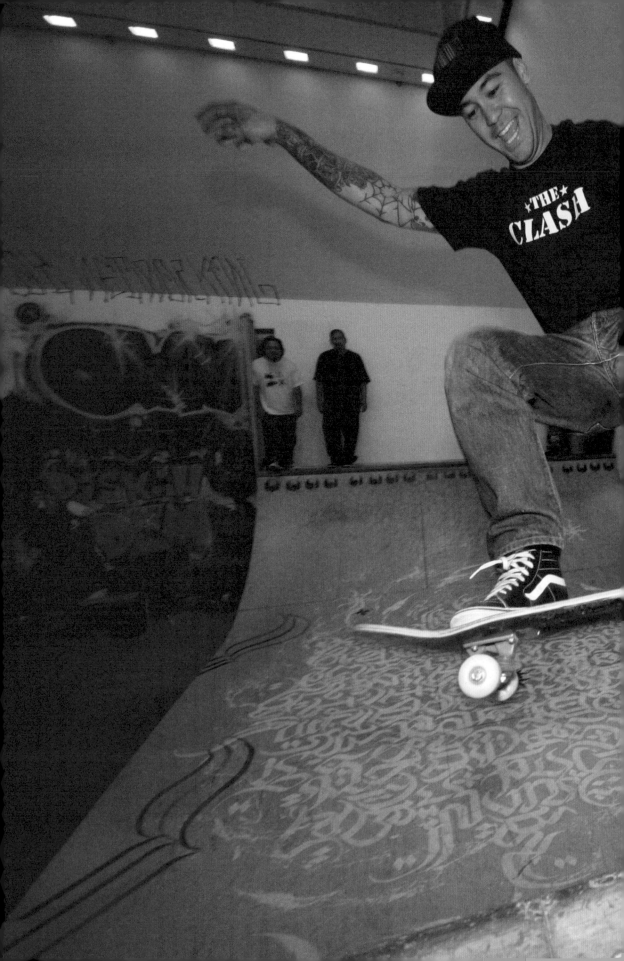

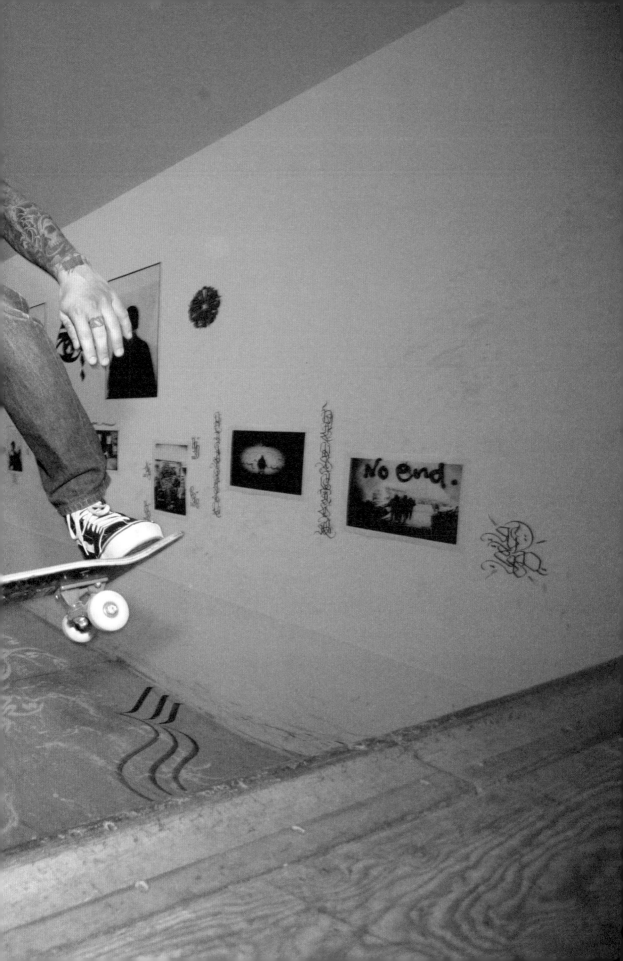

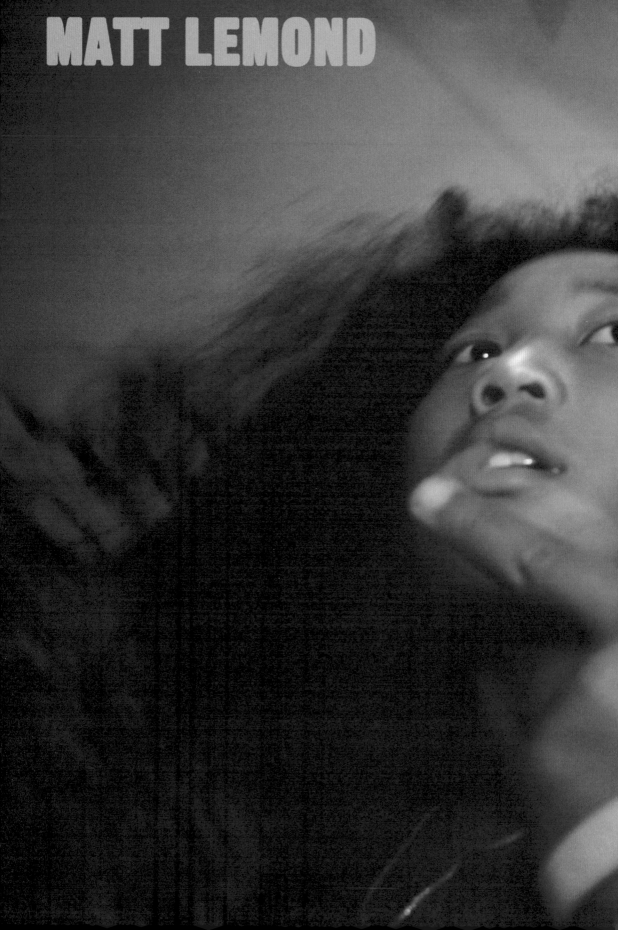

MATT LEMOND

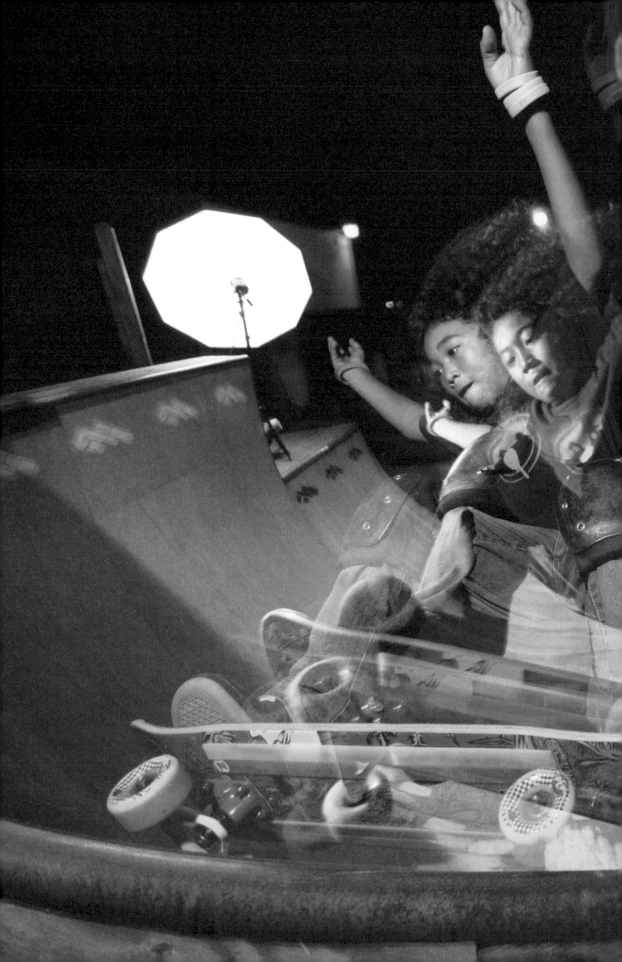

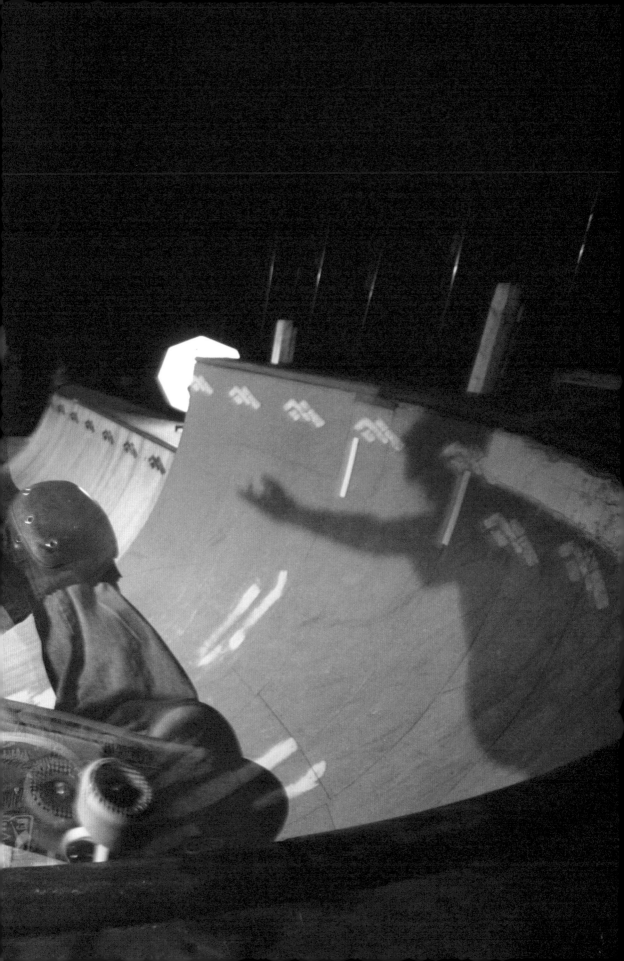

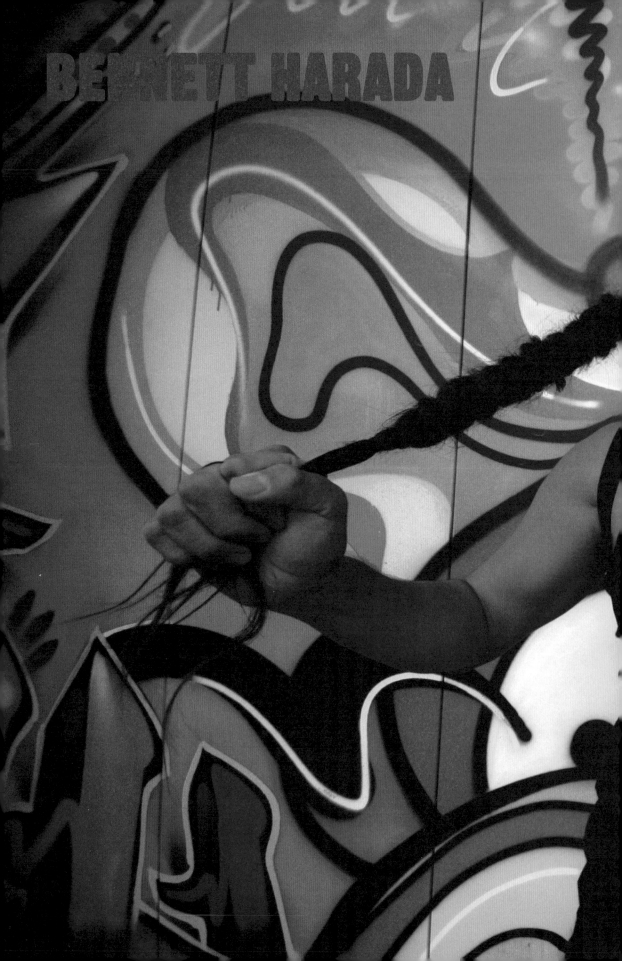

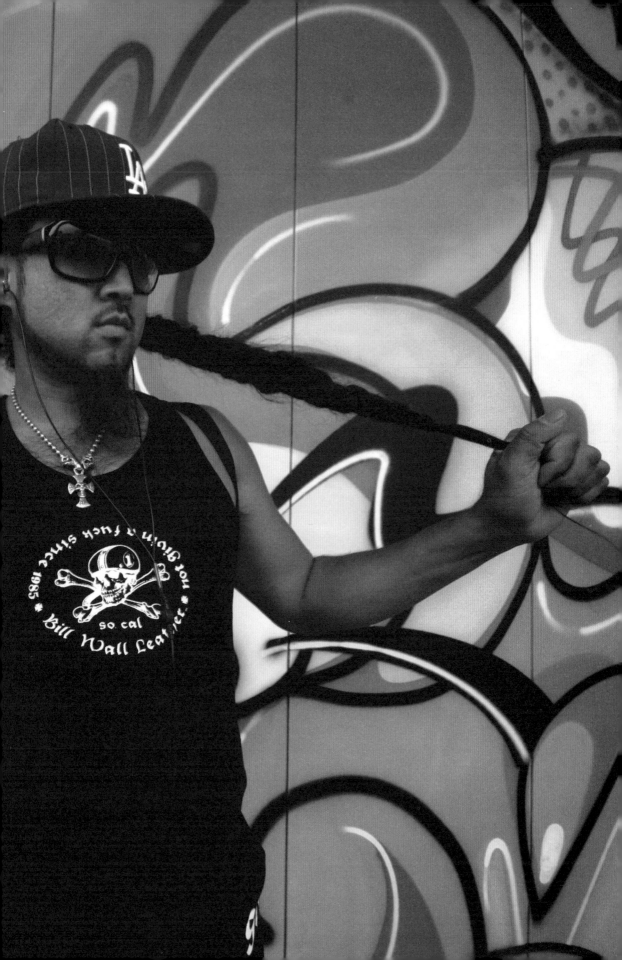

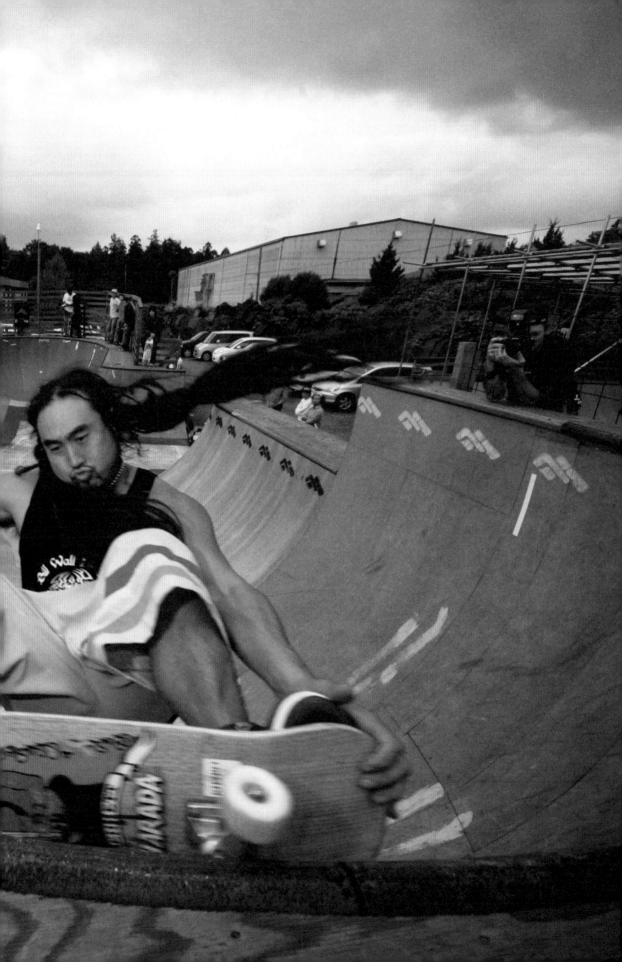

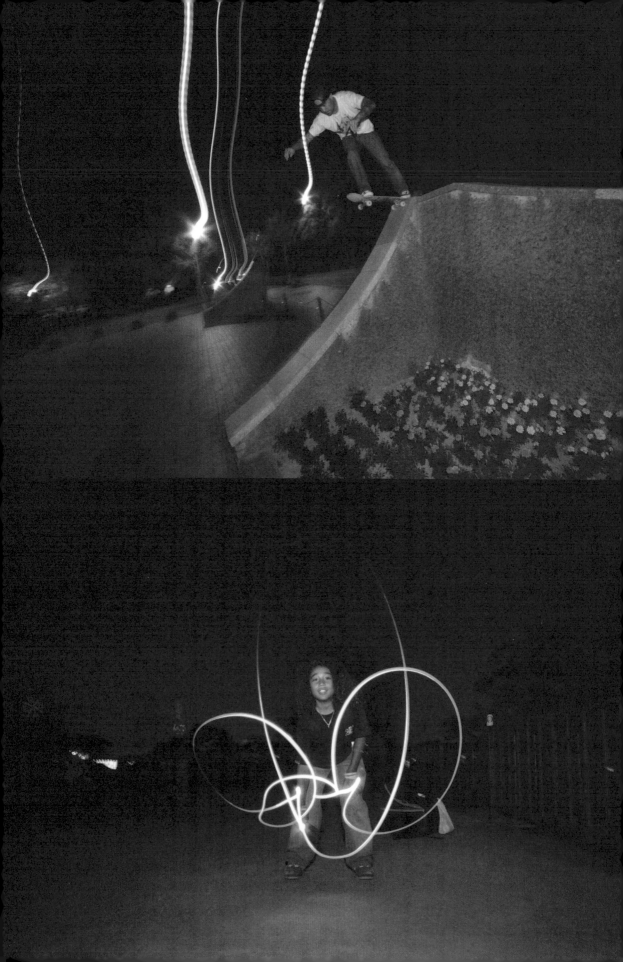

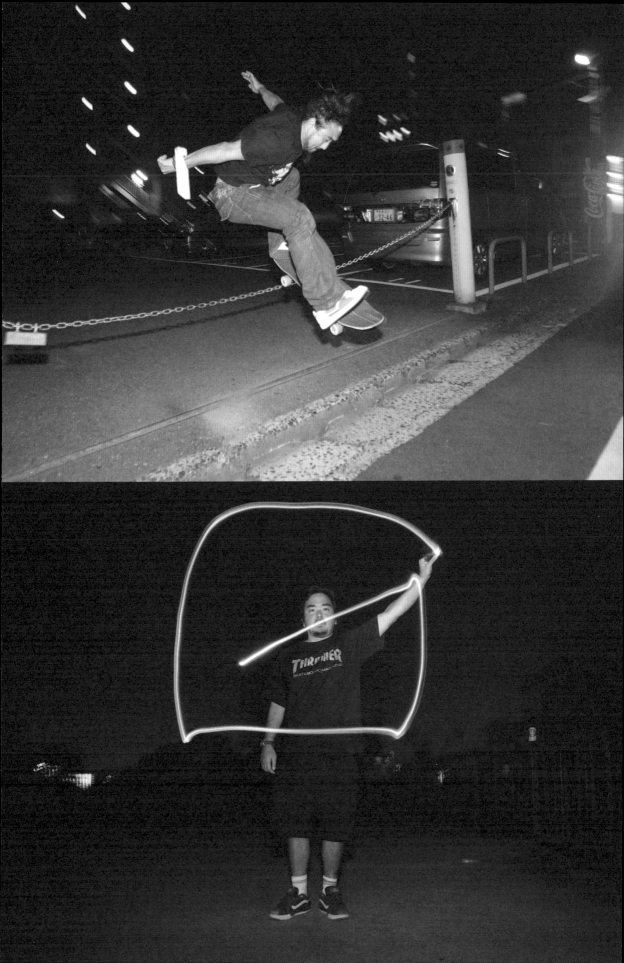

ORGANIZATION = JAPAN

THE ORIGINAL

JL061
NRT
TOKYO/NARITA

1JL857255

In of emergency, please contact:

NRT
TOKYO
JL06

JL06

TS-40771 04.12 @HITACHI I.SI.M

FWR712 LAX/JI
0131 JL857255
JAPAN AIRLINES

The tides have turned. The Japanese in the past where
100% American inspired. But now Japan is leading pop-culture.
What disturbs me is the lack of Roots. Never forget
the past. Read to a book & talk to your grandparents.

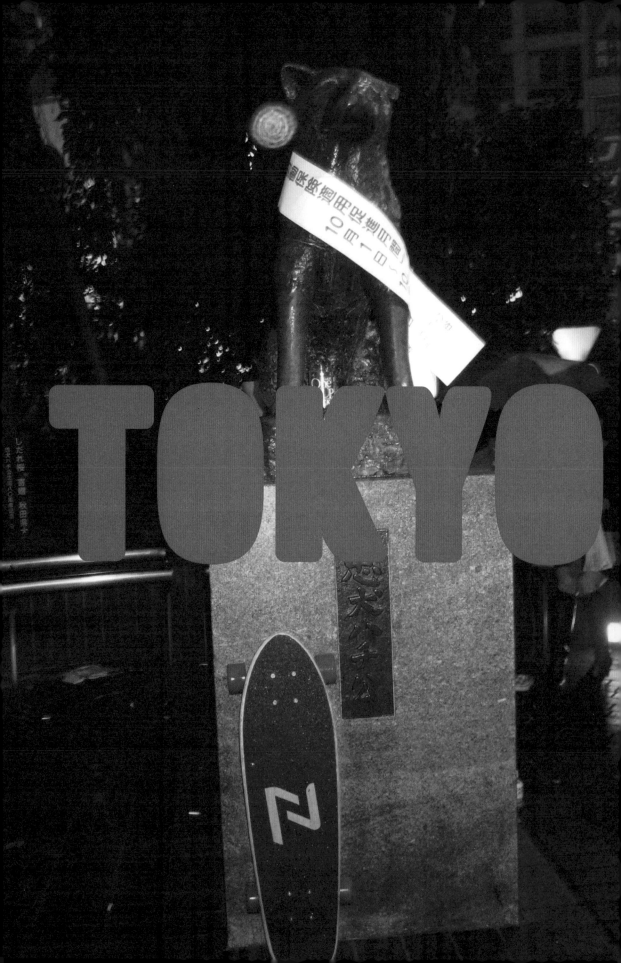

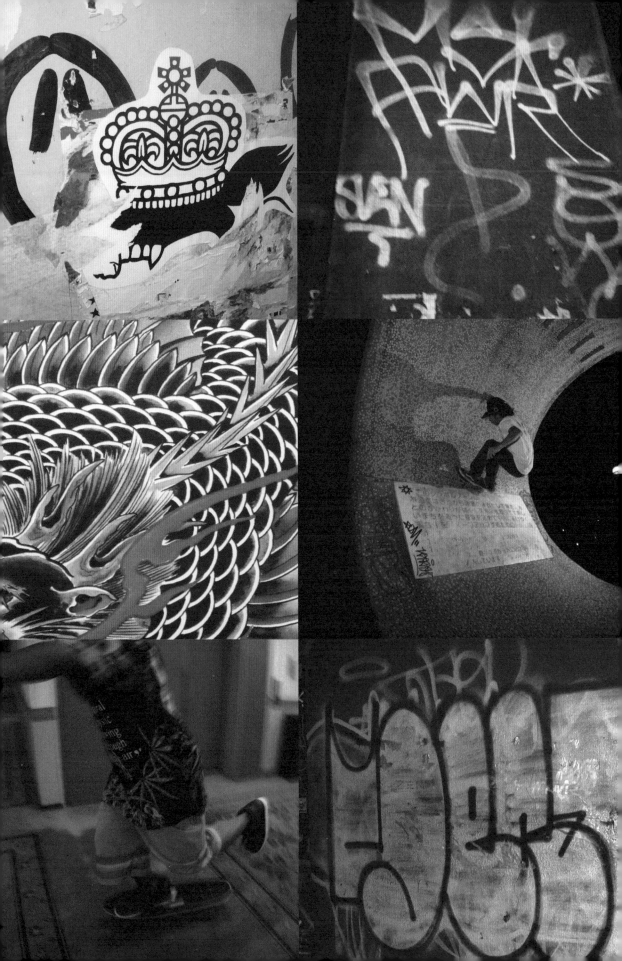

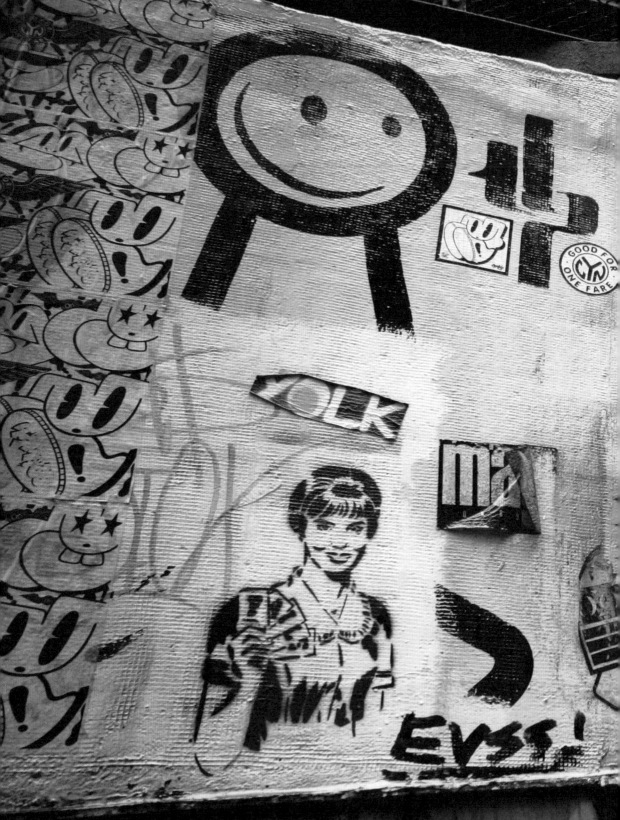

ART EVEN UNDER THE BRIDGE.

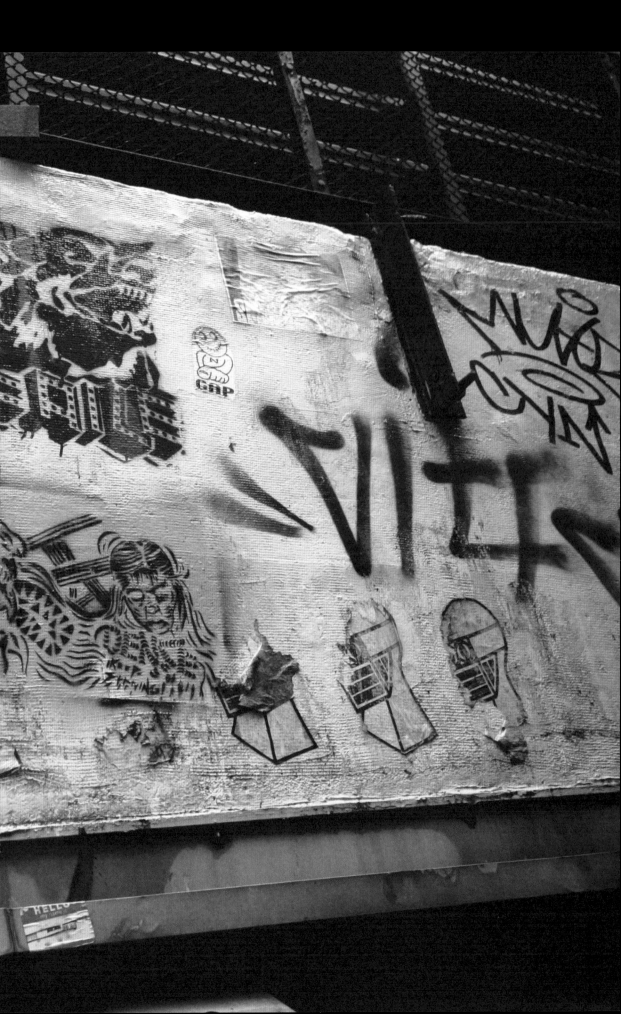

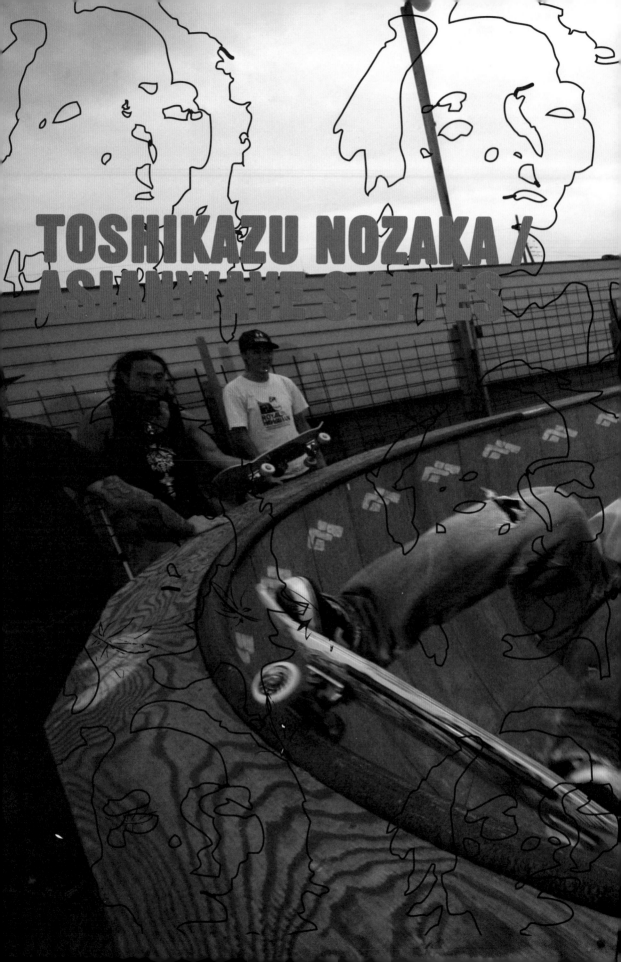

TOSHIKAZU NOZAKA /
ASIAN NATIVE SKATES

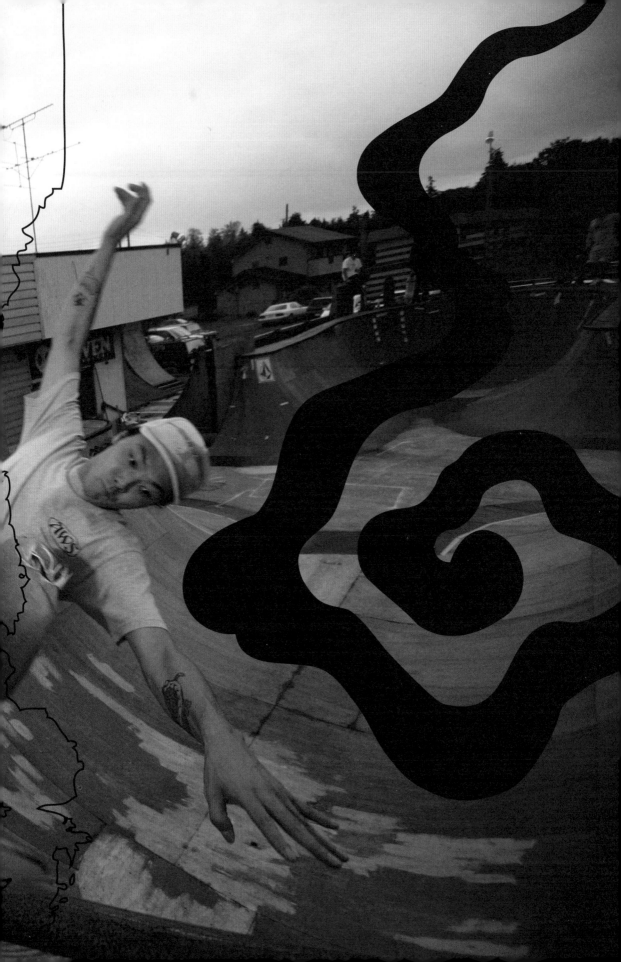

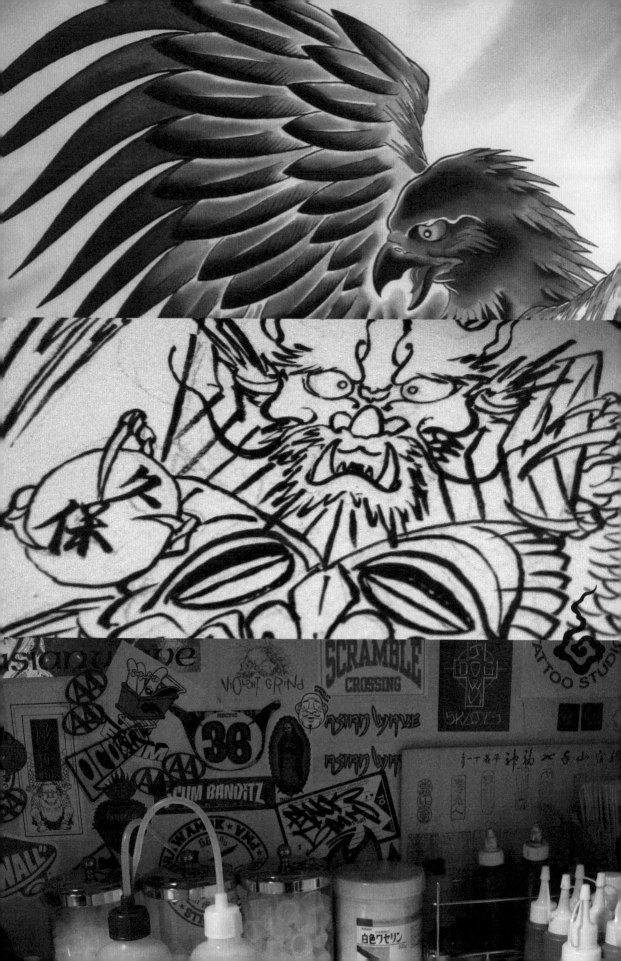

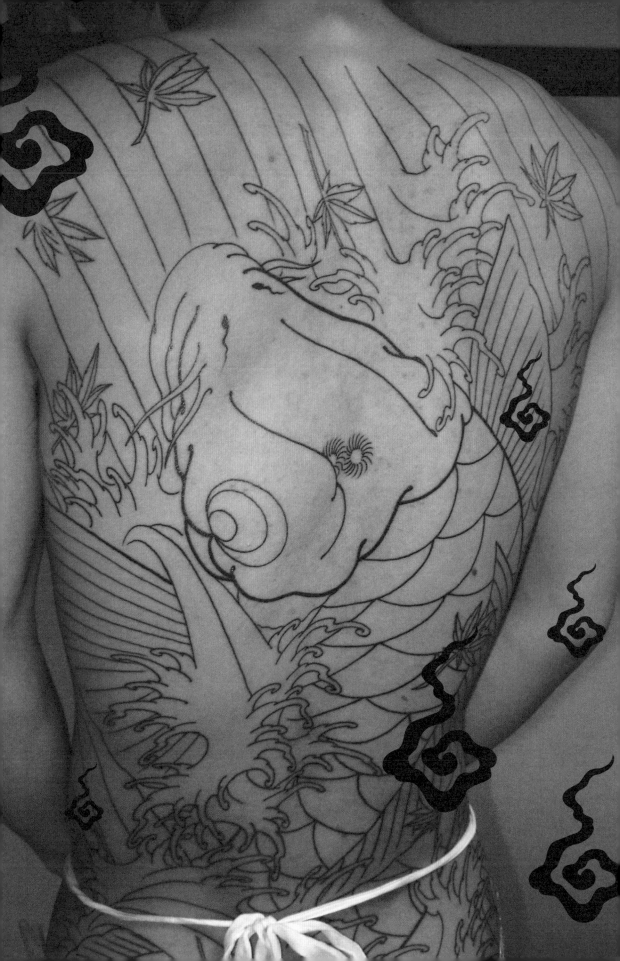

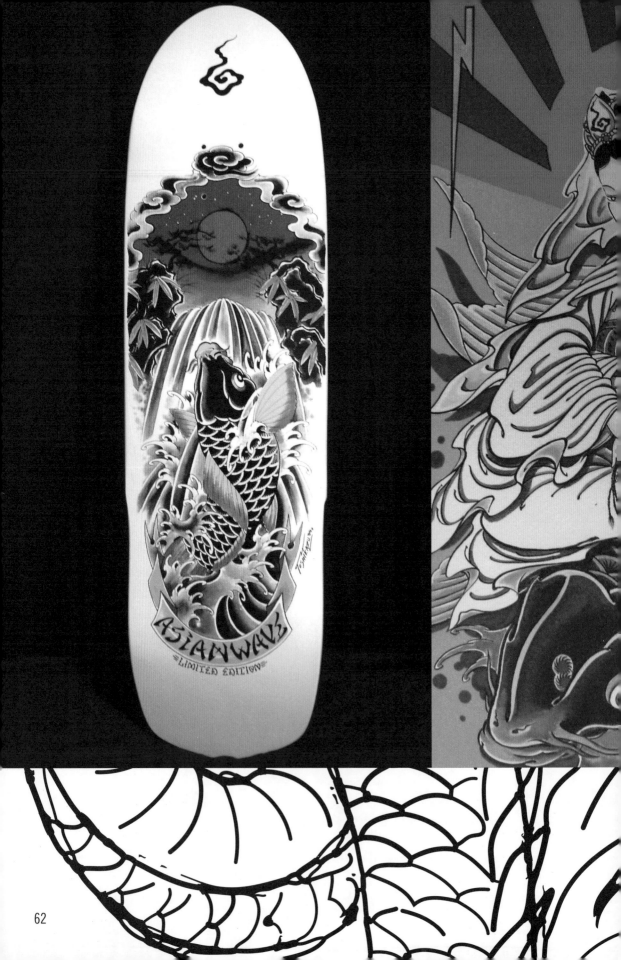

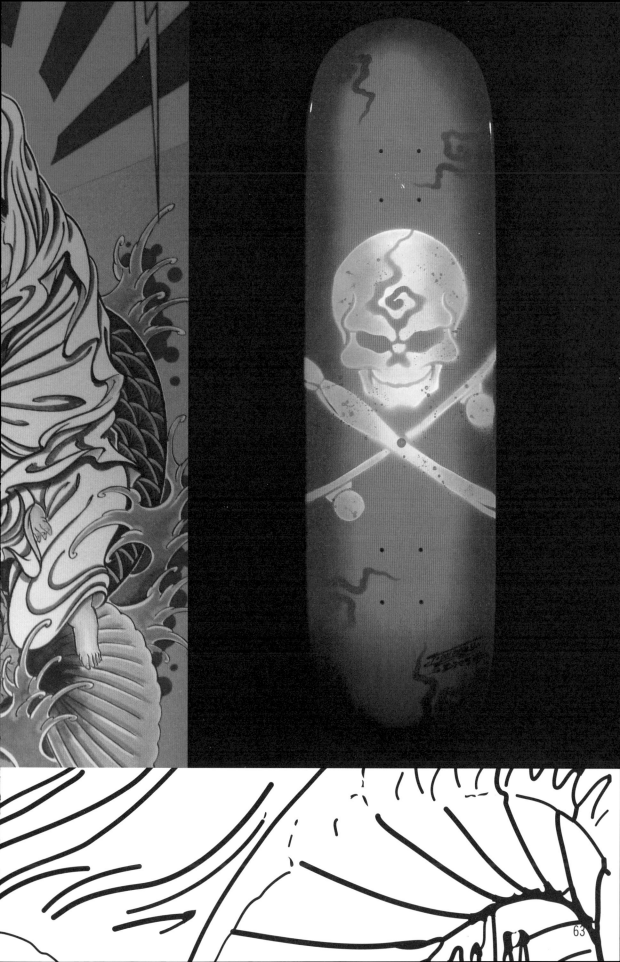

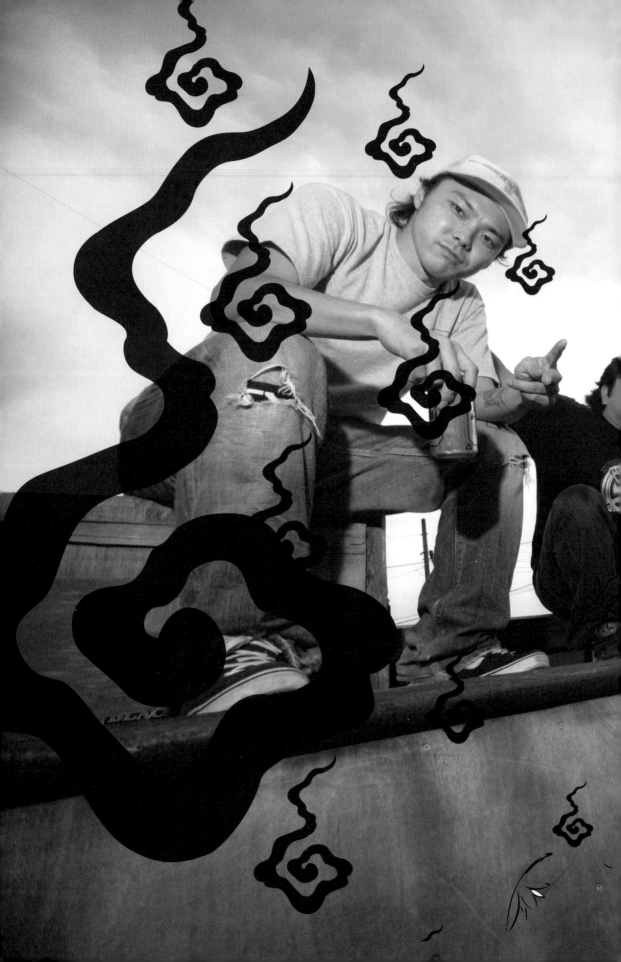

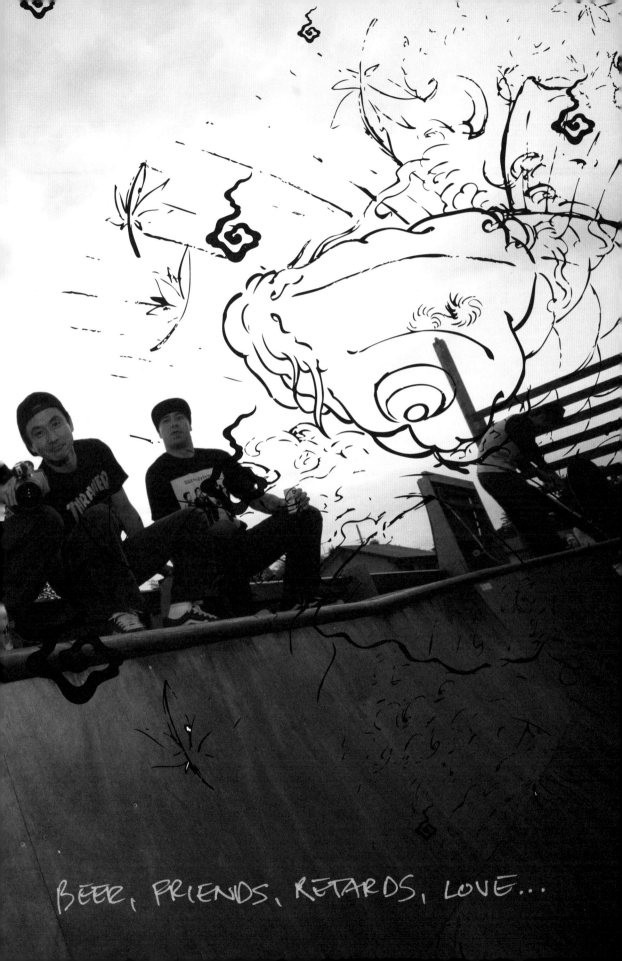

BEER, FRIENDS, RETARDS, LOVE...

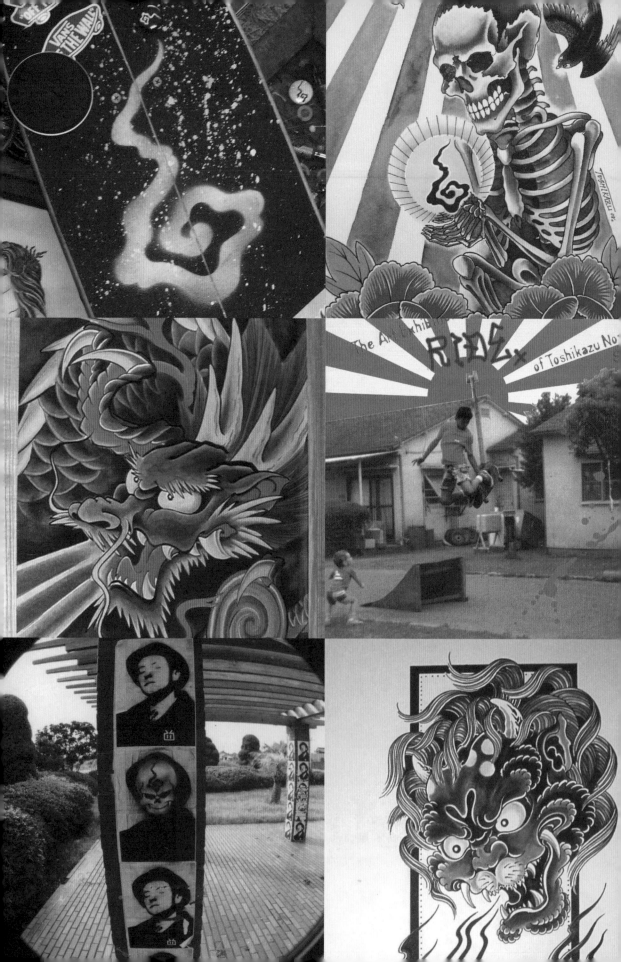

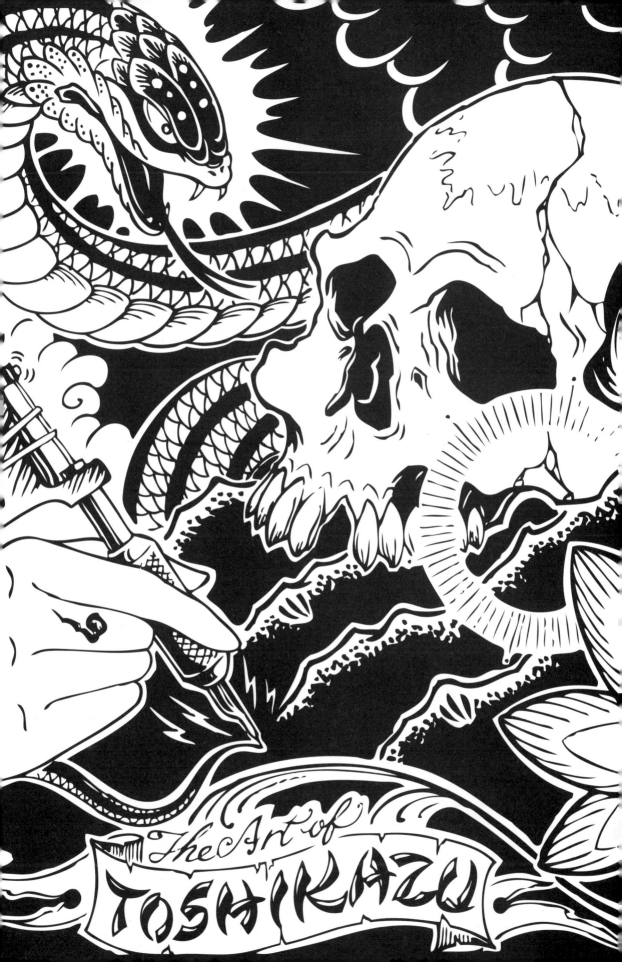

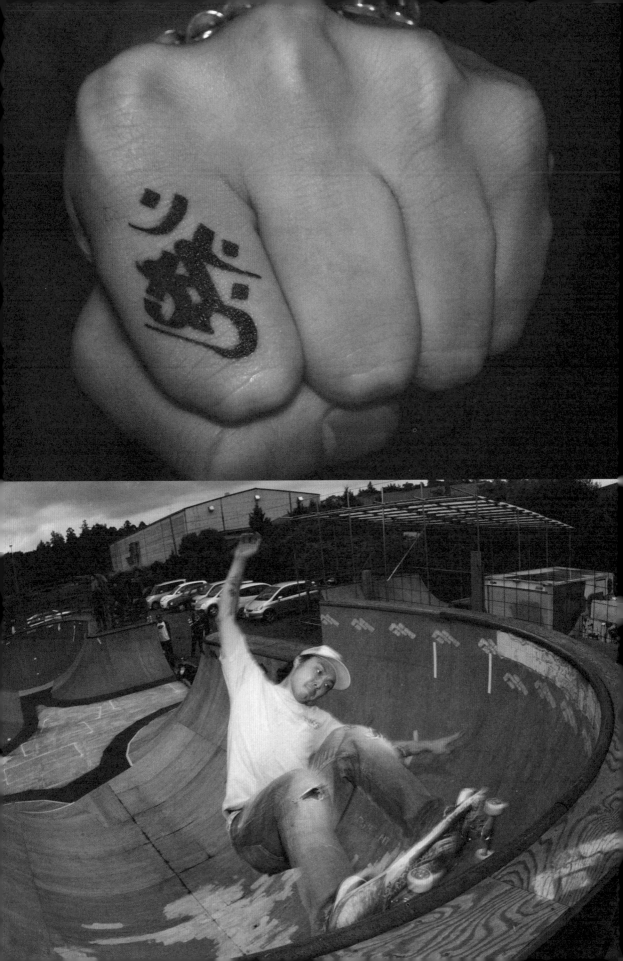

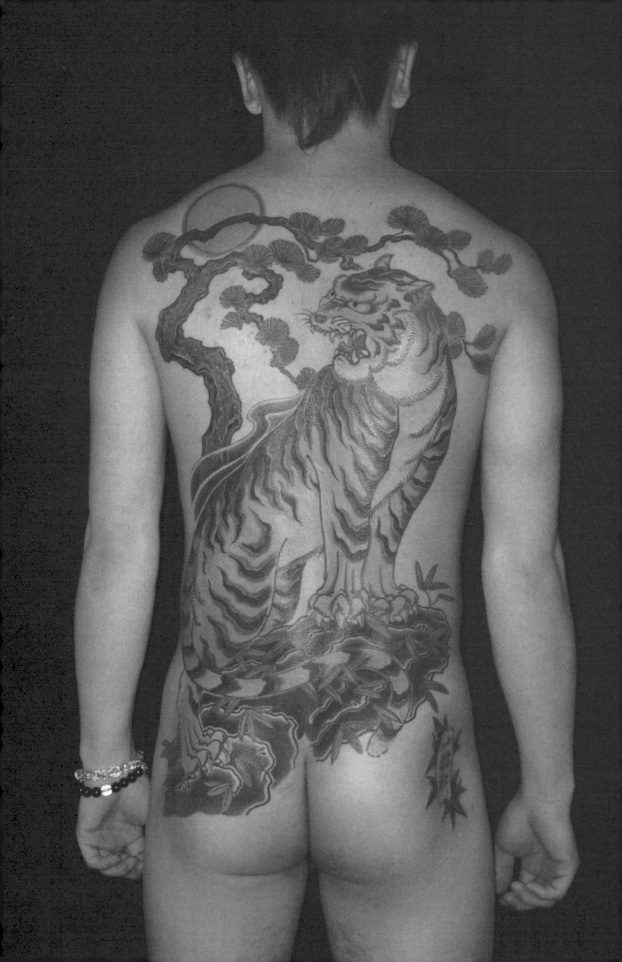

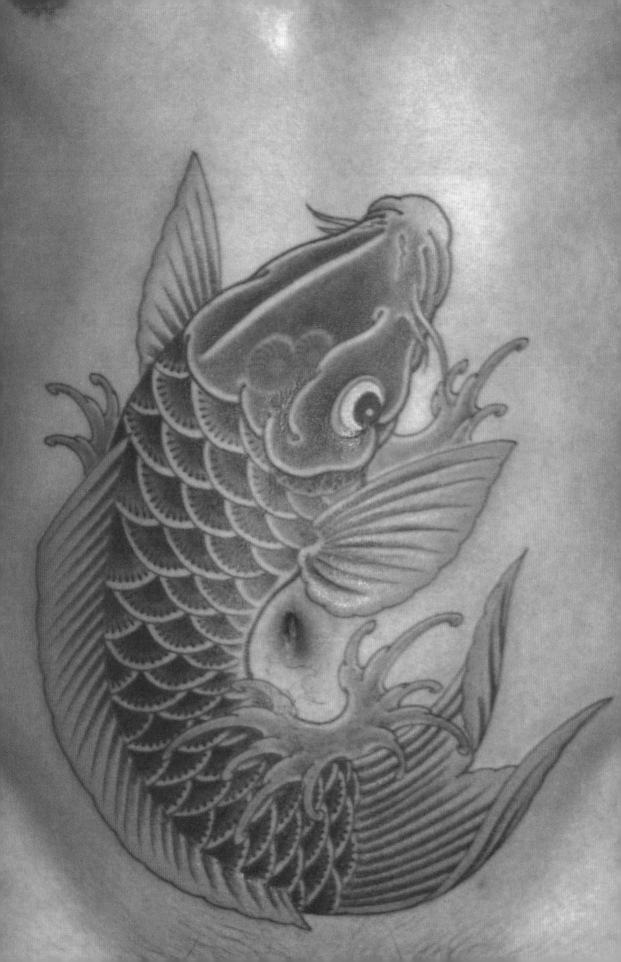

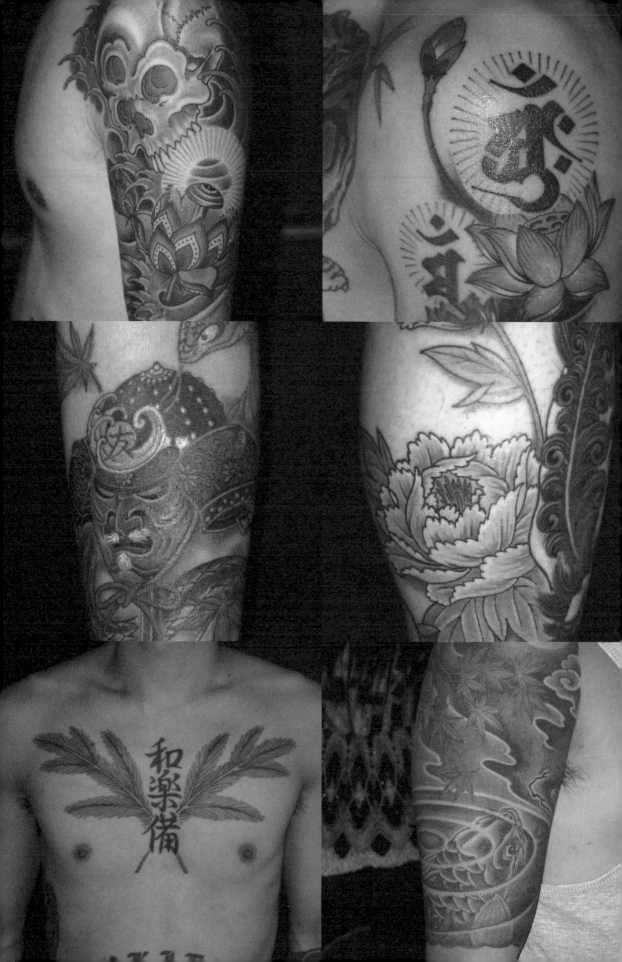

DON'T GET TATTOOED!!!
IF YOU DO GET IT ON YOUR PACE....

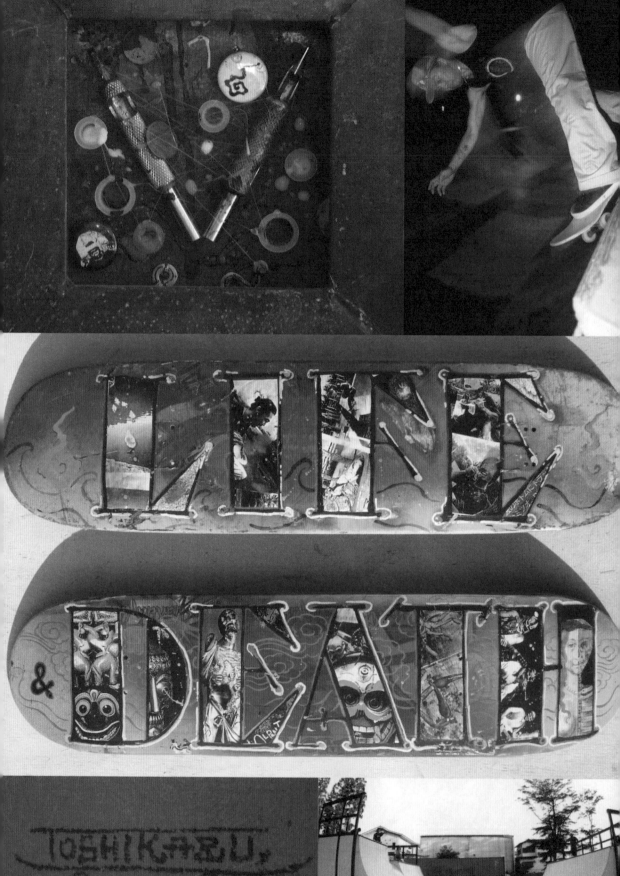
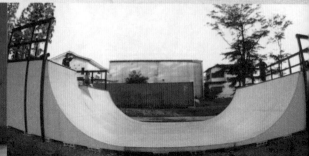

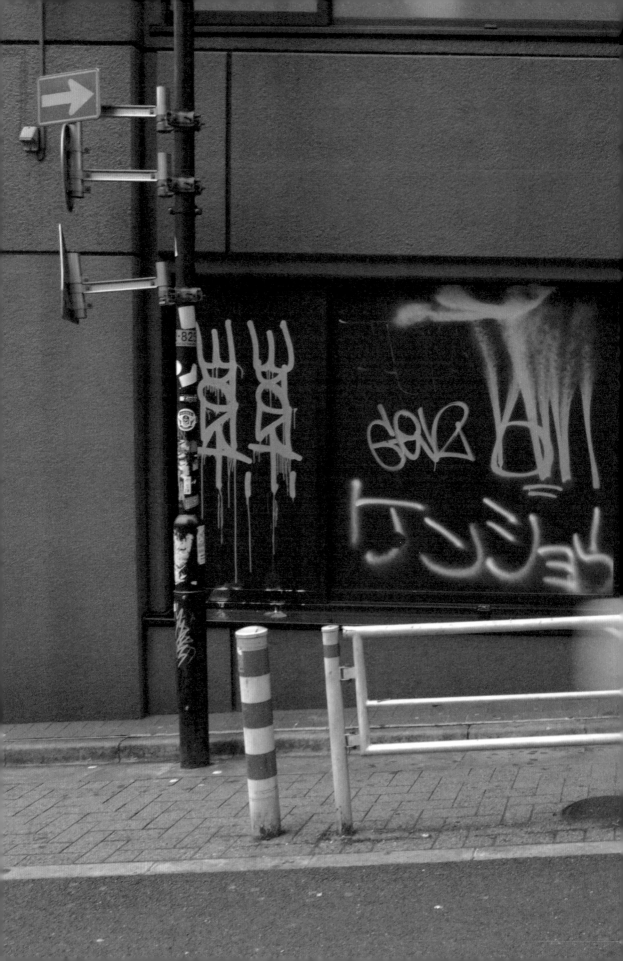

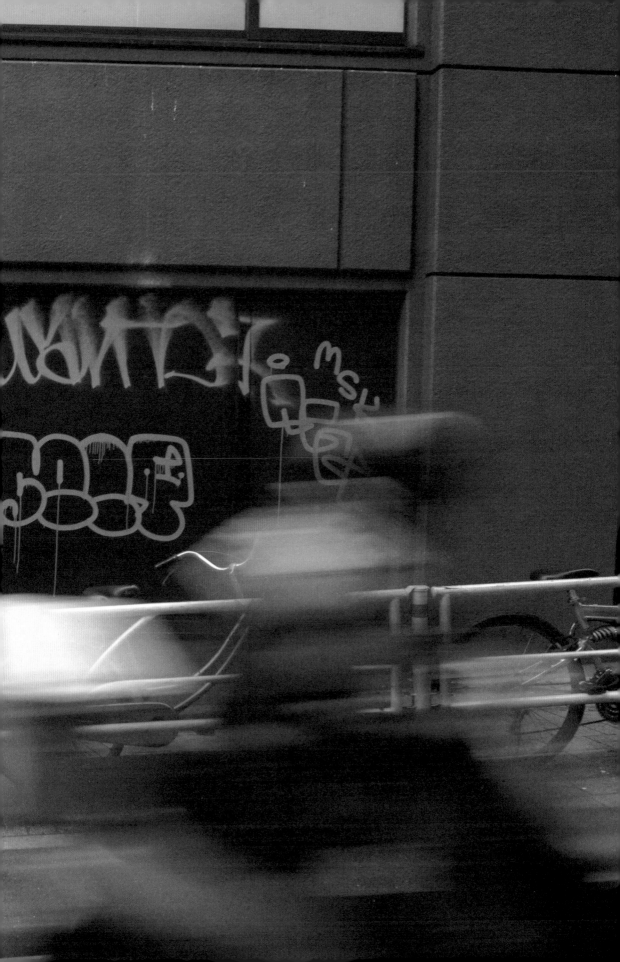

T-19

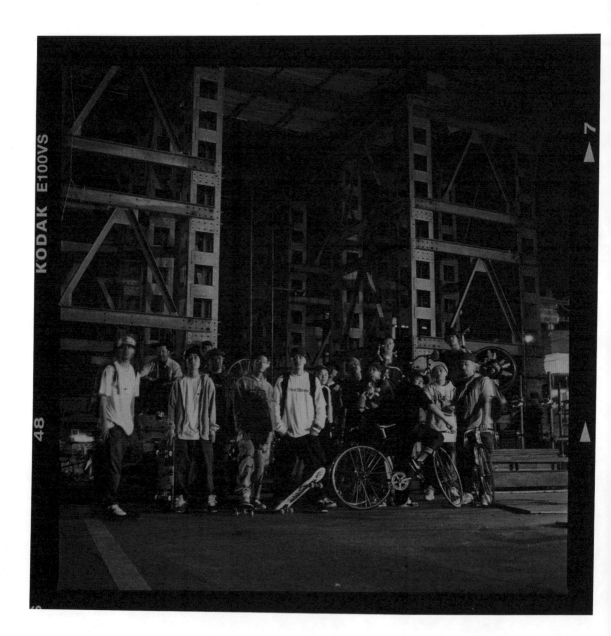

CONTENTS T19 PINK

NOT FOR UNDER 18

LARGE 7 5/85

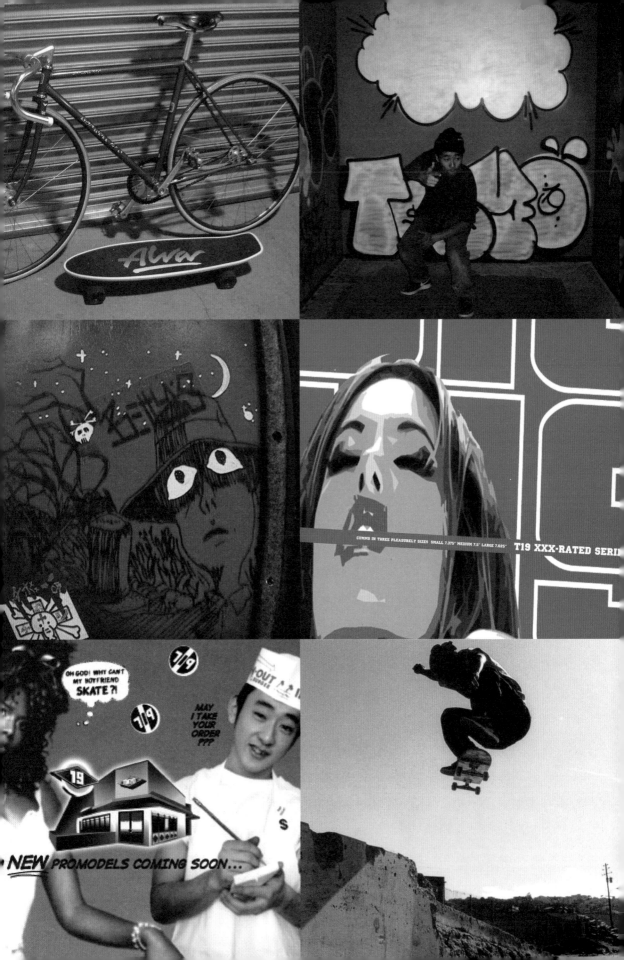

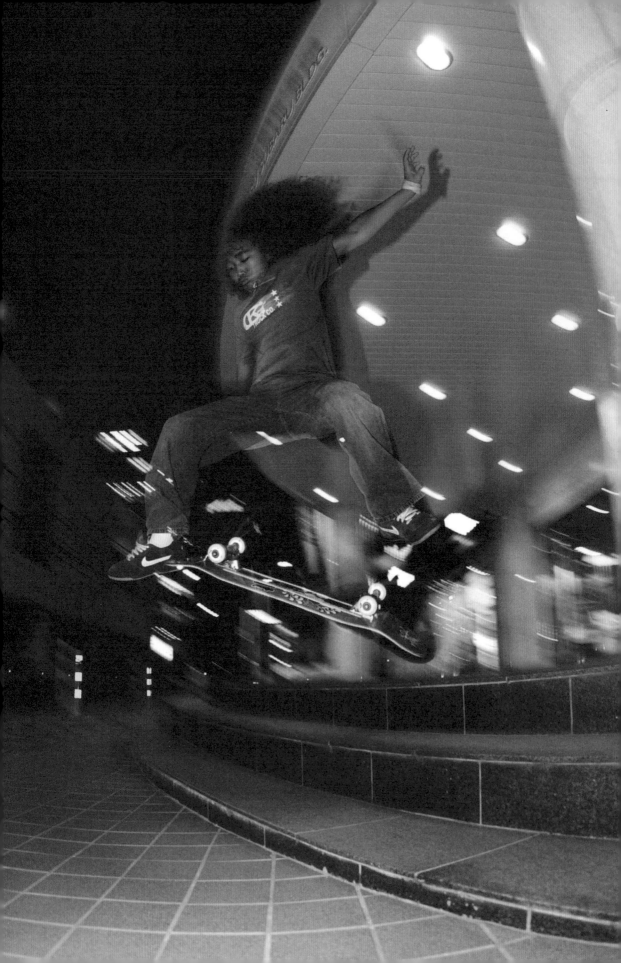

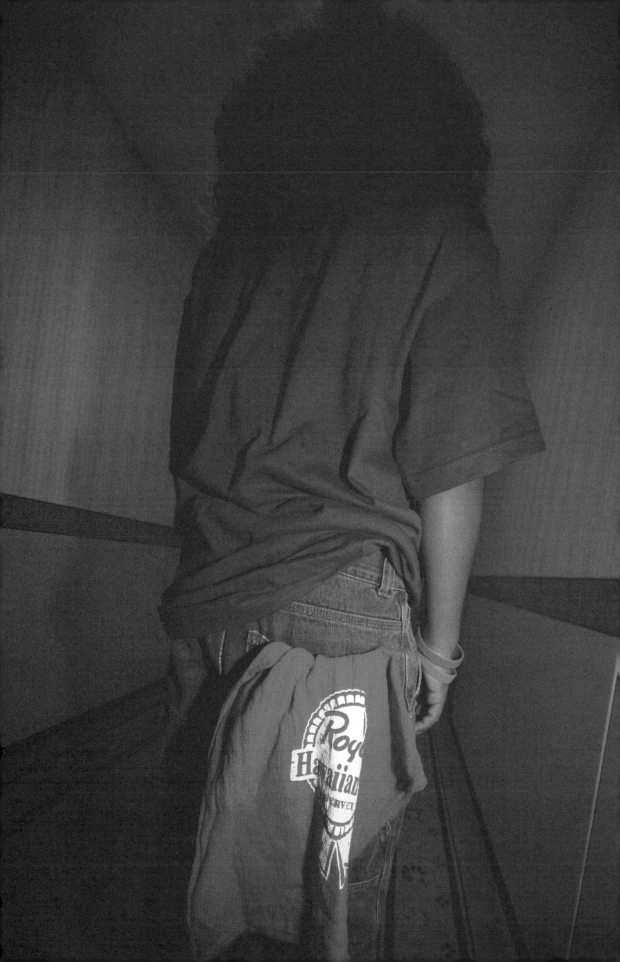

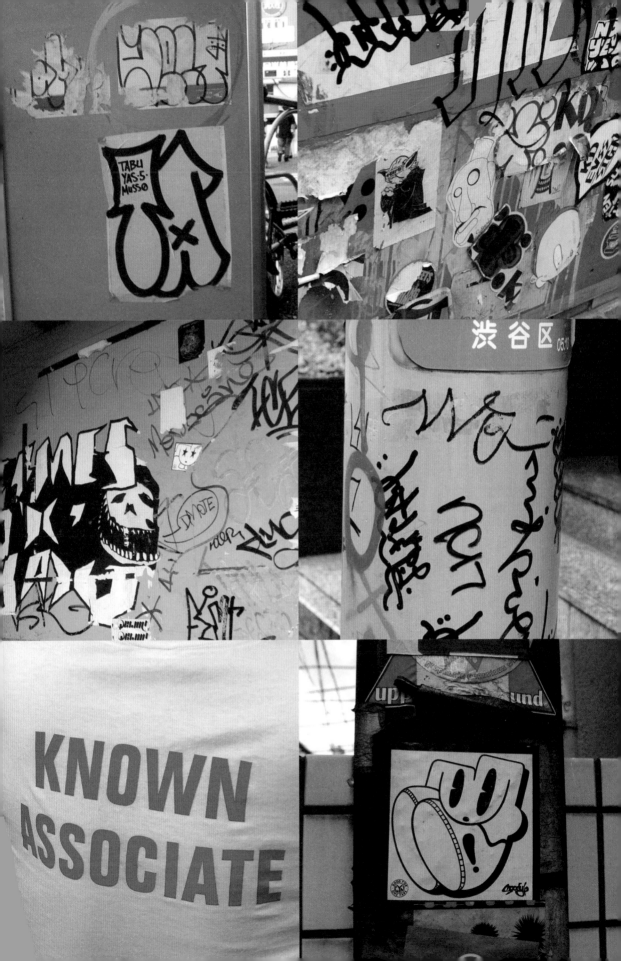

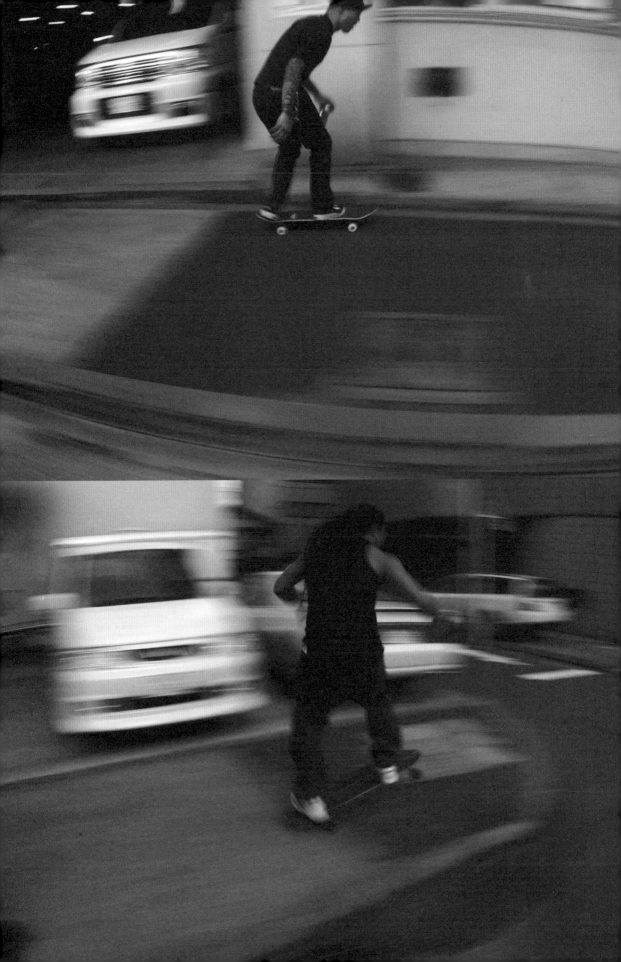

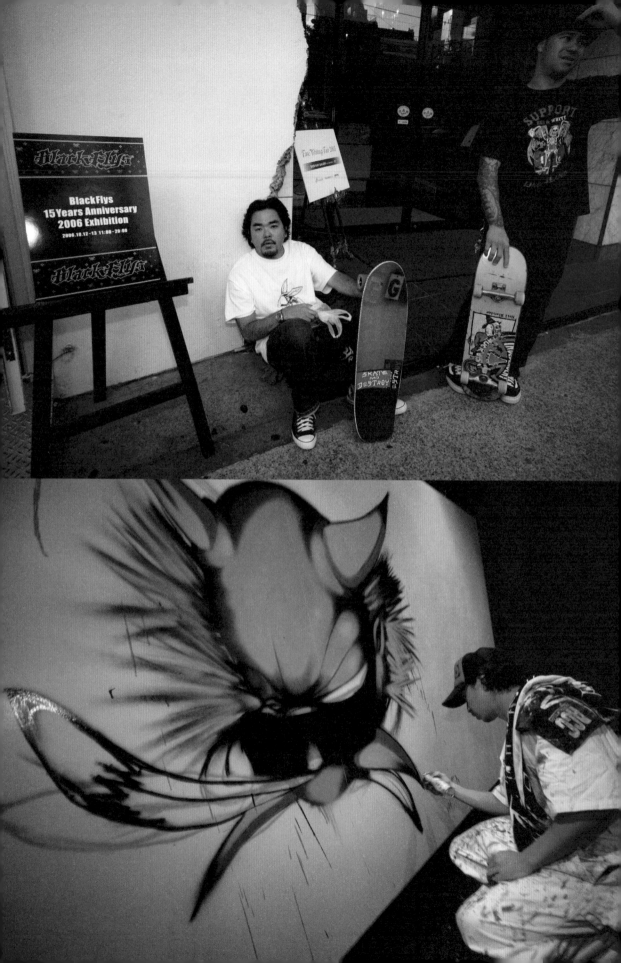

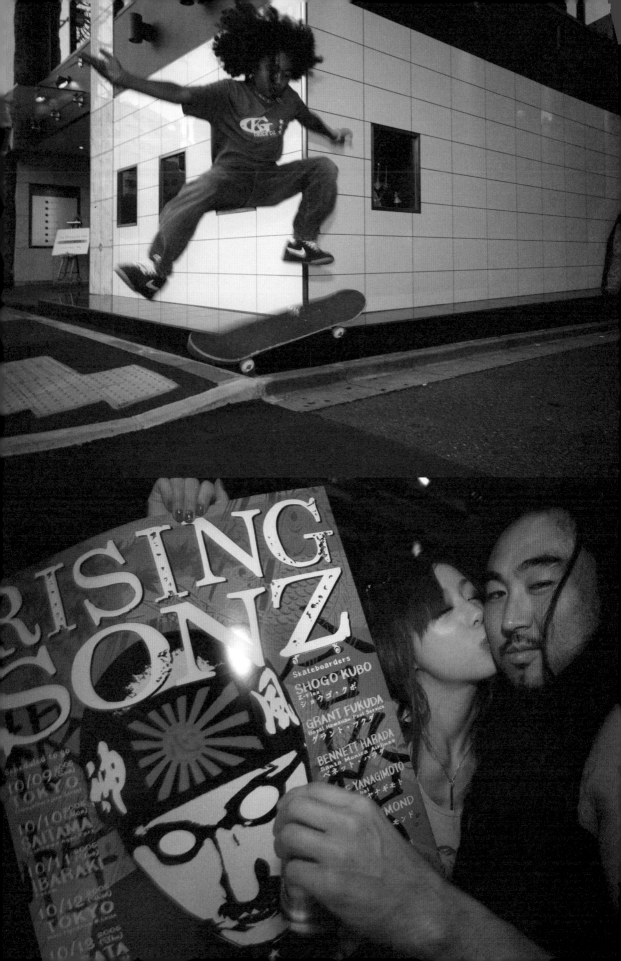

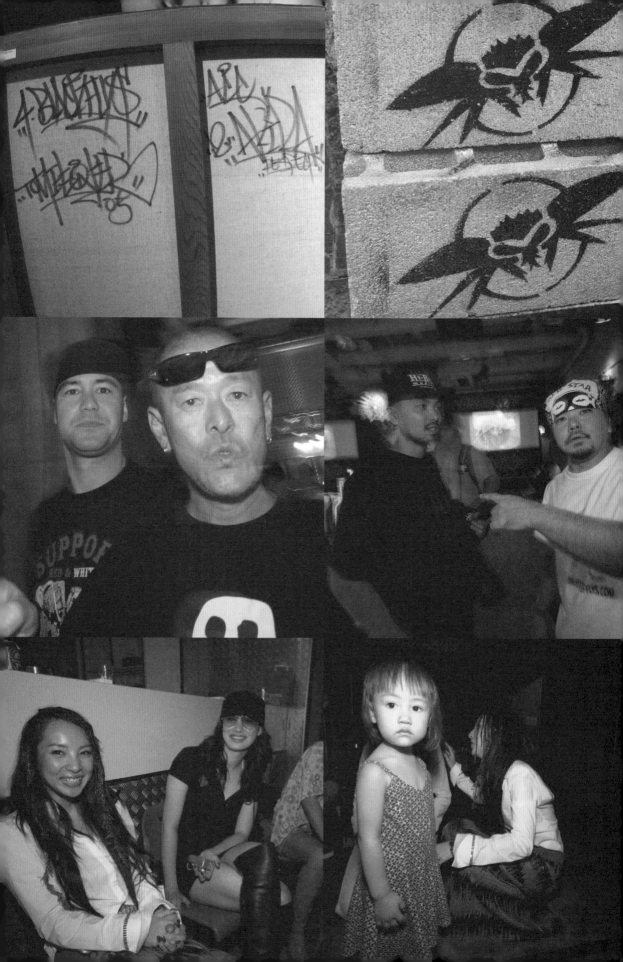

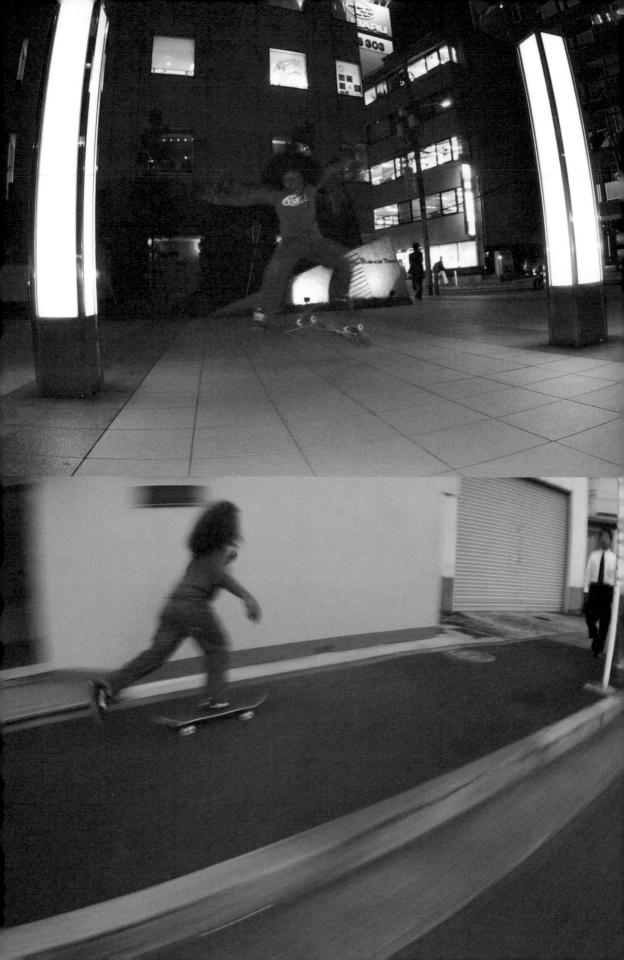

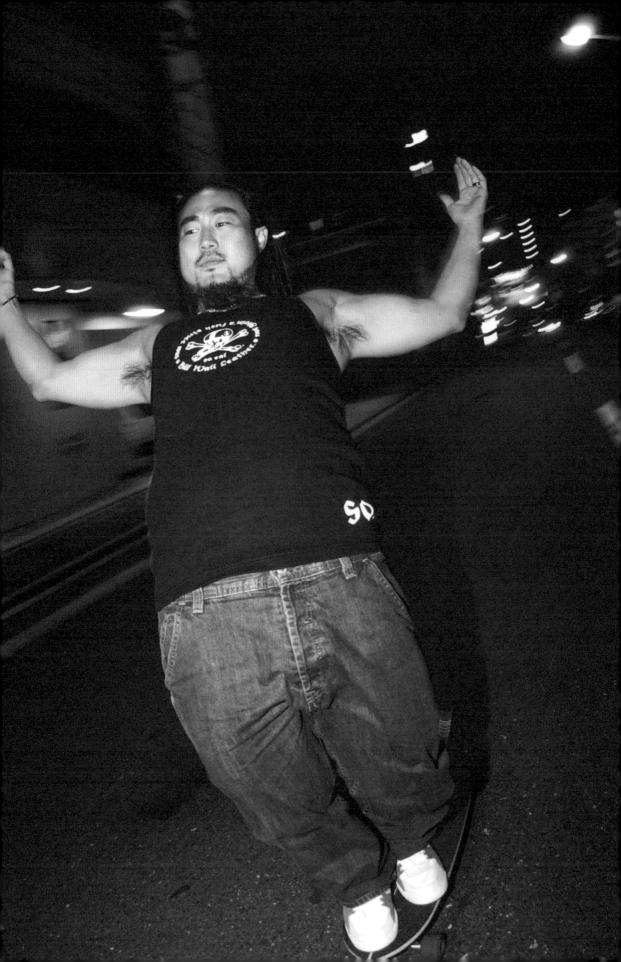

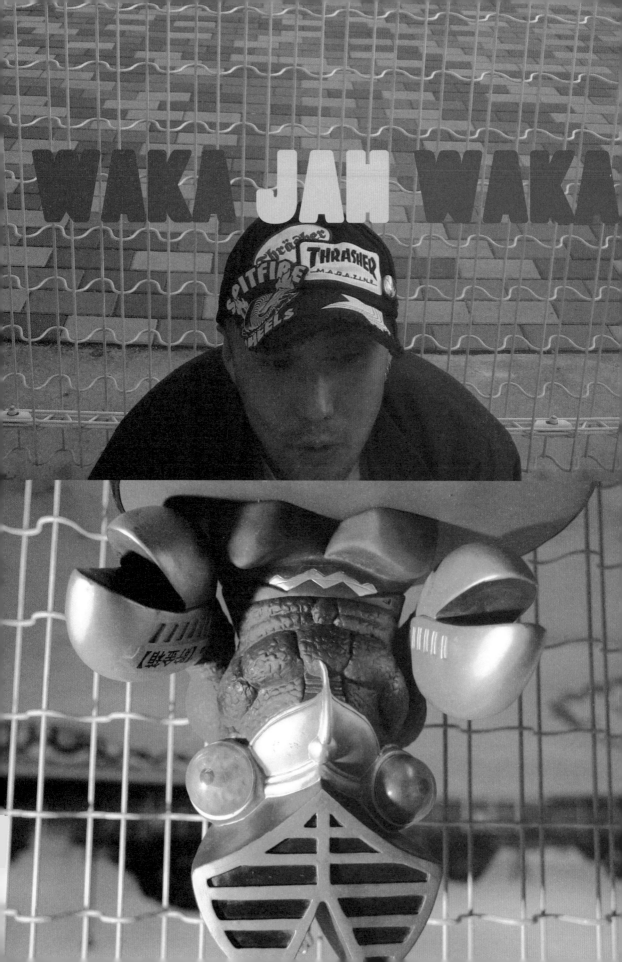

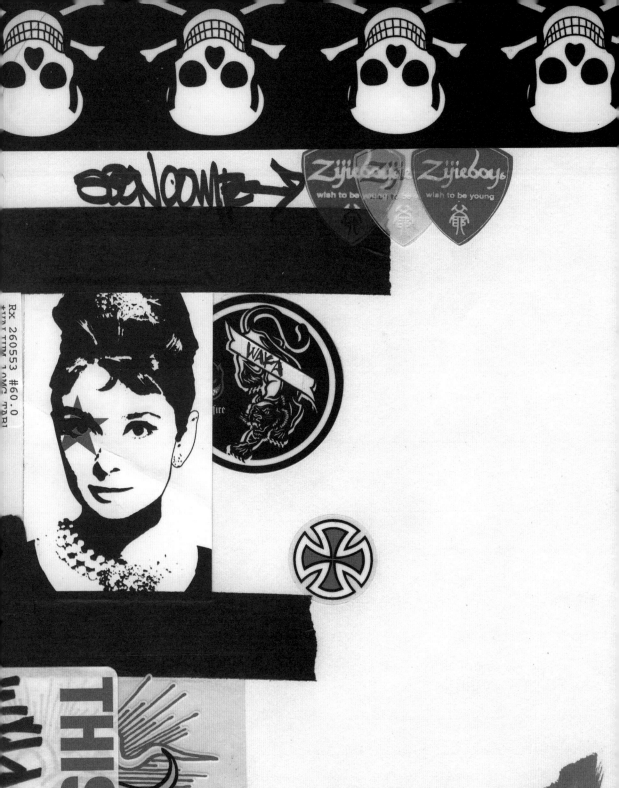

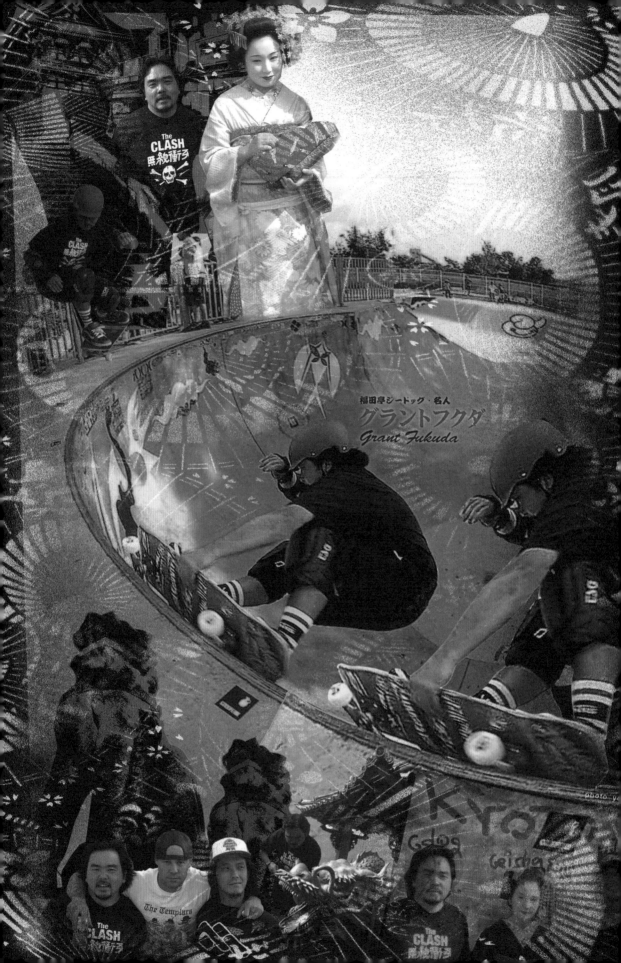

福田亭ジードッグ・名人
グラントフクダ
Grant Fukuda

原田孝べに～と・真打

ベネットハラダ

Bennett Harada

DIE TO
SKB SKB
TO DYE!
KYLE THE PILE

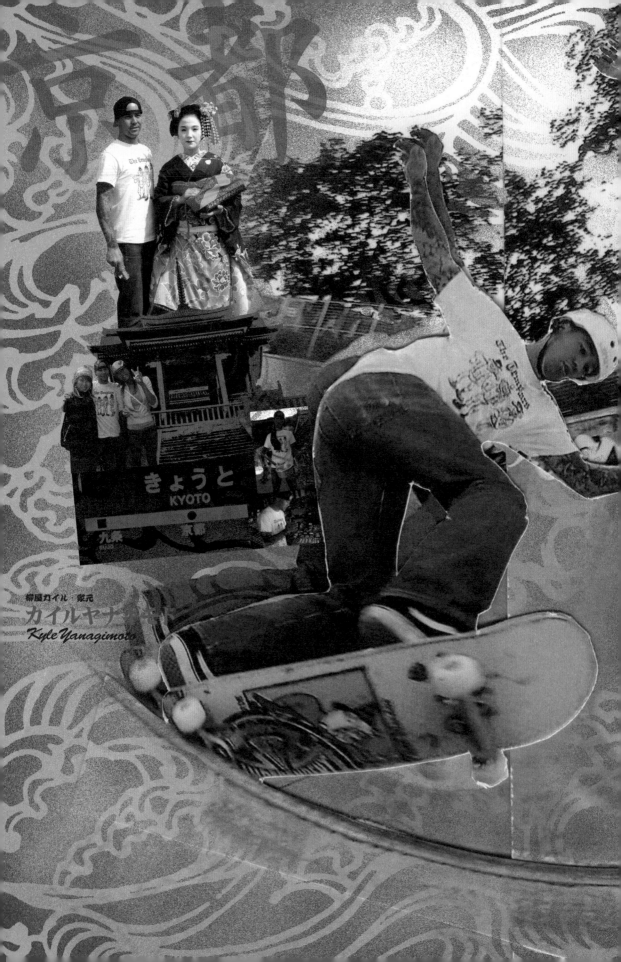

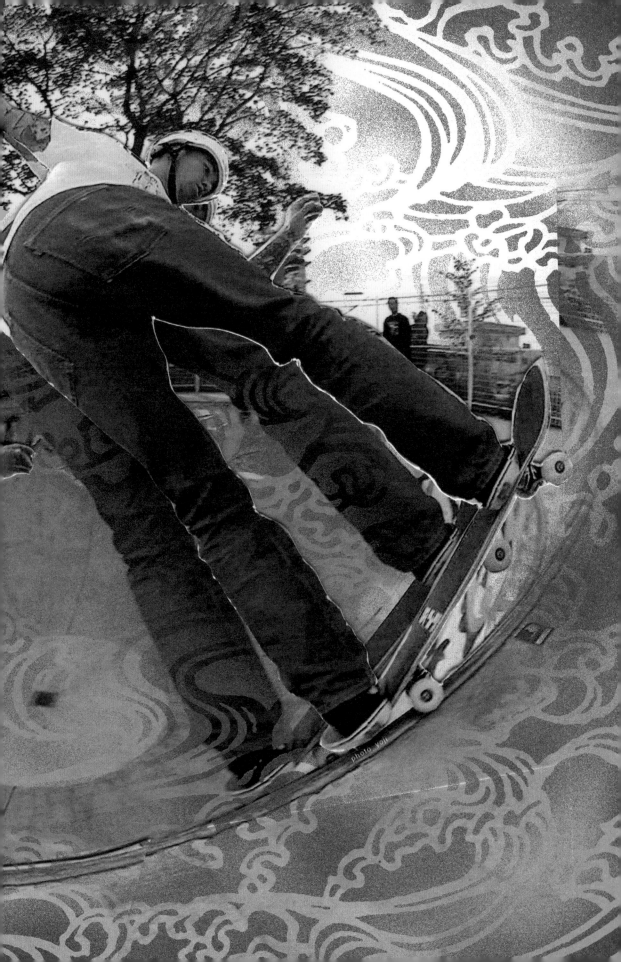

photo. voll

X-COLOR GRAFF
ACUTE, AKIM, AMES,
CASPER, COSA, CS, D...
DISKAH, ESOW, FATE,
JOTA, KAMI, KANE, K...
MAKE, NEIM, NESM...
REW, ROM, SASU S...
TABU, SUIKO, VE2Y...

ティ in Japan

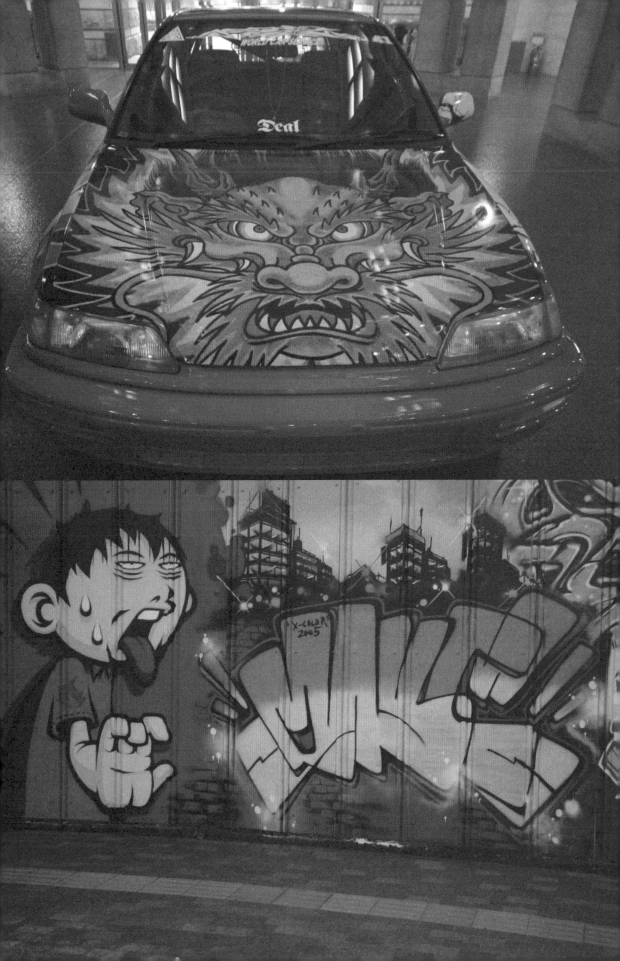

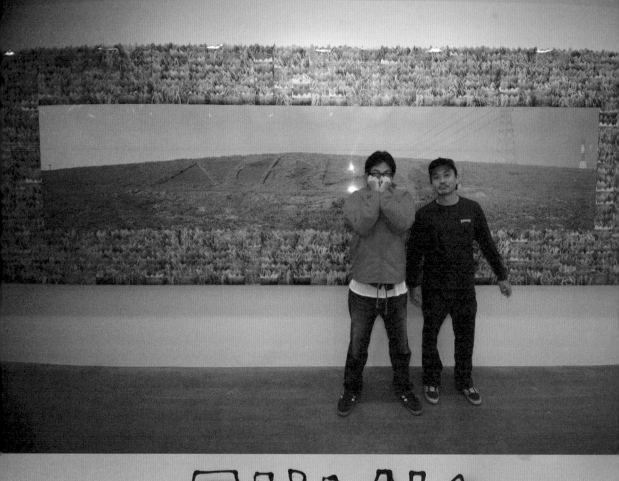

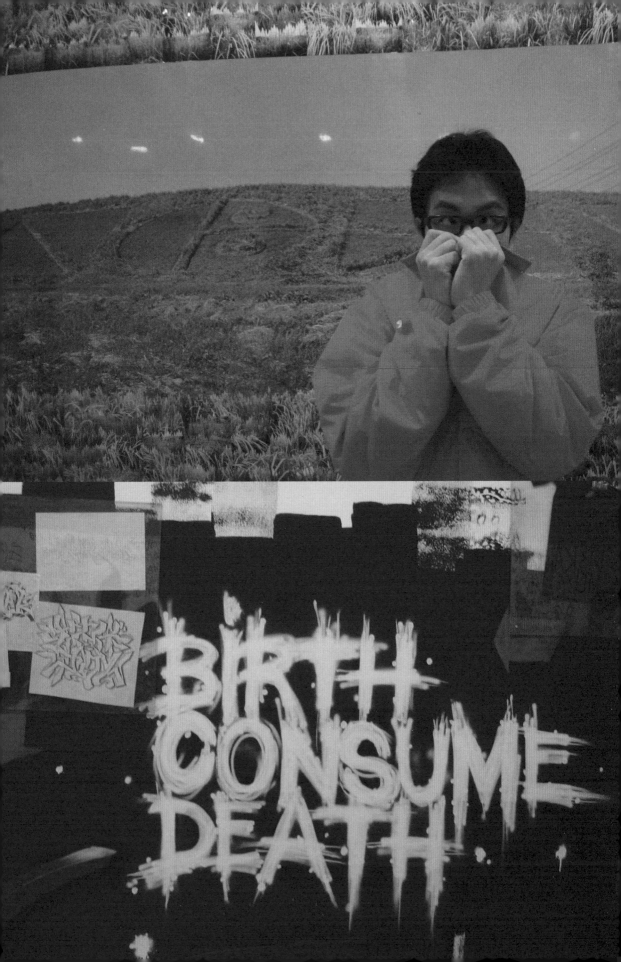

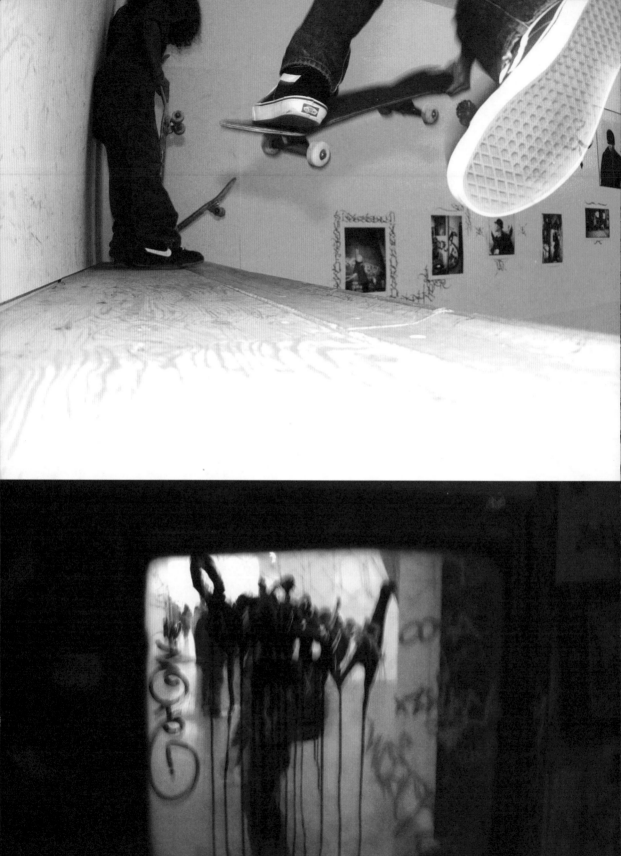

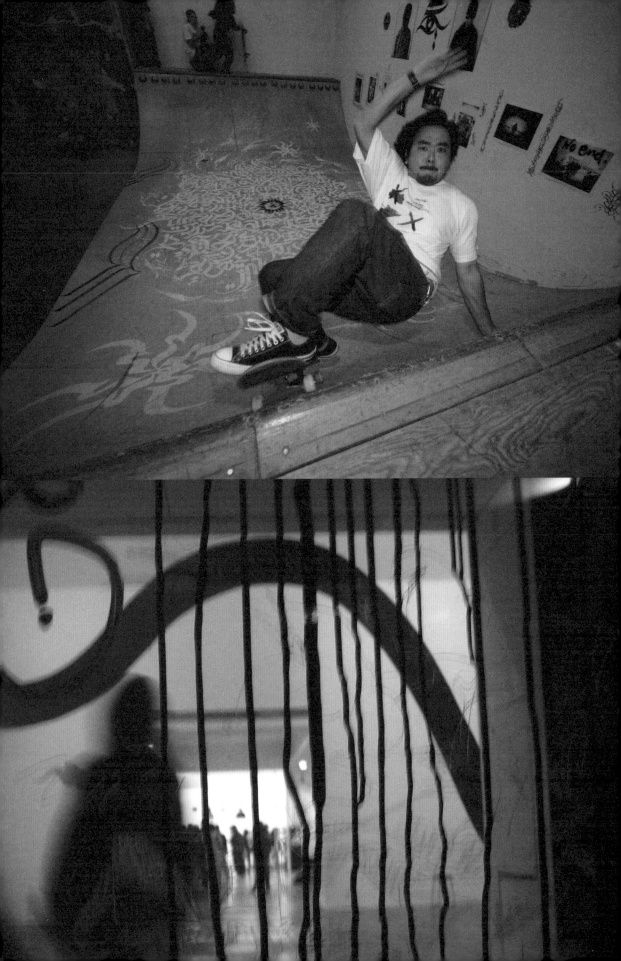

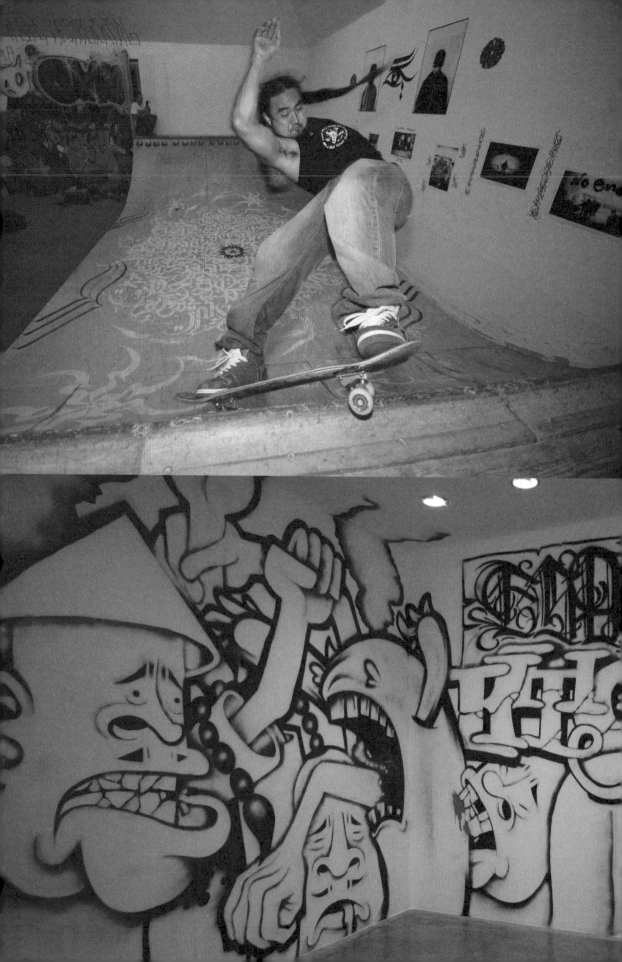

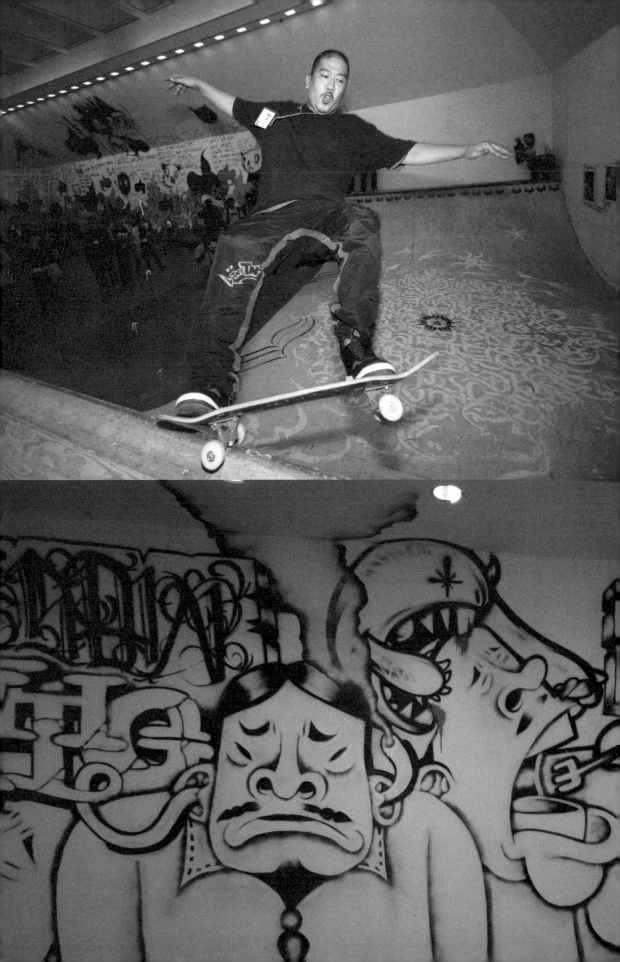

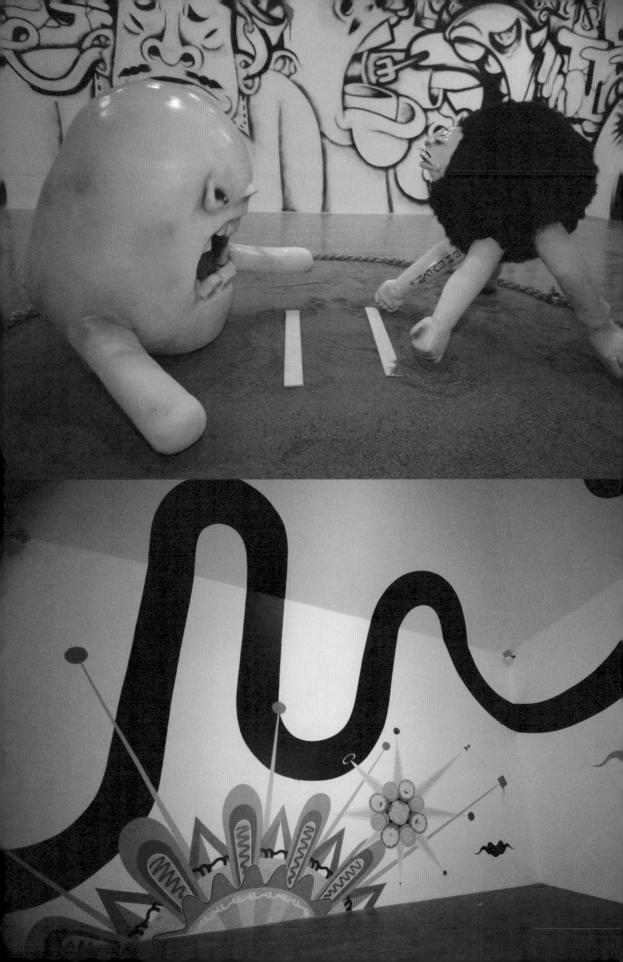

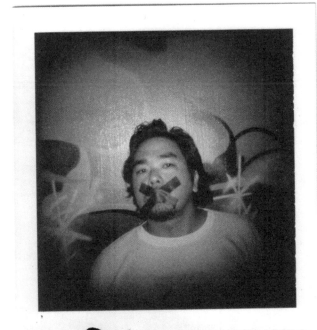

RISING SONZ!]— research
BUDDHA HEAD

painters: past and present

Dali, Van Gugh, Mark Gonzales, Risky & Mr. Carton, Huey Pritchard.

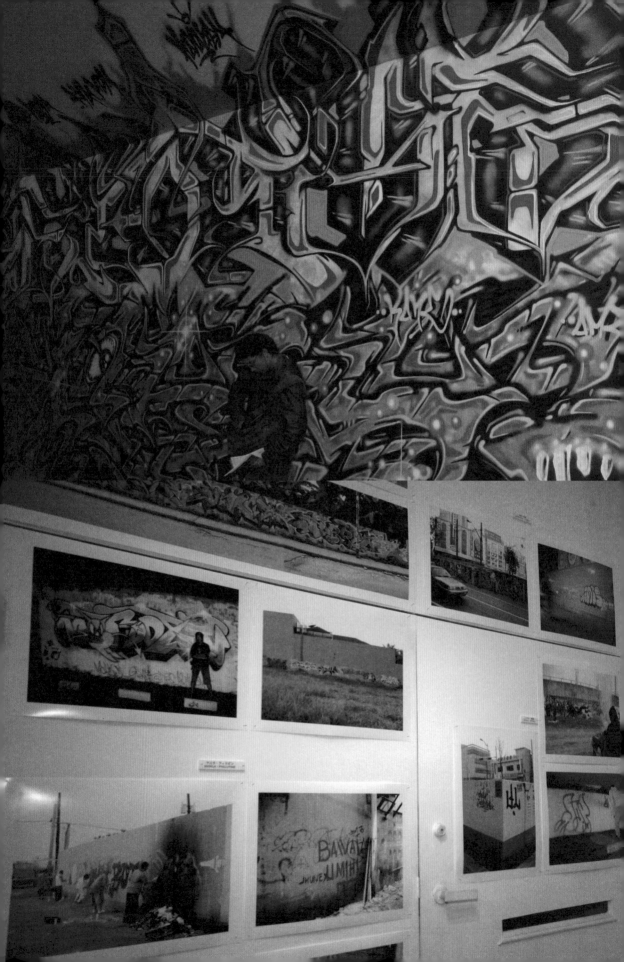

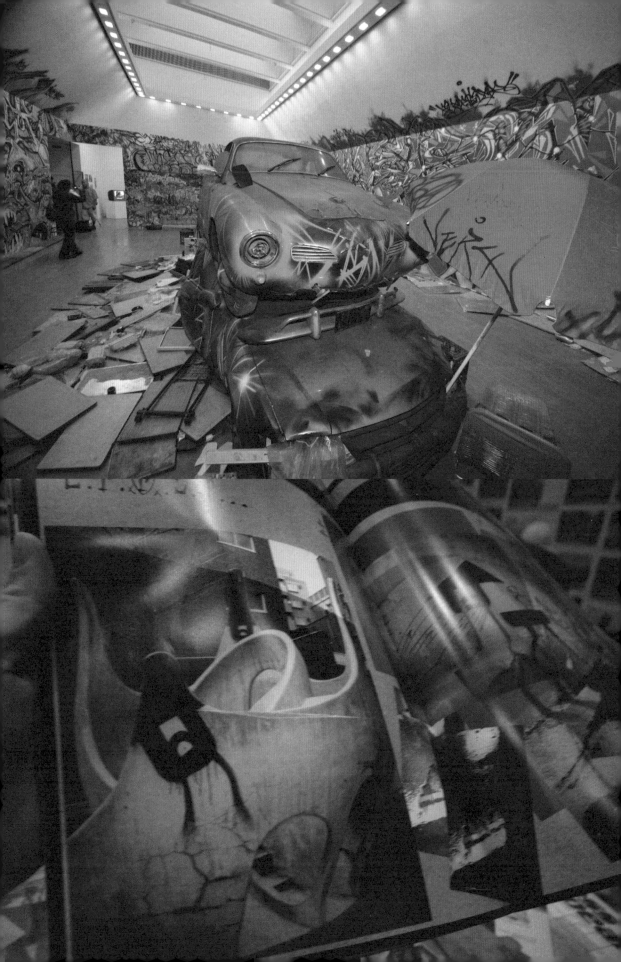

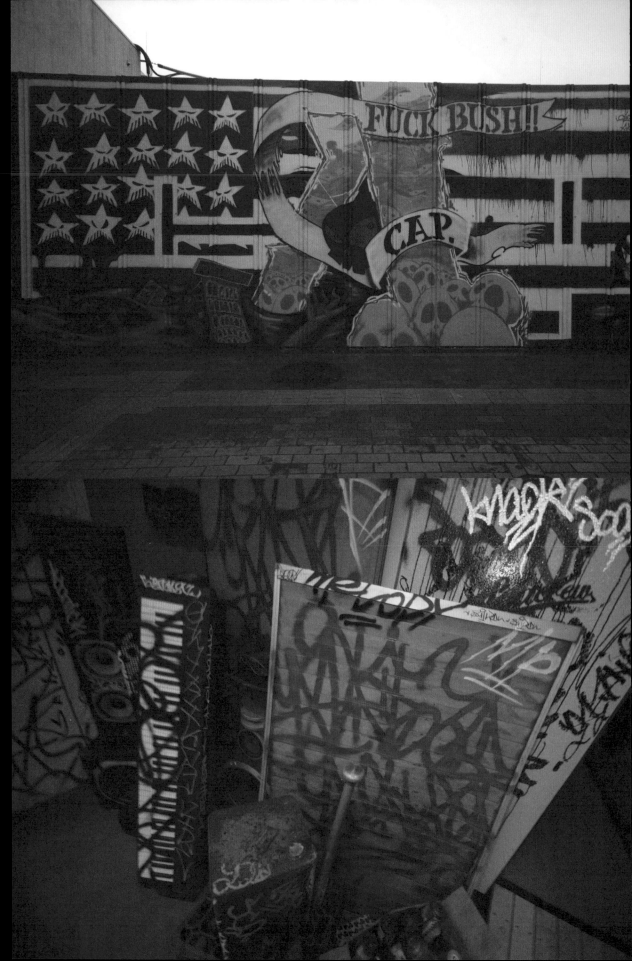

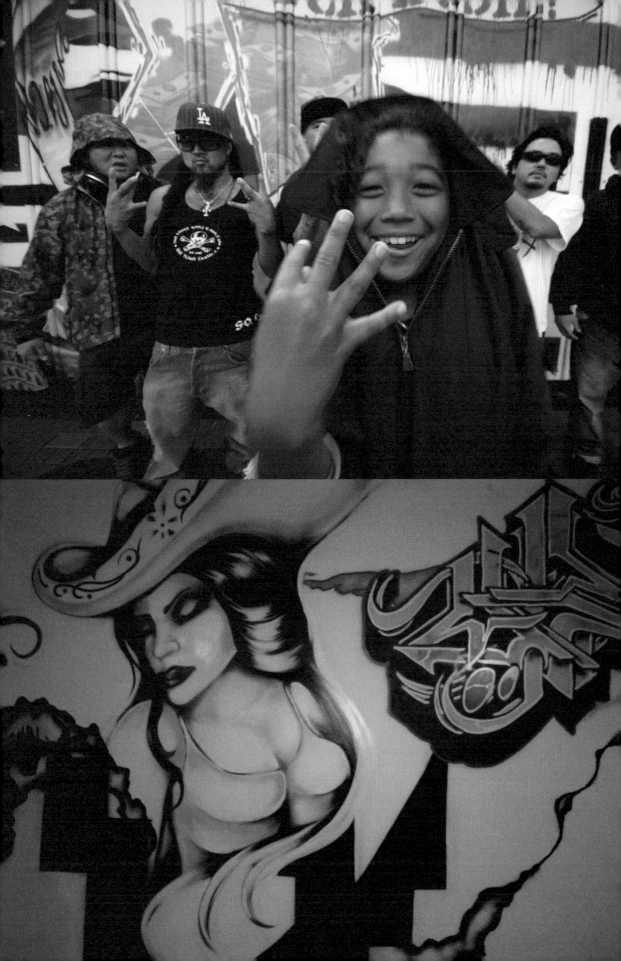

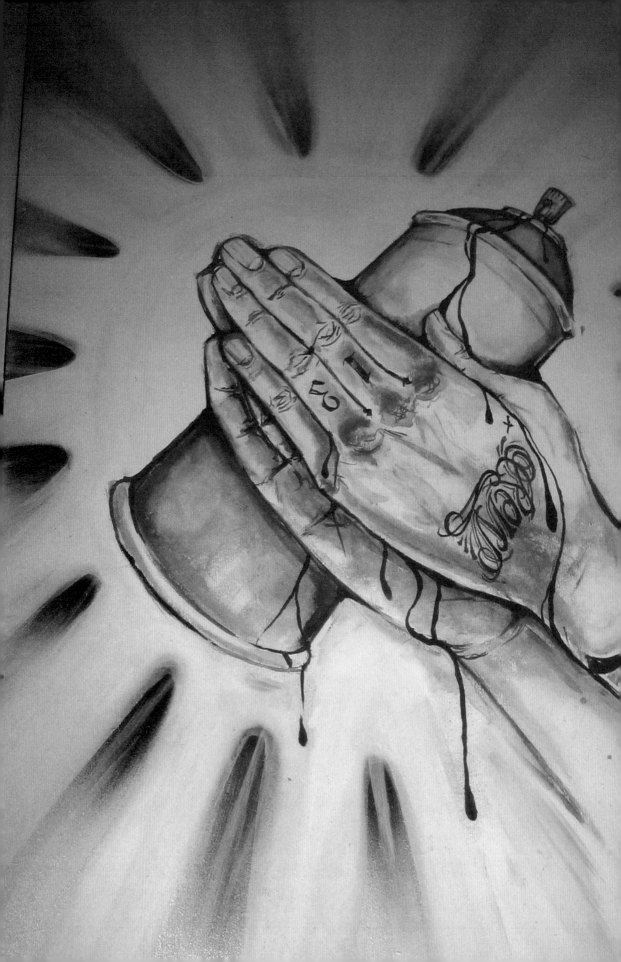

WR7I2
131 JL
JAPAN

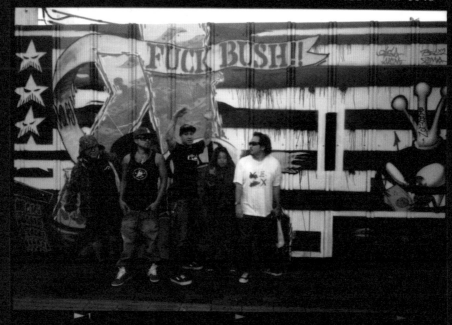

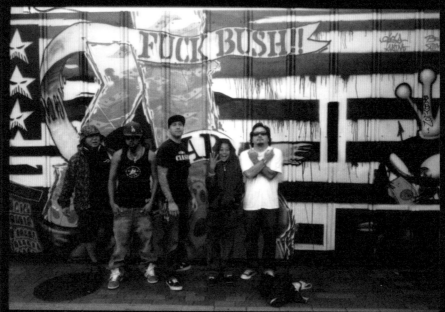

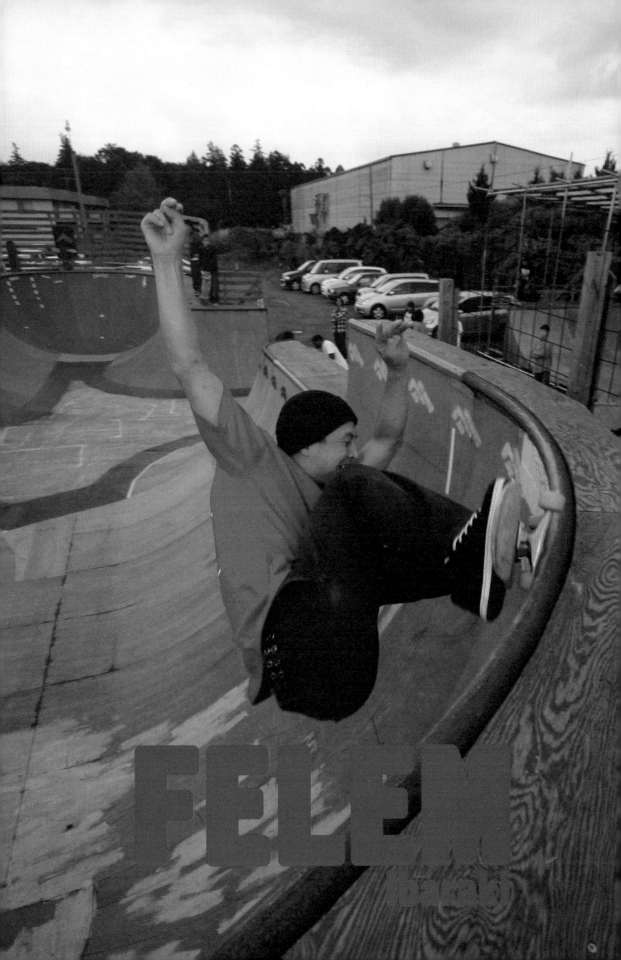

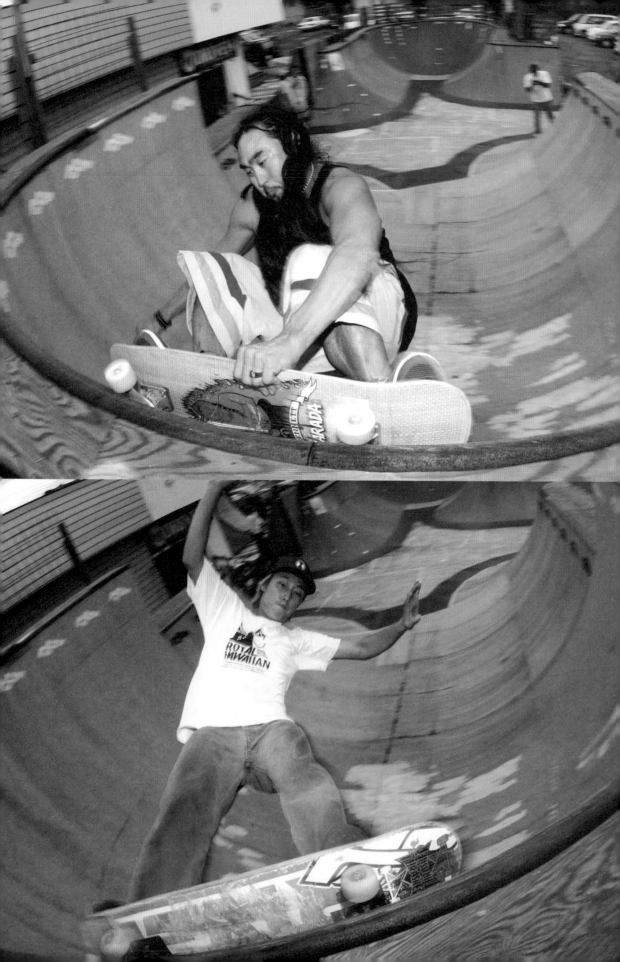

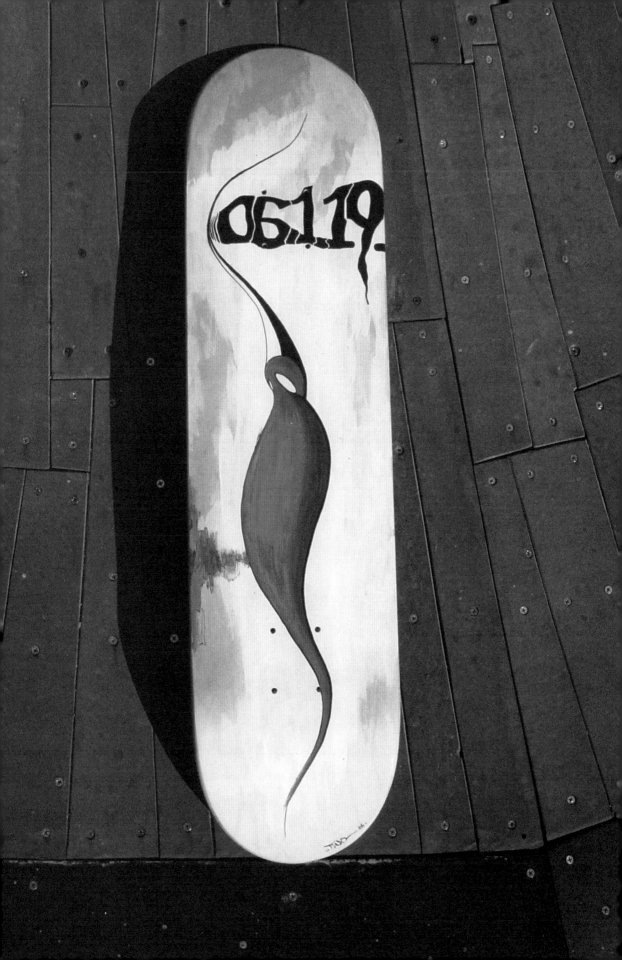

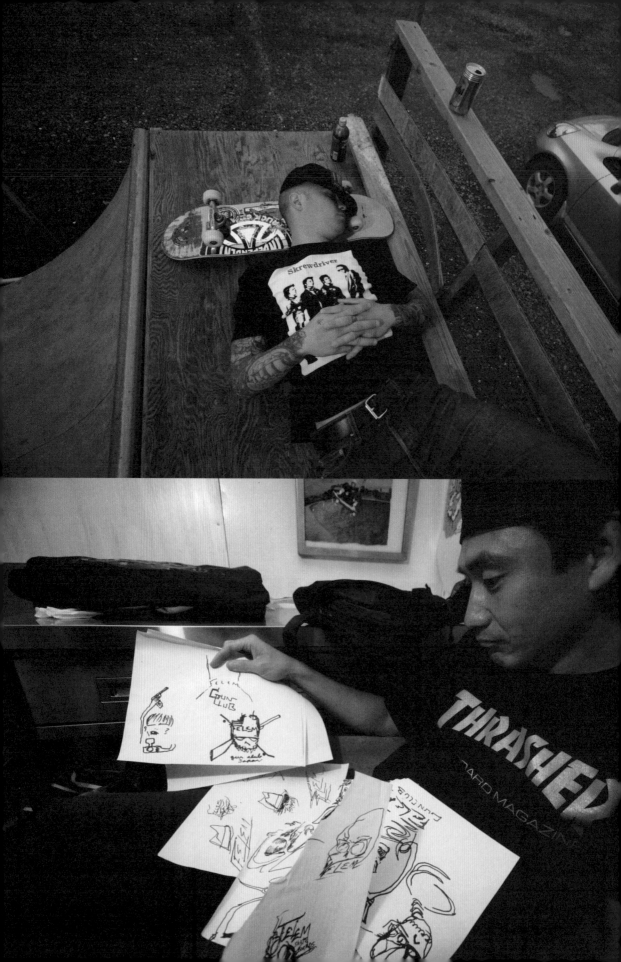

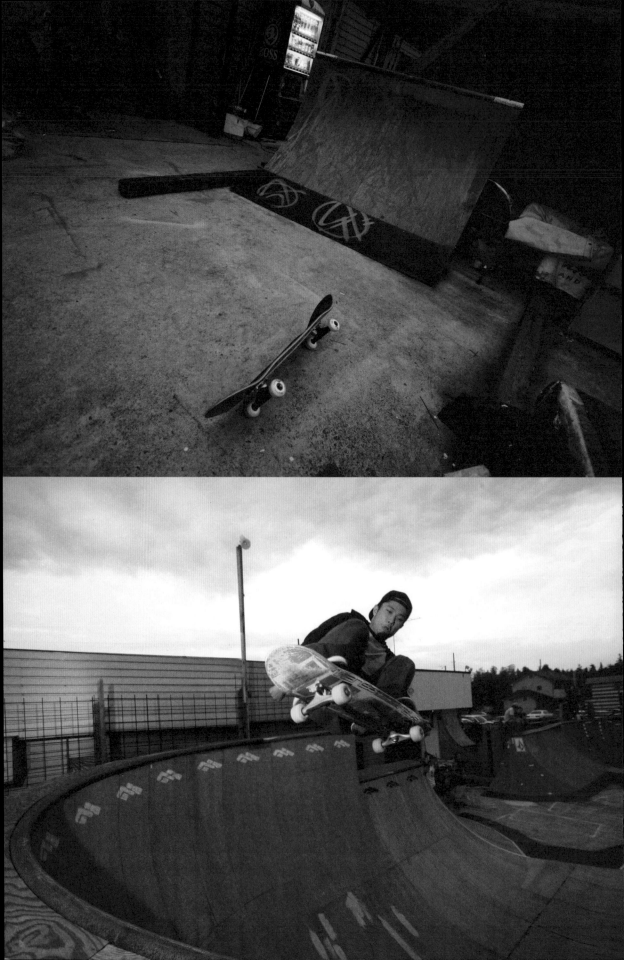

LIMITED
RELEASE

JAL JAPAN AIRLINES

☐ FRAGILE OR INADEQUATE PACKING
 動揺品又は不完全梱包品

☐ PERISHABLE
 生鮮品

☐ RECEIVED DAMAGED ● SPECIFY ▷
 損傷品受領

☐ NOT ADMISSIBLE IN CABIN (OVER SIZE)
 機内持込み不可 (過大荷)

☐ PET ANIMAL
 ペット

I AGREE THAT CARRIERS PARTICIPATING IN TRANSPORTA-
TION OF THIS ITEM MAY NOT ACCEPT CLAIMS RESULTING
FROM THE ABOVE CONDITIONS OF ACCEPTANCE

(私は、航空会社が、上記の理由に基づき受領する手荷物に
ついないことを了承します。)

RECEIVED SIGNATURE

MARK DAMAGED AREA ON DIAGRAMS

TOP
SIDE
BOTTOM
END

THIS IS FOR
YOUR
FRIENDS :)

PEEL BACK
TO HERE
(NO NEED TO TAKE OFF THIS PA

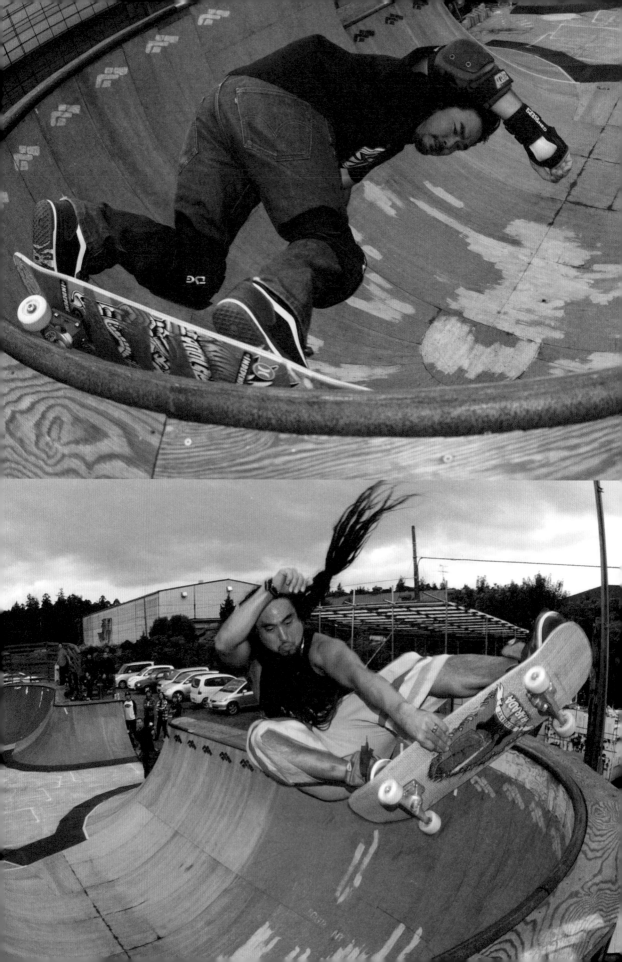

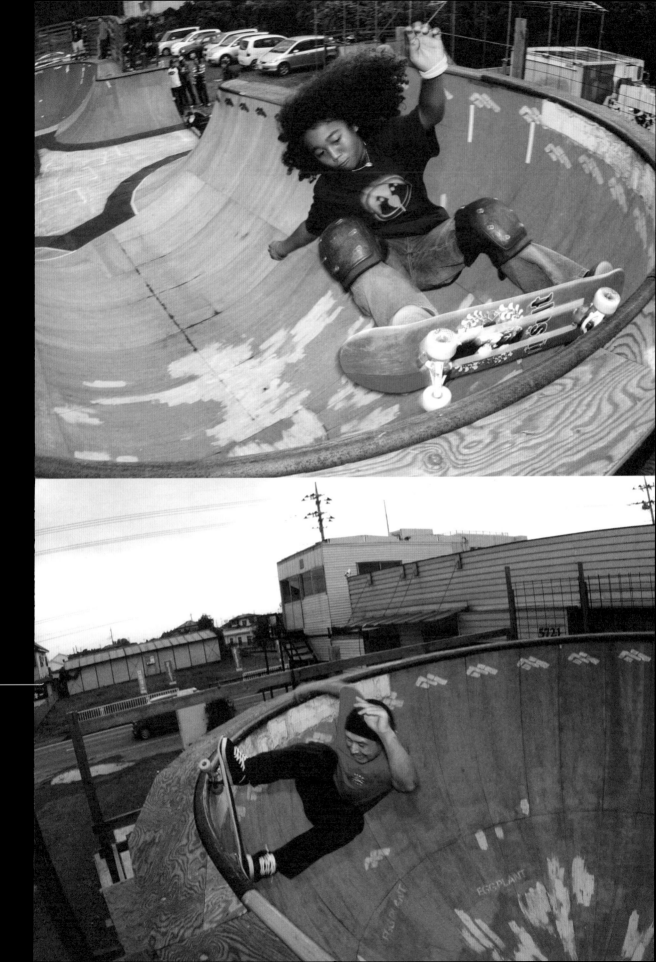

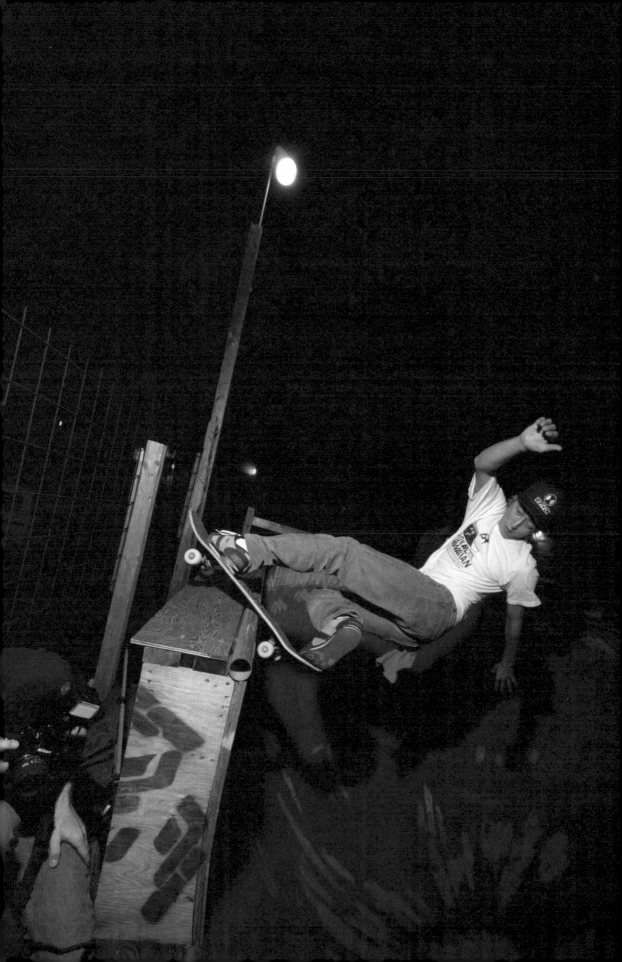

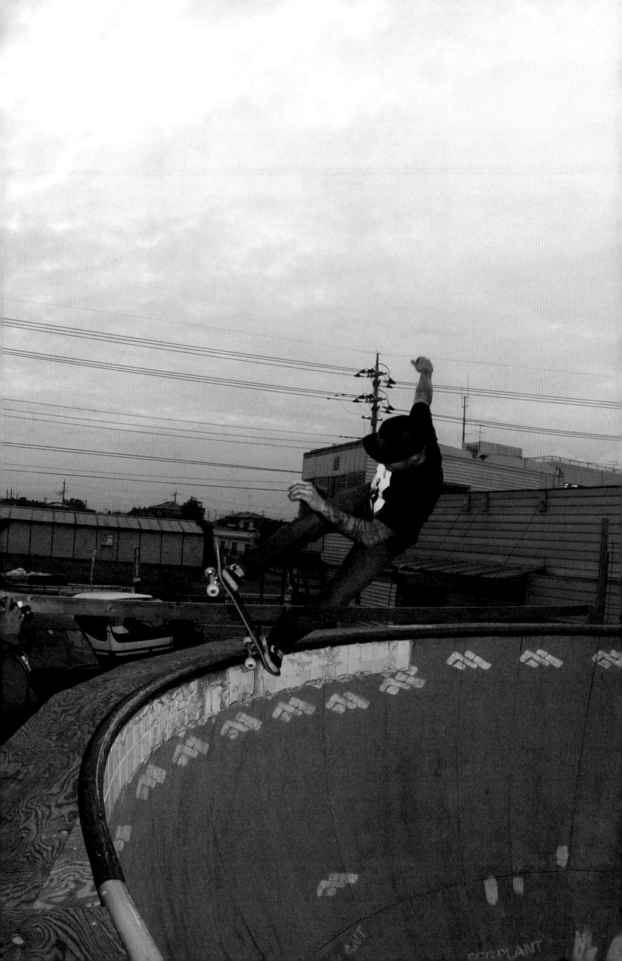

we leave HAKATA, FUKUOKA and ~~IN~~
~~seth~~ Head 3 hours north to
KYOTO. we pass HiRoshima (the city
where the ~~ATOM~~ ATom Bomb Hit in
WWII — this is also the city where my
Family the FUKUDA'S are From). MY
FATERS FATER owned land in this

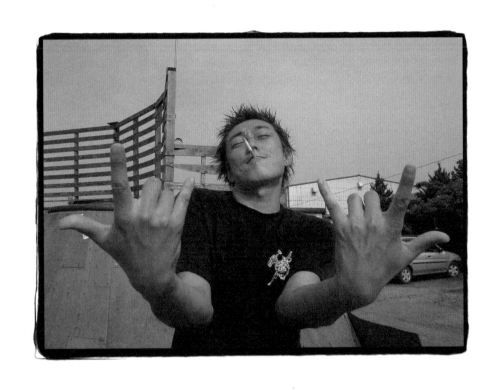

district. Shogo gets off the train
to visit his mom for the Night.
Kyoto is a very cool & Historic
city. Certain streets Remind me
of SAN FRAN. The Zijieboys pick
us up & we skate the Kyoto
park. It is killer a Nice Flow

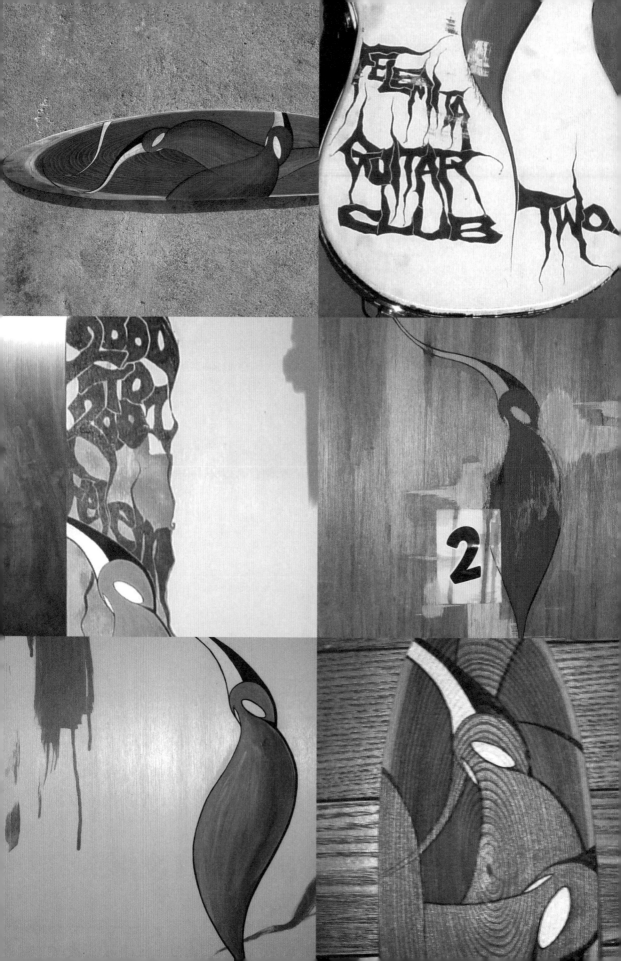

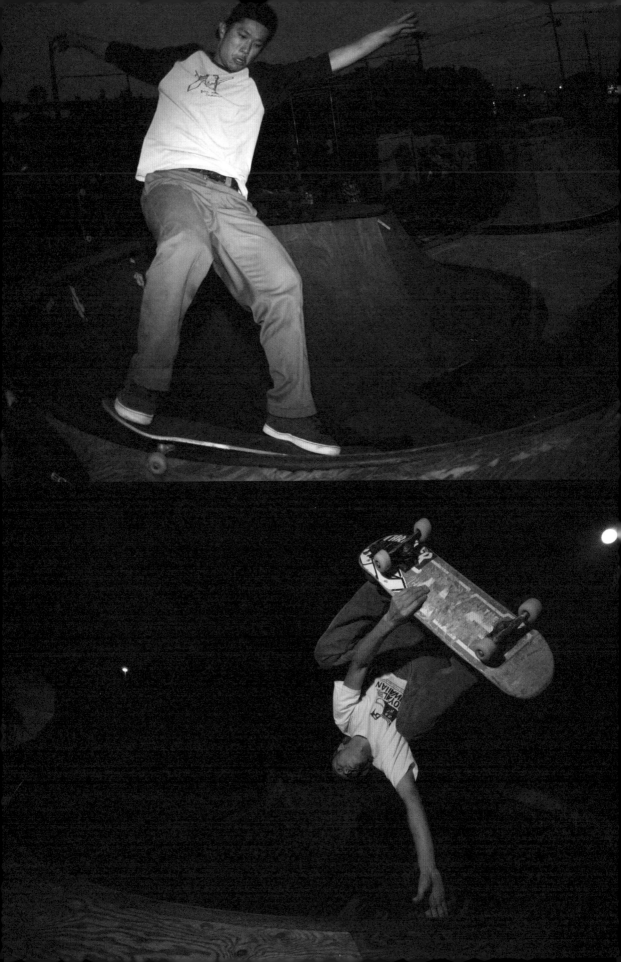

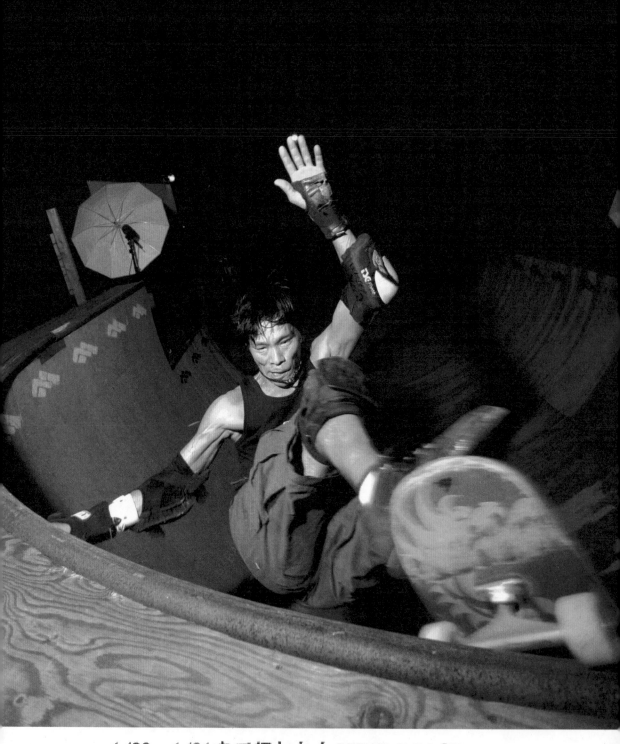

1/23〜1/31まで行われたDREAM PILLOW。
☆☆☆みなさん、素敵な夢を教えてくれてありがとう☆☆☆

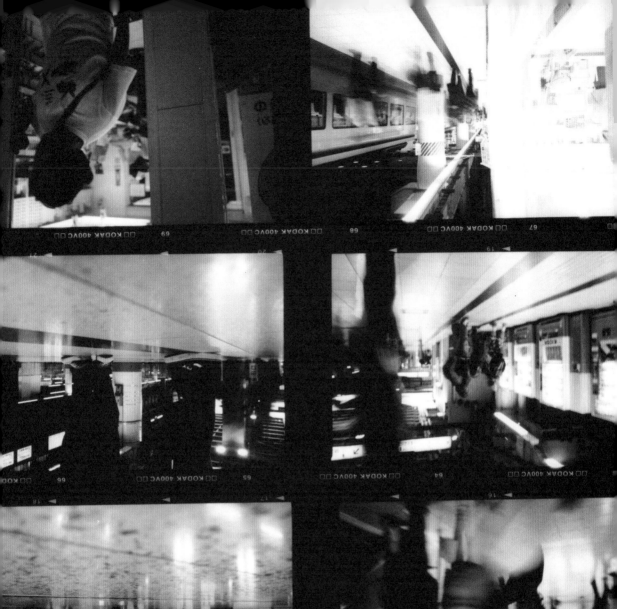

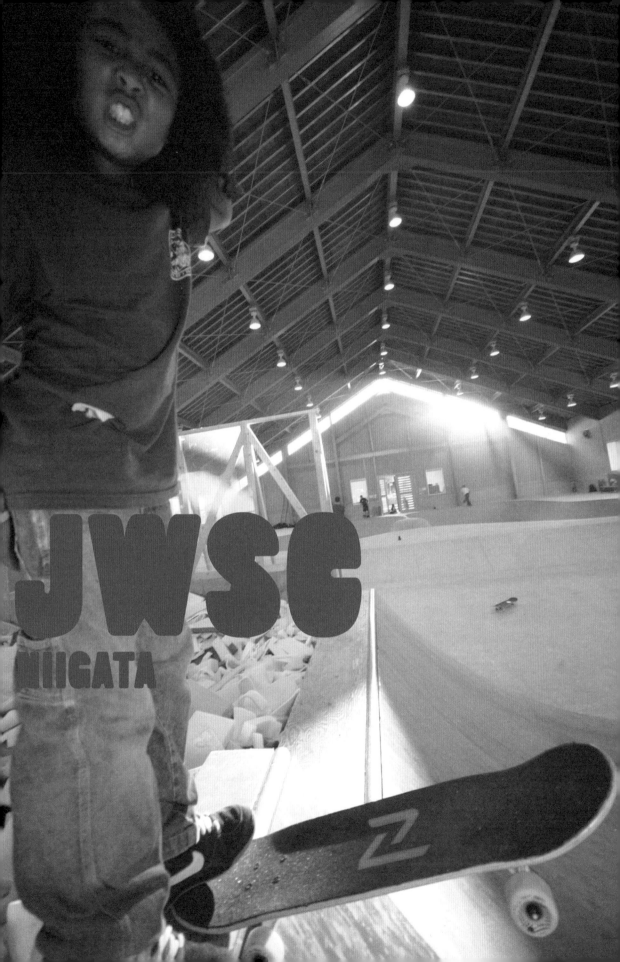

JWSC
NIIGATA

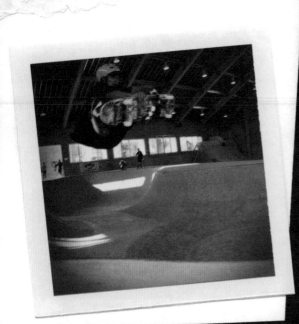

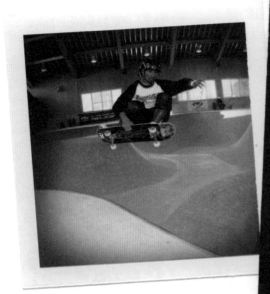

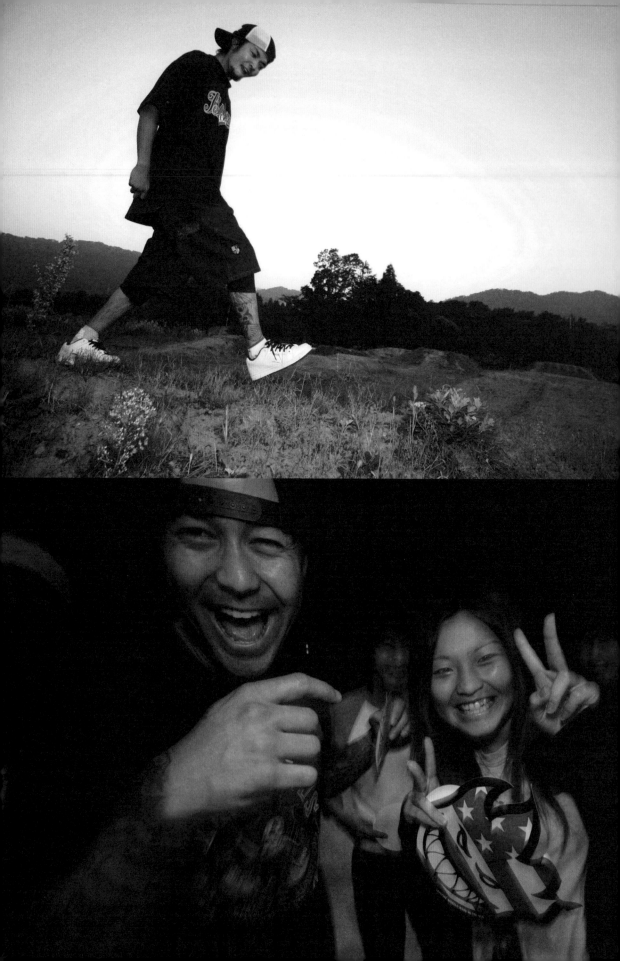

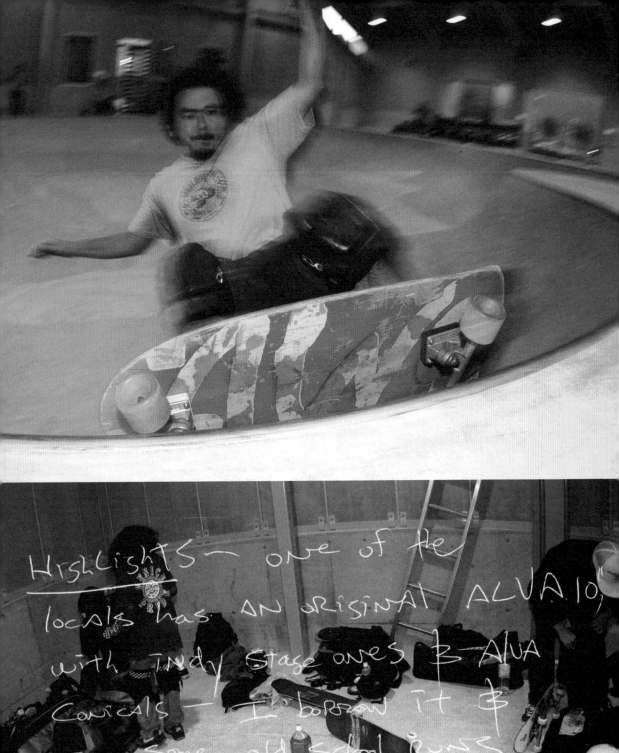

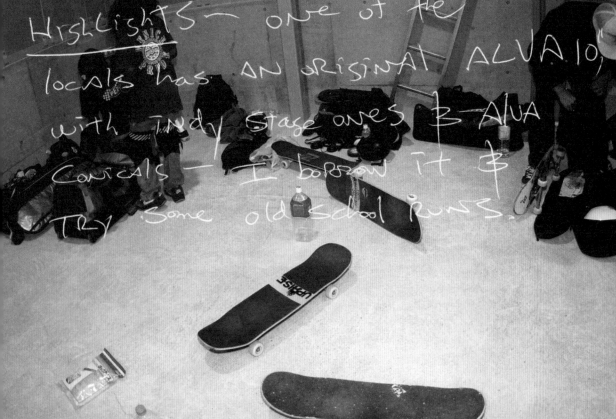

HIGHLIGHTS — one of the
locals has AN ORIGINAL ALVA 10,
with INDY stage ones & ALVA
conicals — I borrow it &
TRY some old school RUNS.

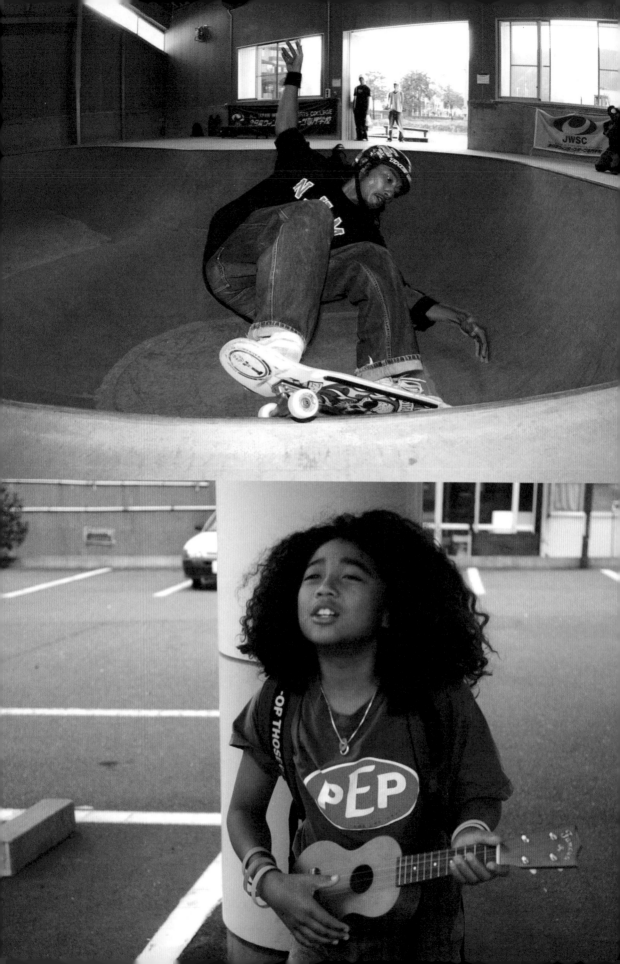

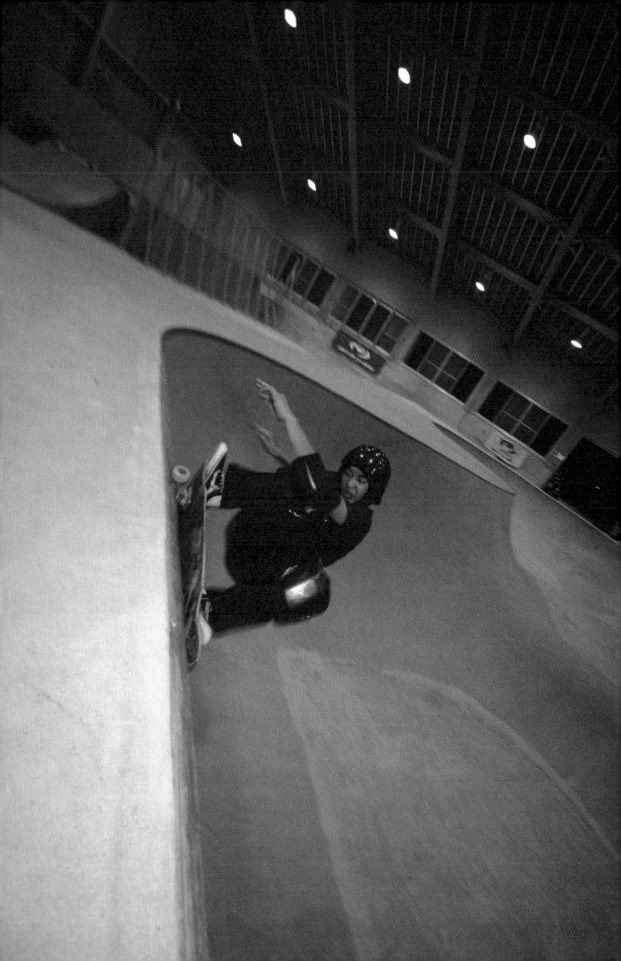

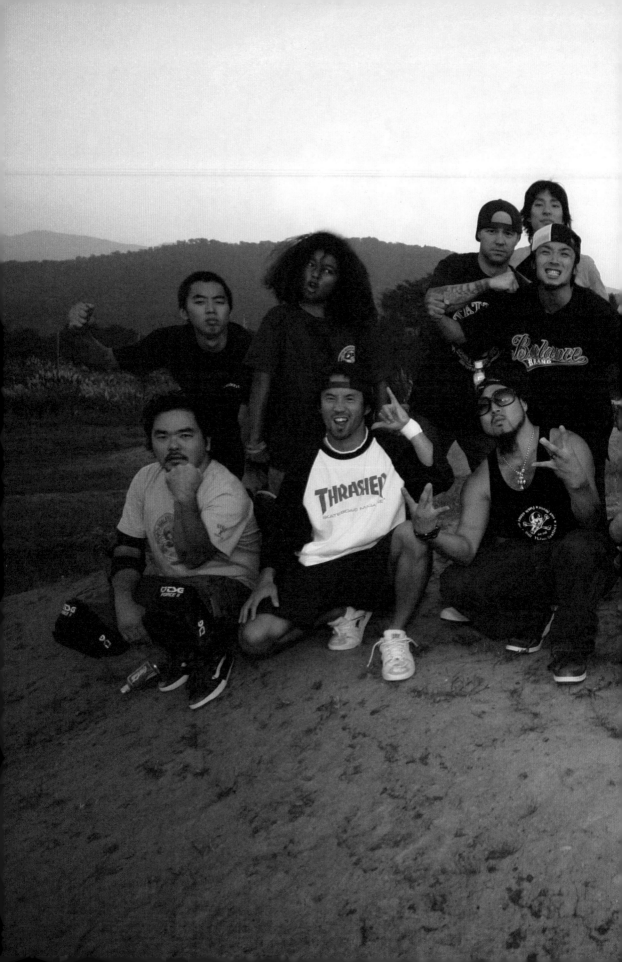

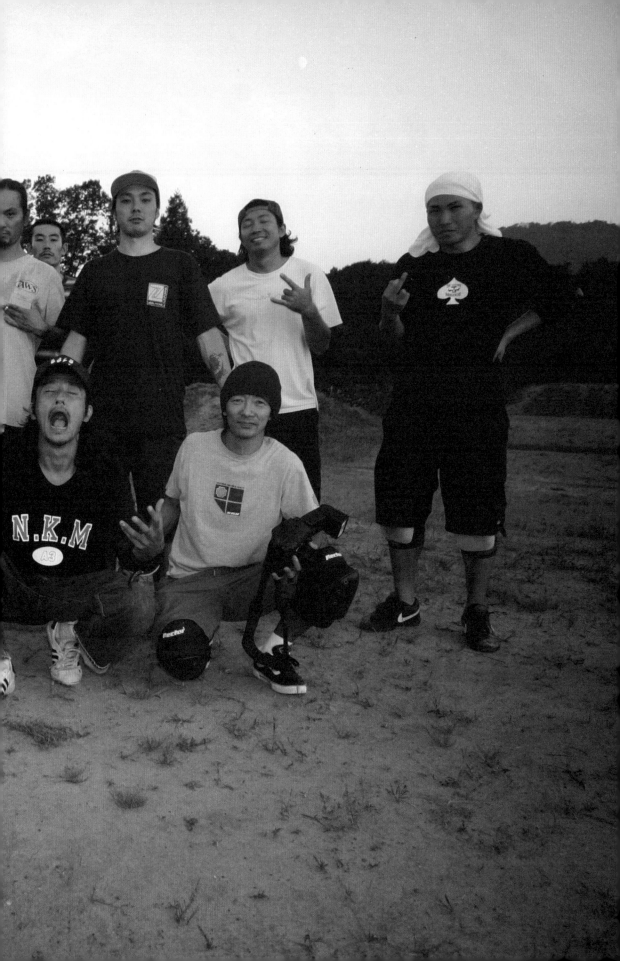

DETERMINED, PISSED OFFNESS, & THEN STOKEDNESS

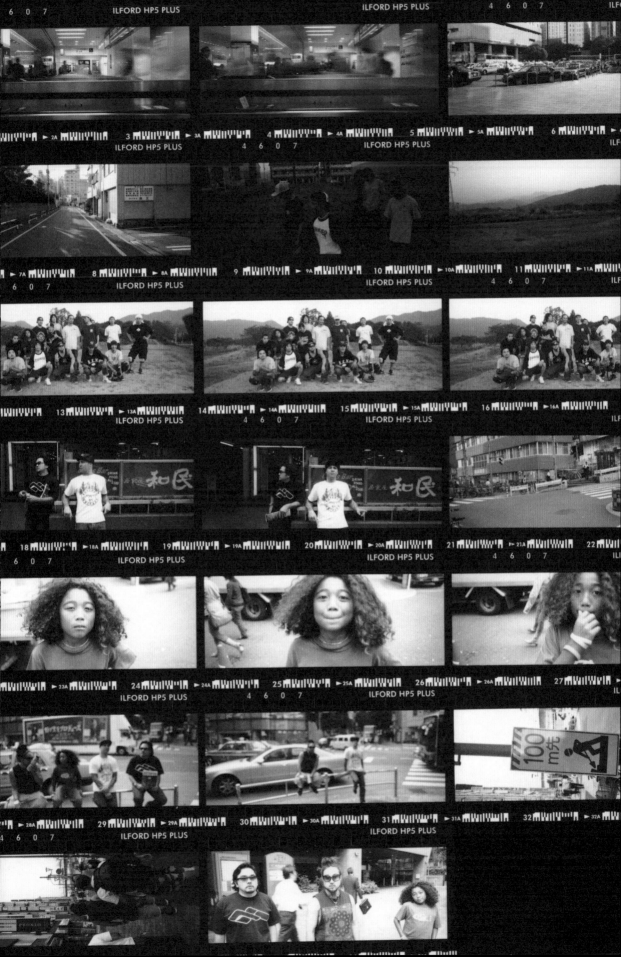

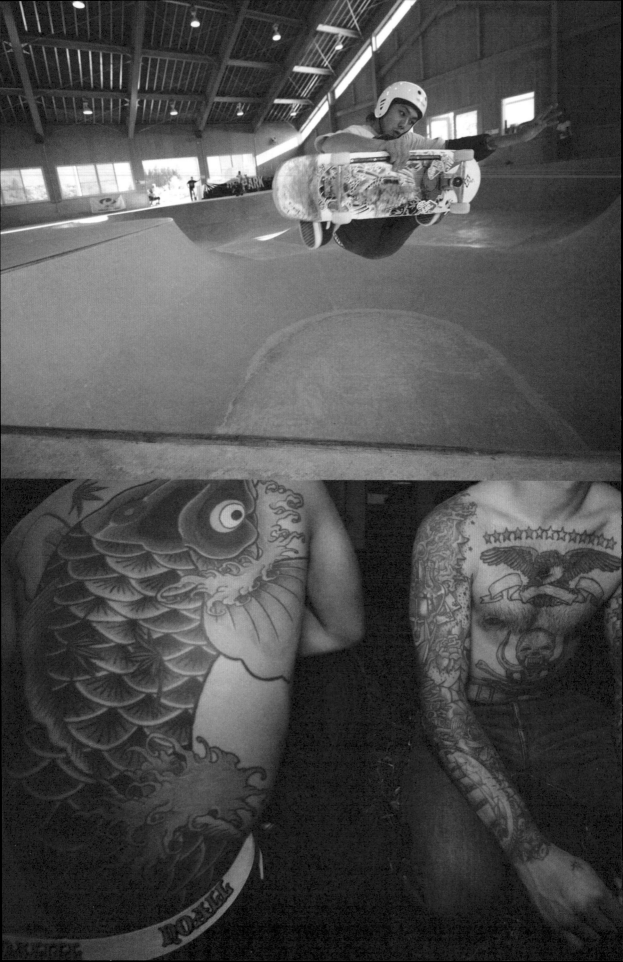

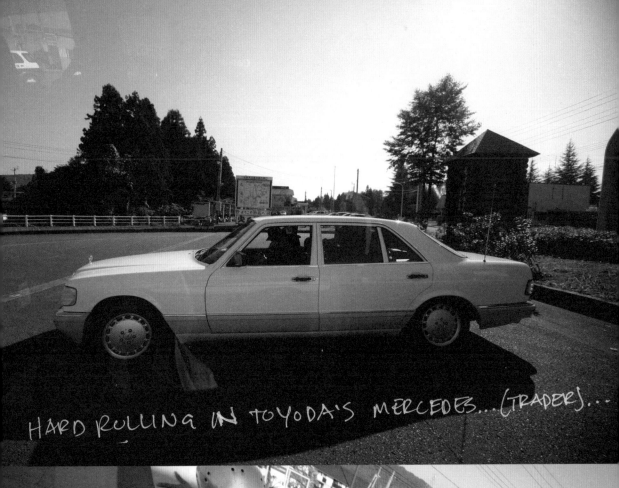

HARD ROLLING IN TOYODA'S MERCEDES....(TRADER)...

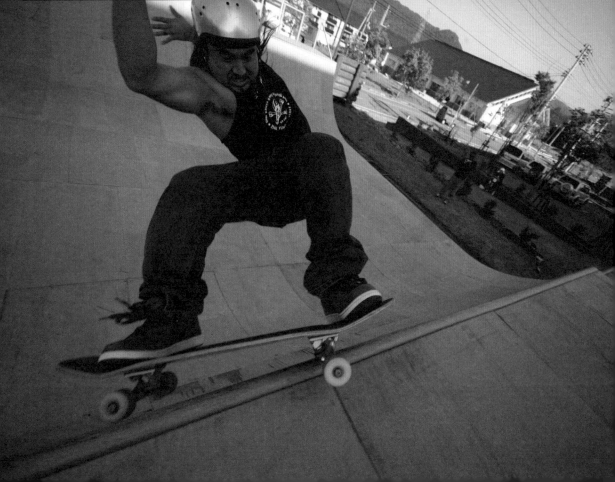

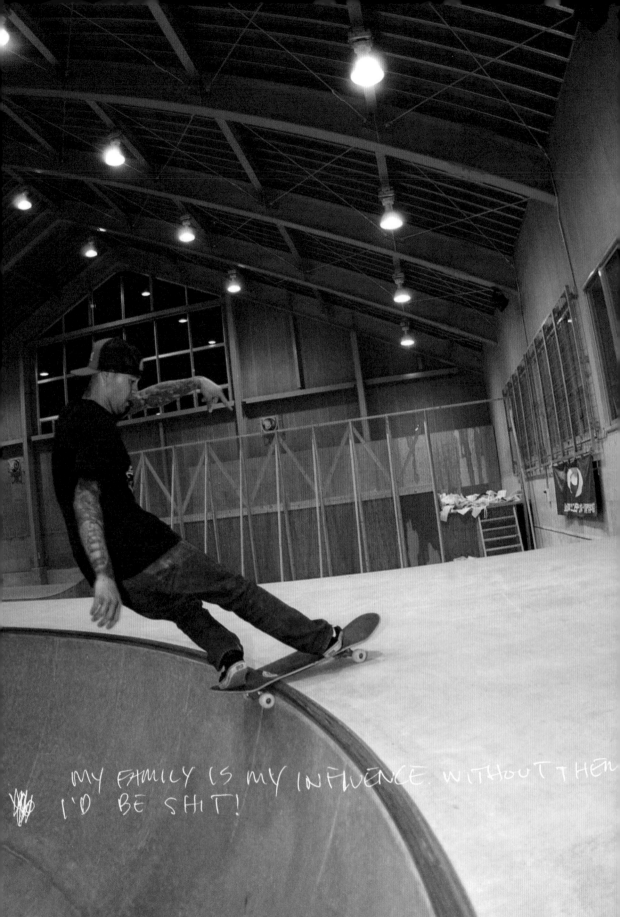

MY FAMILY IS MY INFLUENCE. WITHOUT THEM I'D BE SHIT!

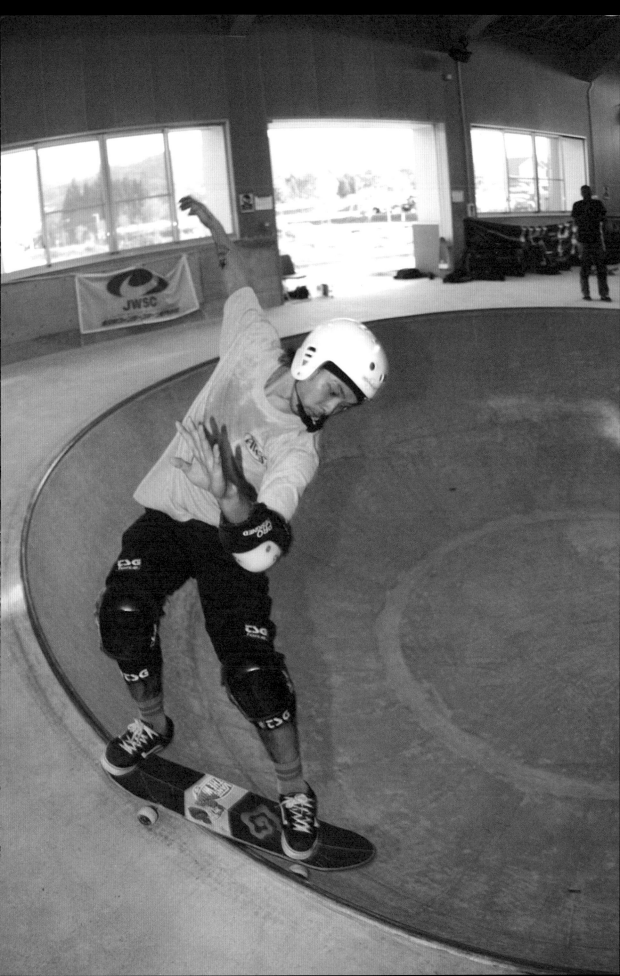

OCT 13th DAY 5

We are Heading out to the country.
To get there, we take 3 trains —
one of them is the Bullet train. The
Bullet train gets up to 162 MPH!
After 3 hours of commuting, we
arrive in the beautiful MYOKO district
legendary best skater TOYODA
picks us up $ hit his skatepark.
It consists of a killer clover bowl $
street course.
The locals here are very humble $
kind. MYOKO is located in the mountains,
it is a ski town, the park was
designed by toyoda, for skaters $
snowboarders to practice all year long.
A killer session goes down.
BENNETT $ KYLE are stoking
out the locals. the skaters
in this town have power
$ style.

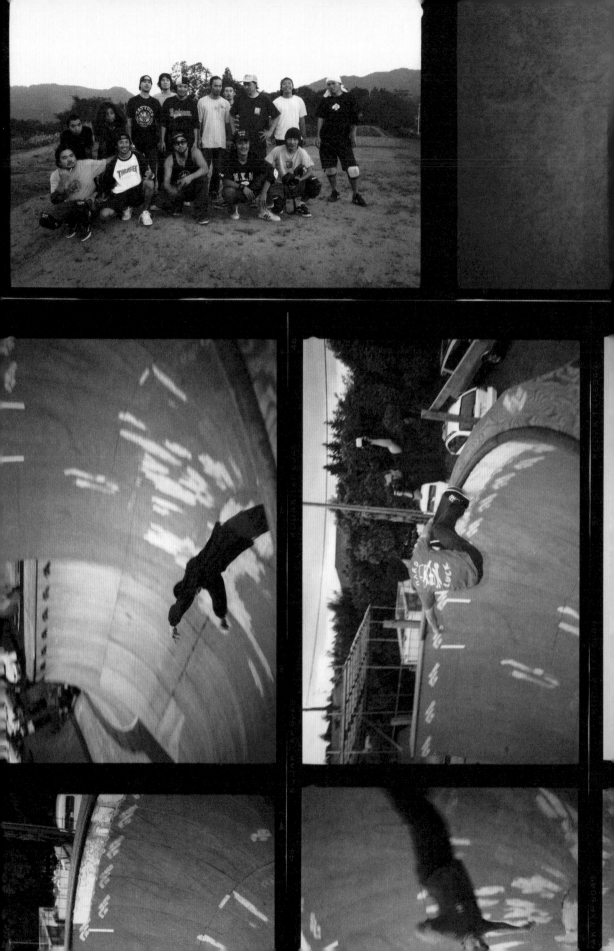

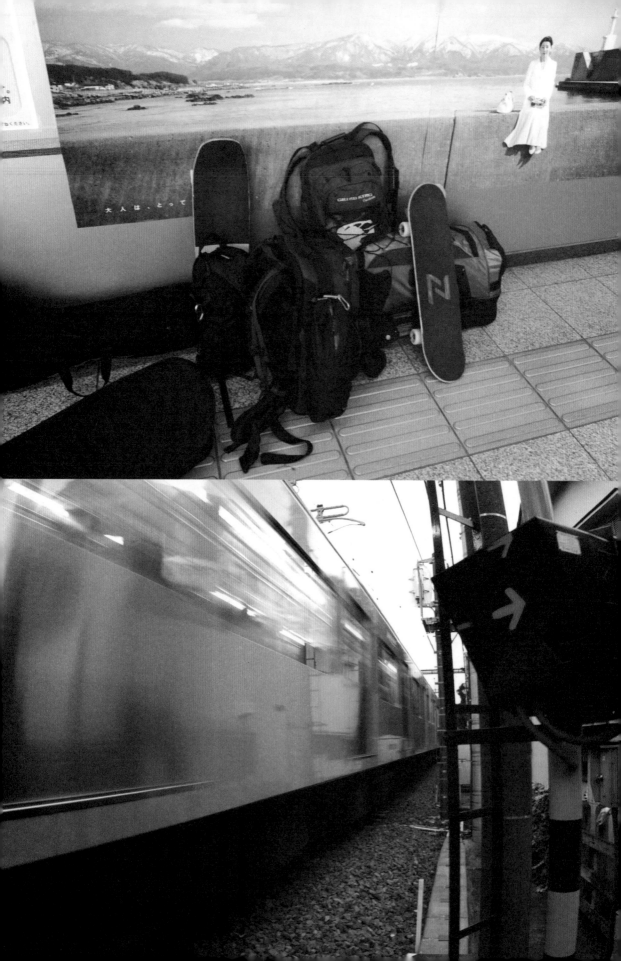

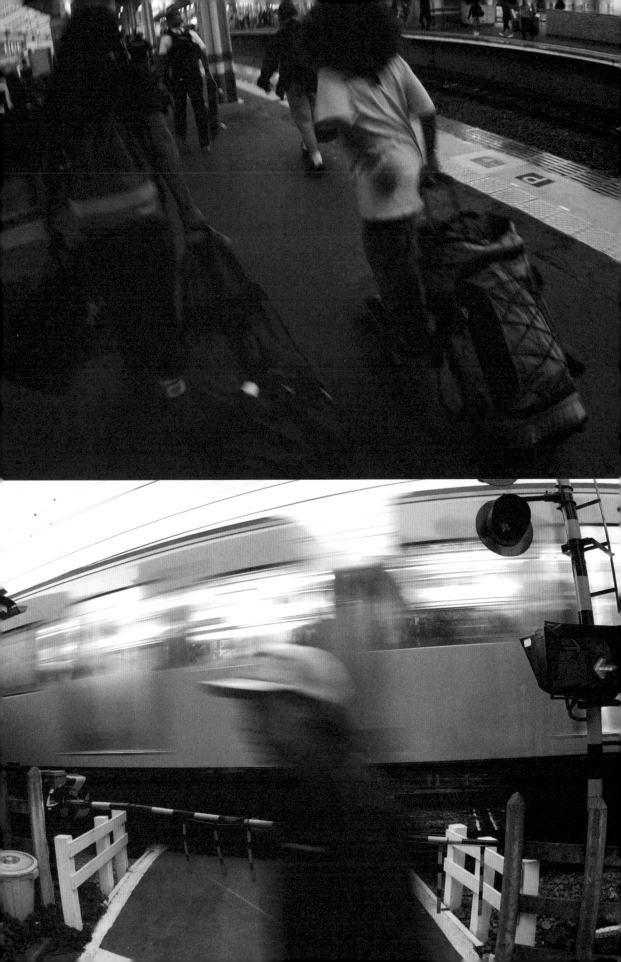

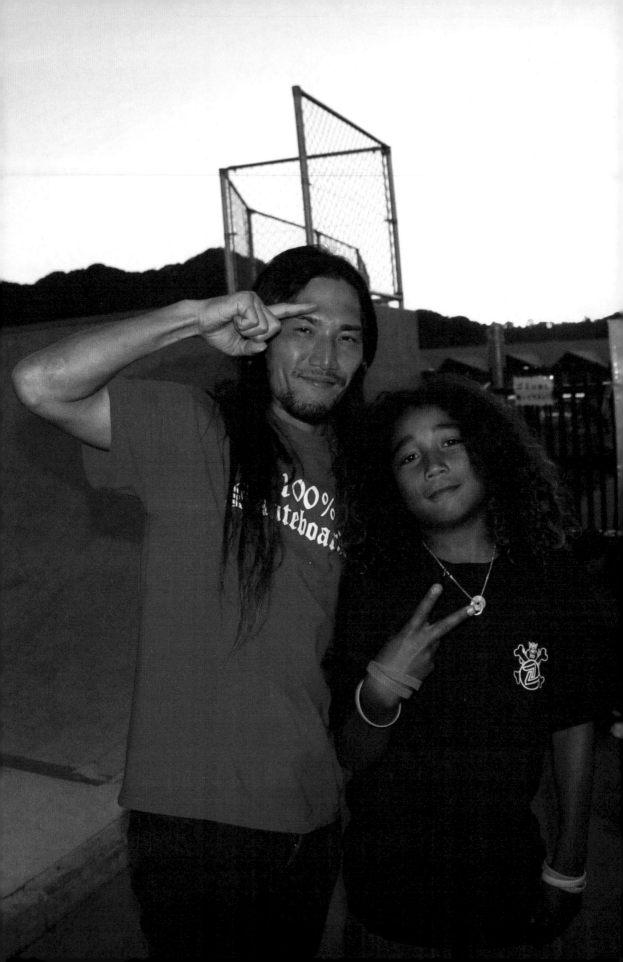

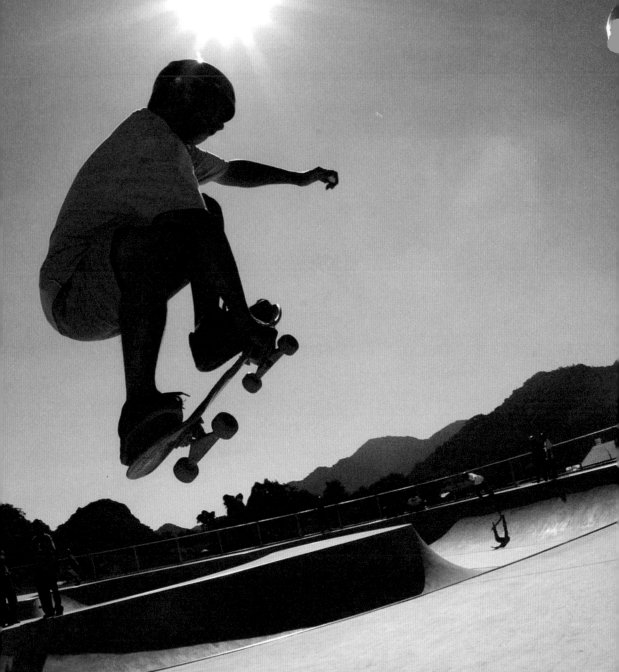

FUKUOKA

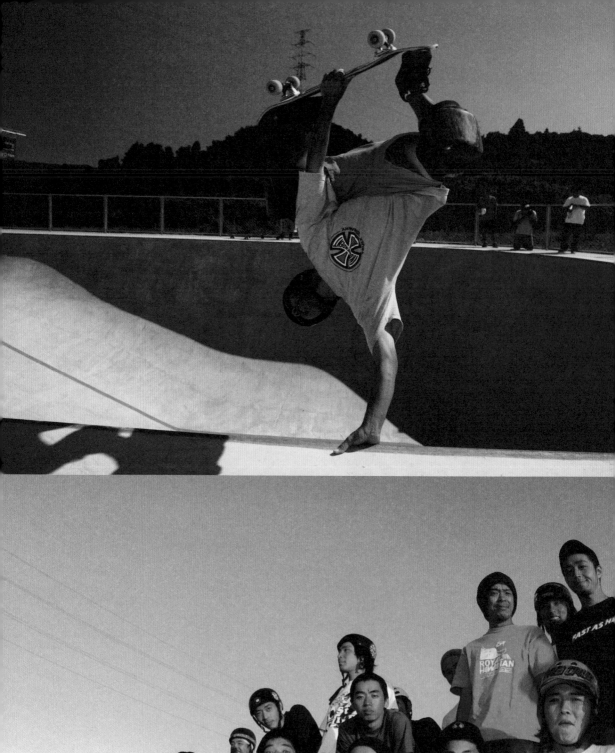
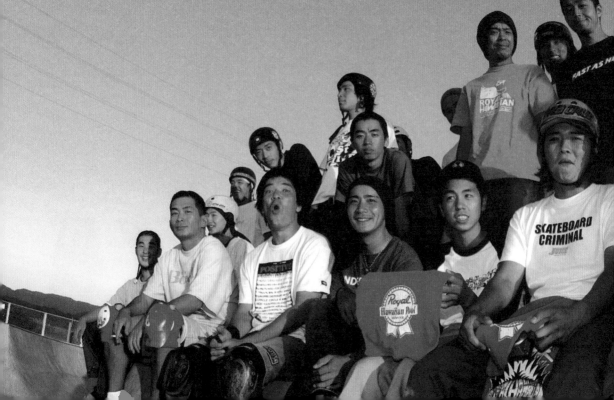

LIFE IS SHORT SO SKATE AND DRINK LOTS BEER!!!!

DRUNKTARD

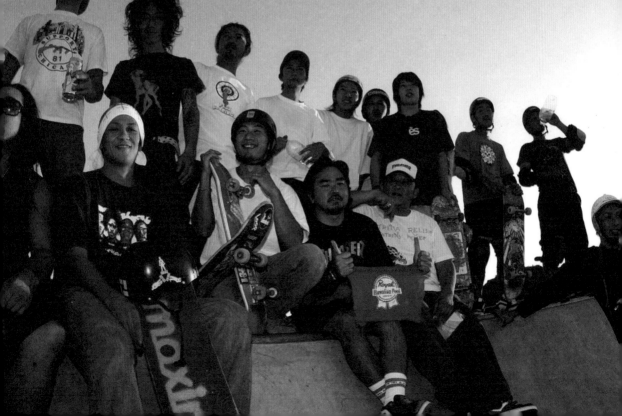

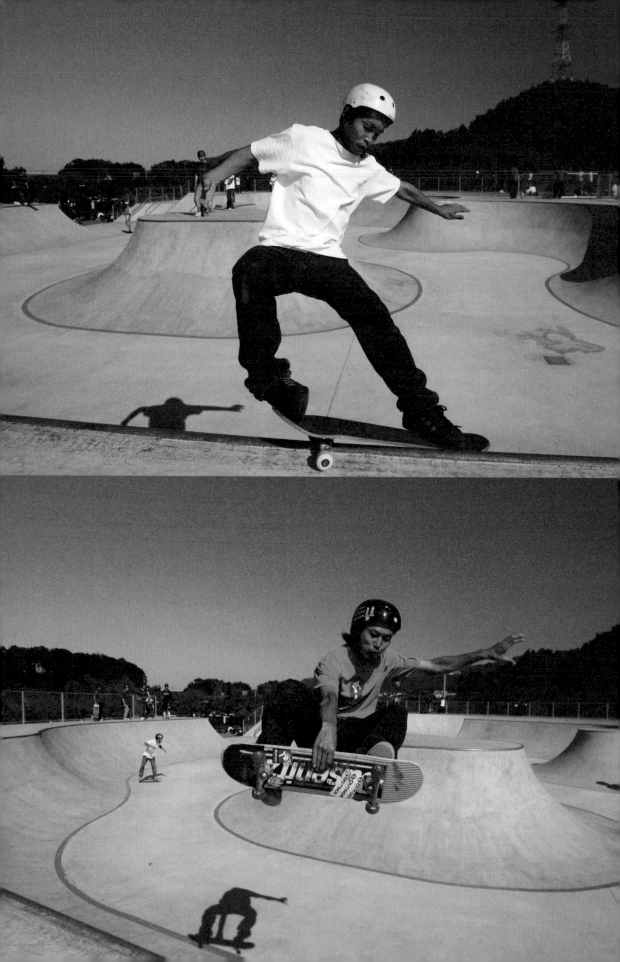

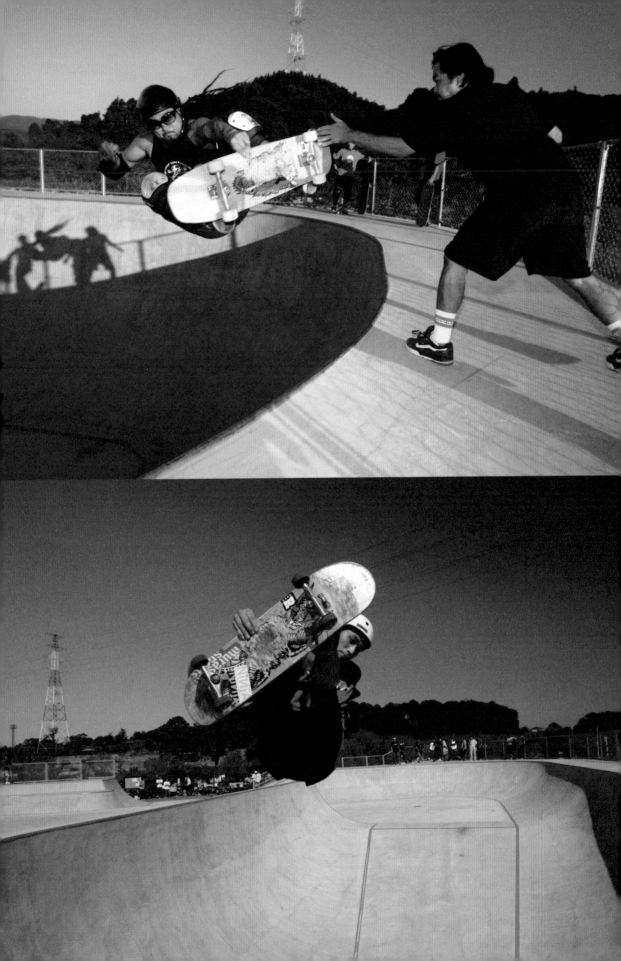

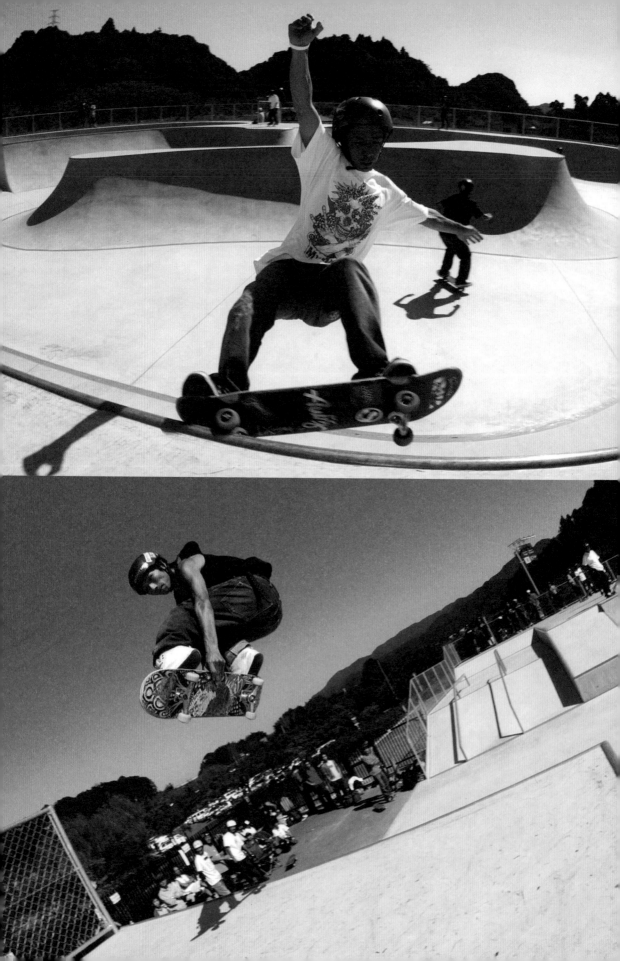

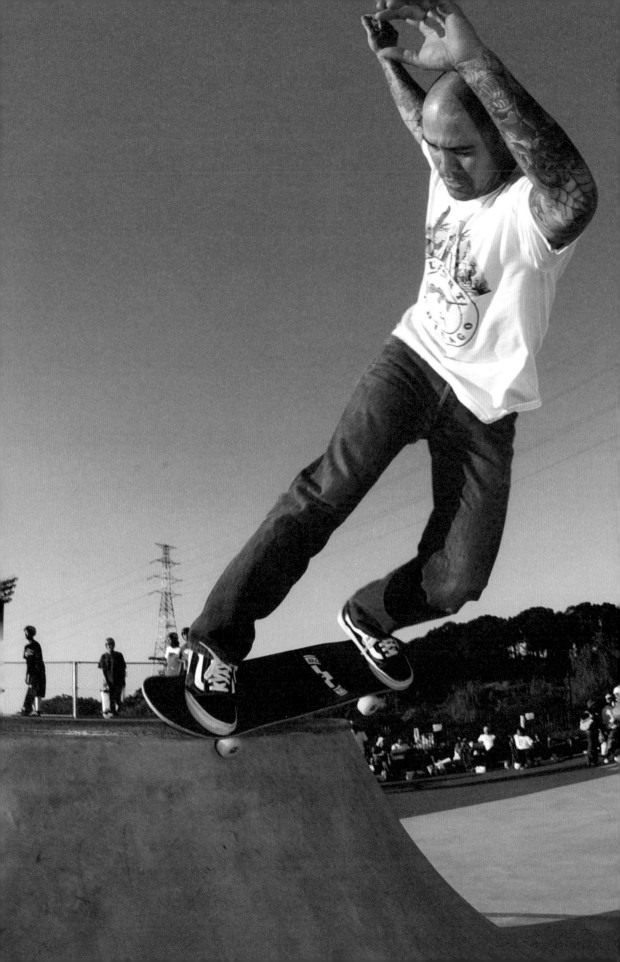

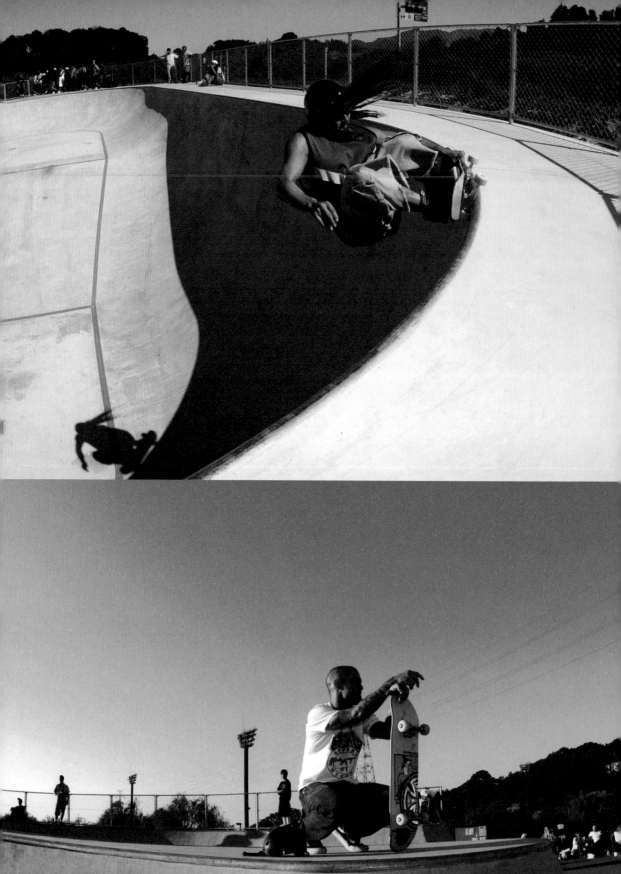

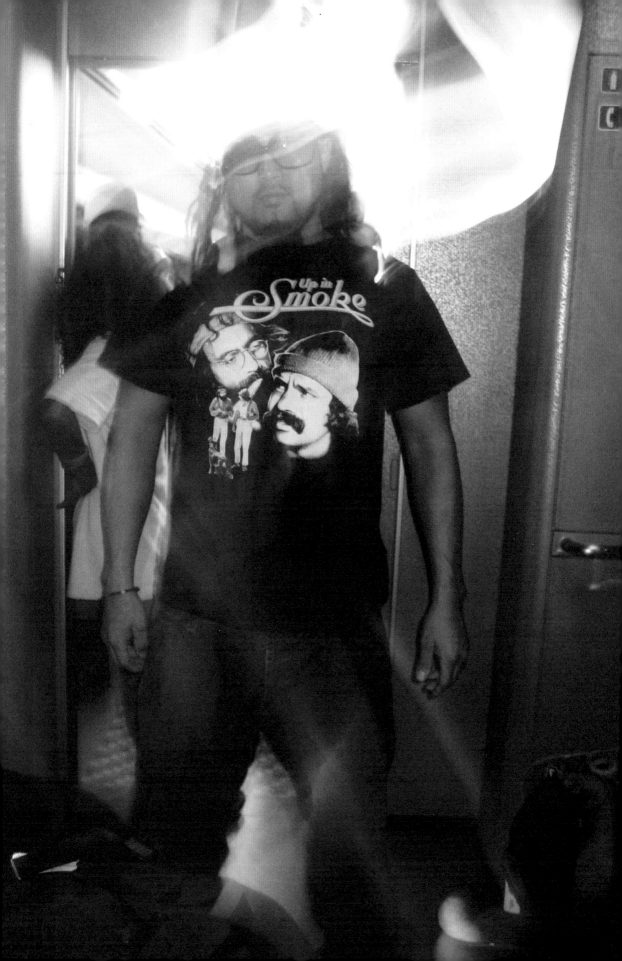

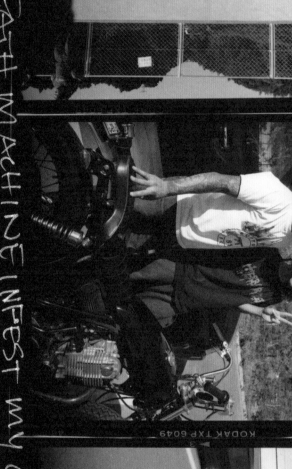

DEATH MACHINE INFEST MY CORPSE TO BE

KODAK TXP 6049

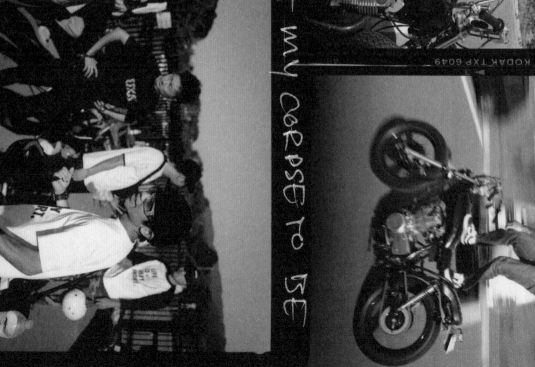

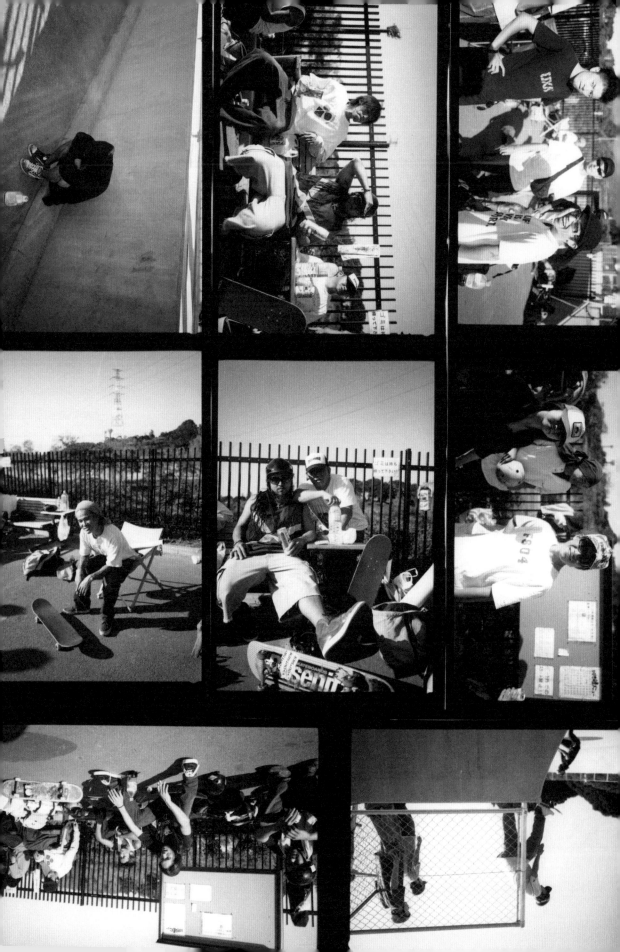

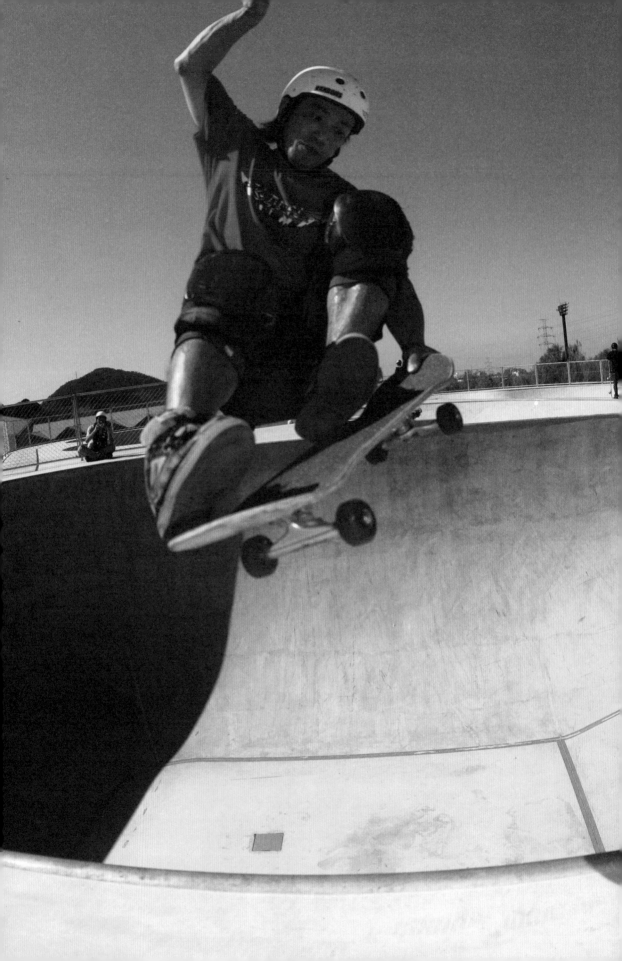

HOT BLONDE GIRLS IN JAPAN!!!

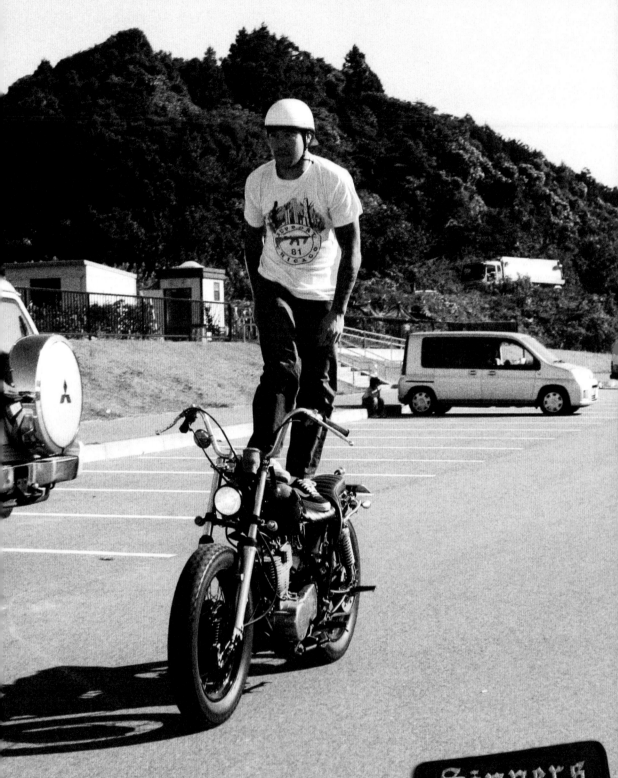

Sinners
So-Cal

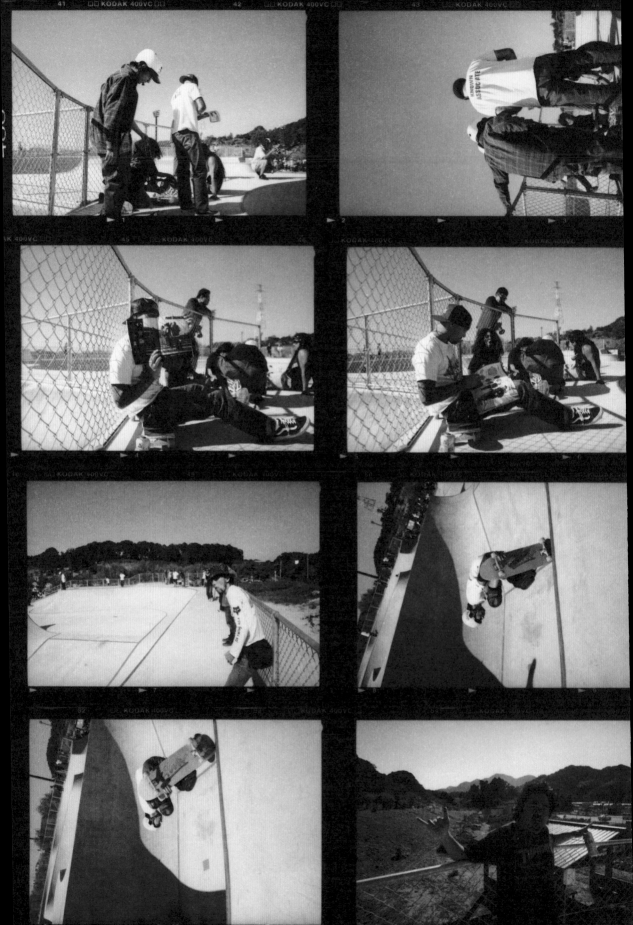

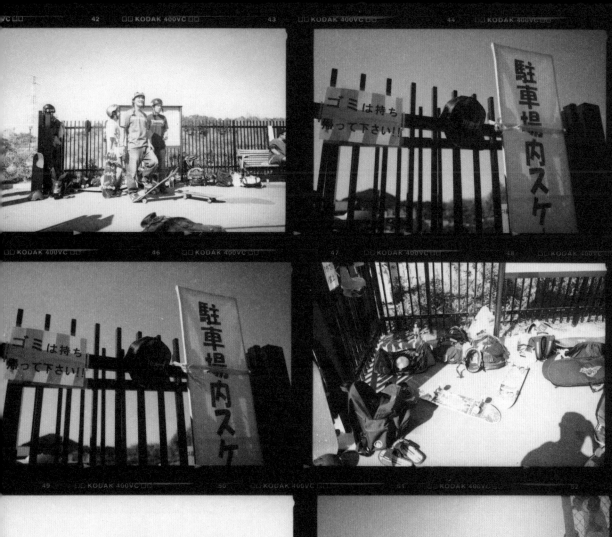
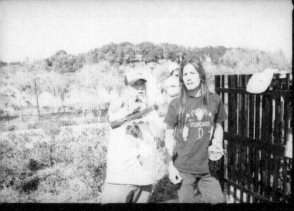
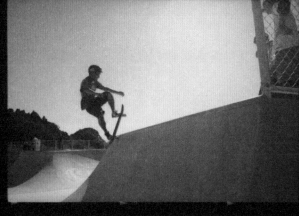
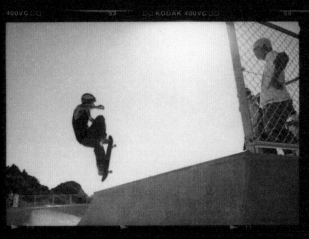
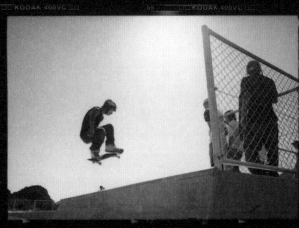

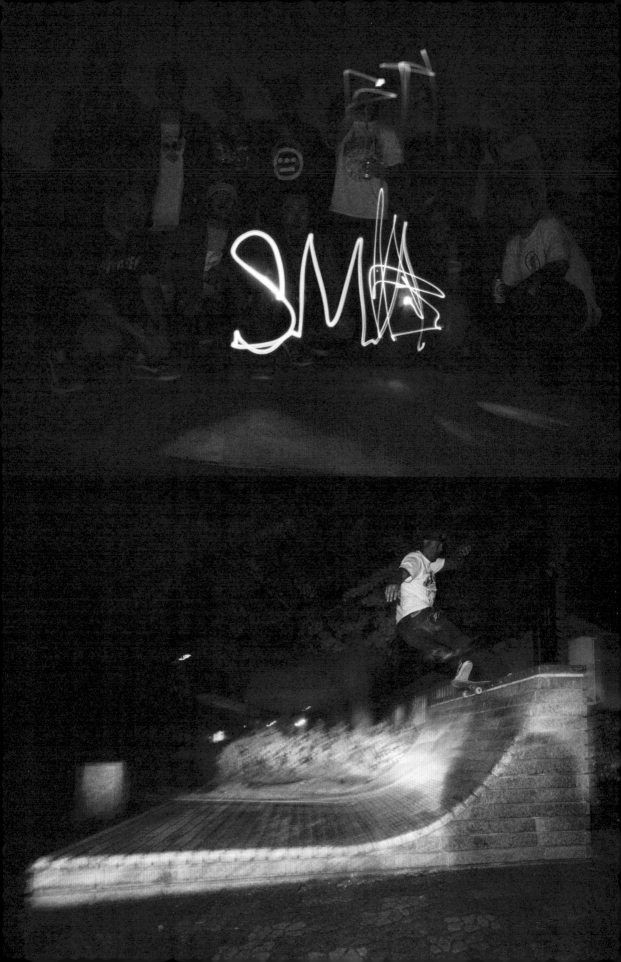

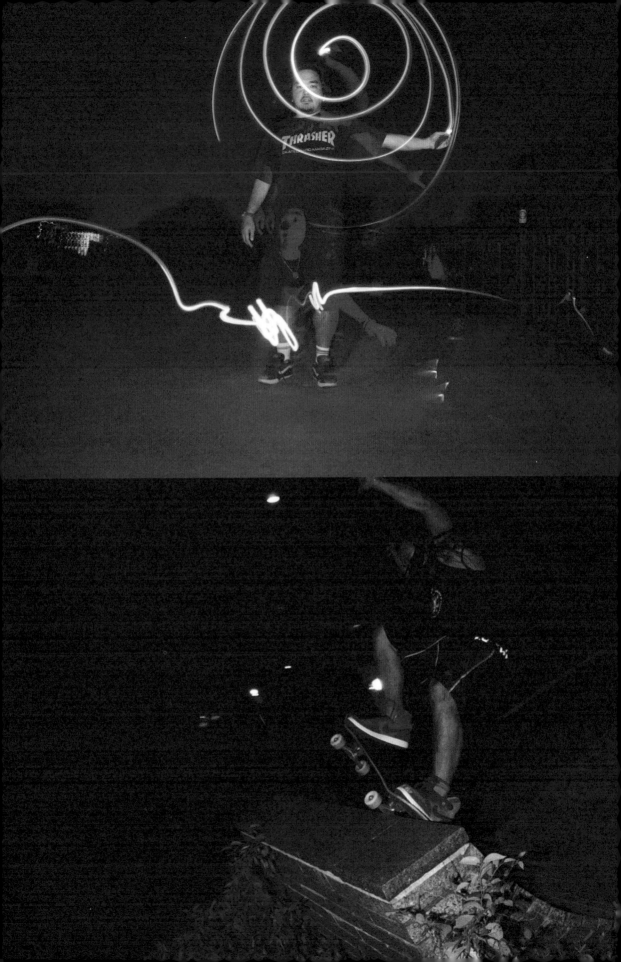

KYOTO

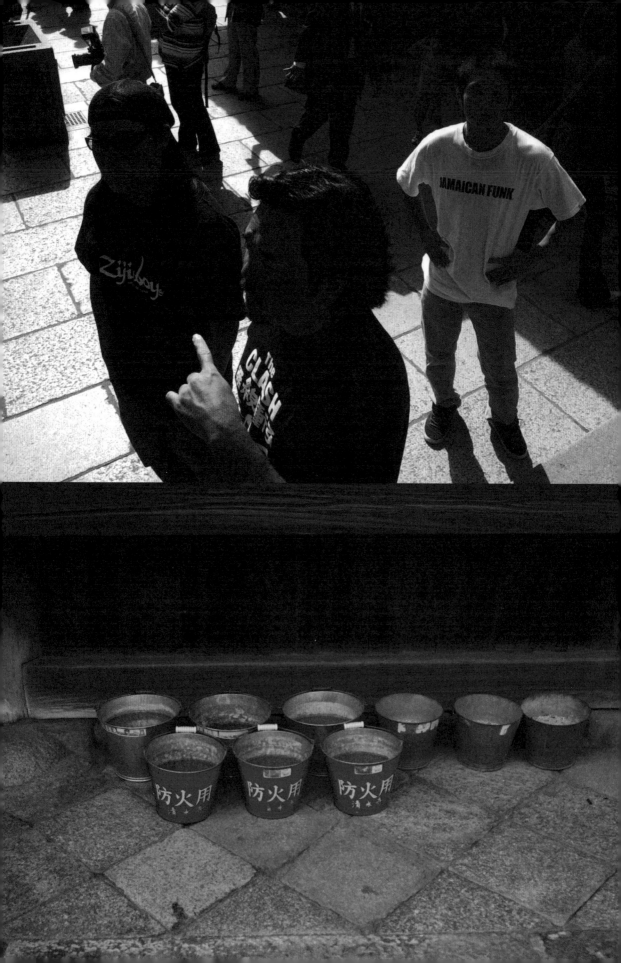

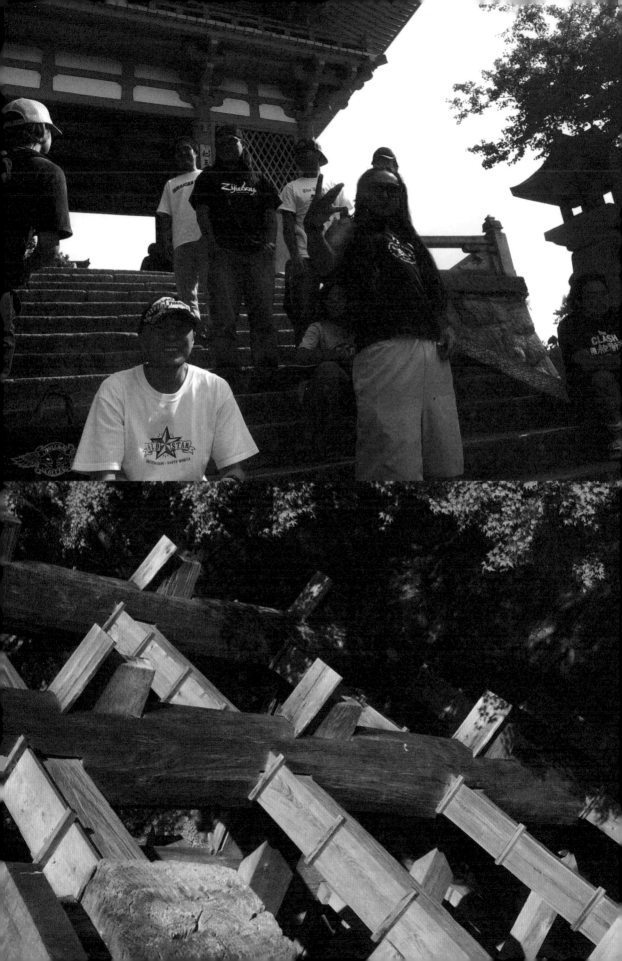

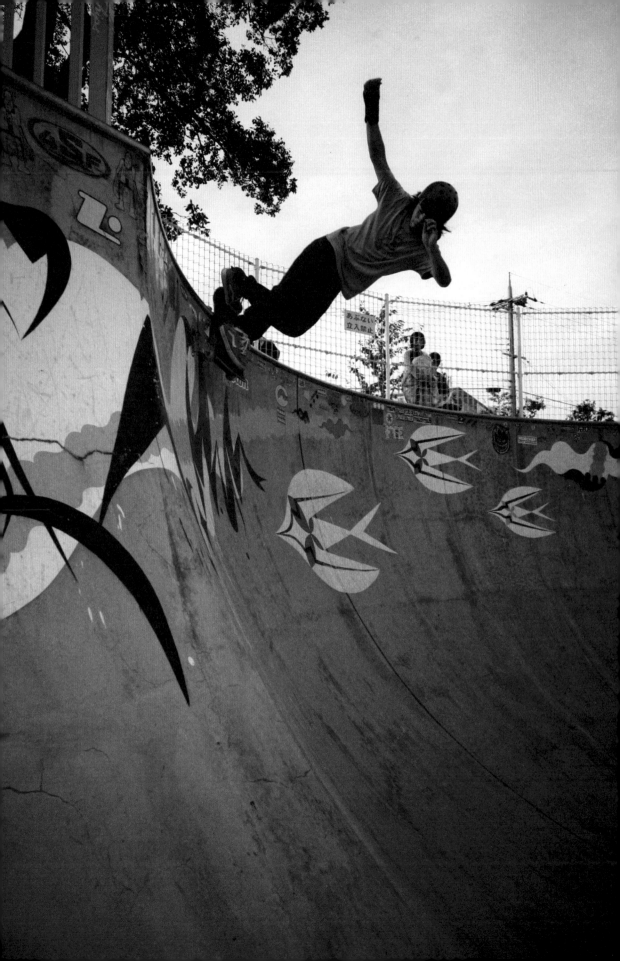

The park is painted with excellent ART we skate for a few hours

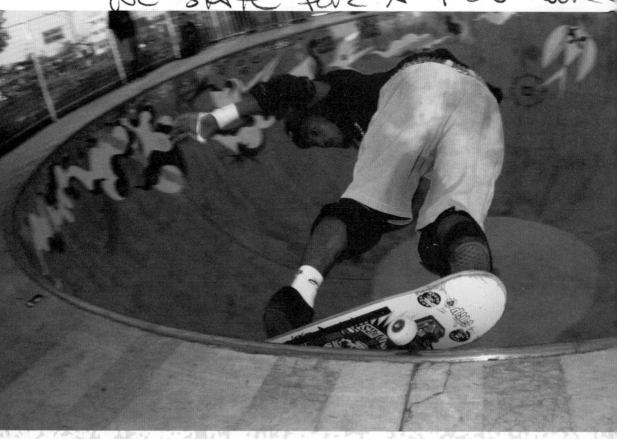

INFO E-MAIL mamaremone@hotmail.com
http://ip.tosp.co.jp/i.asp?i=FTKIDS
http://ip.tosp.co.jp/i.asp?i=mamaremone

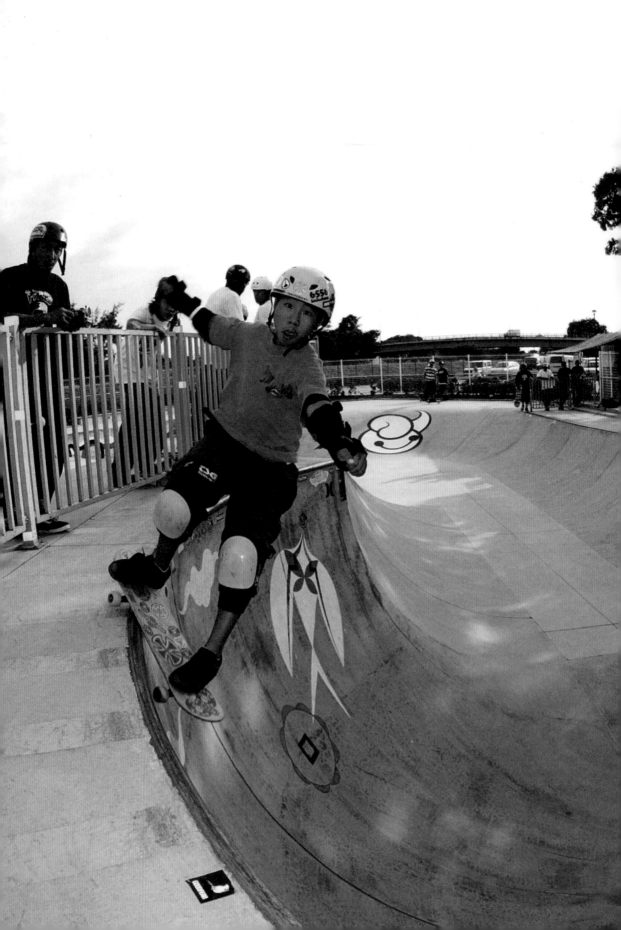

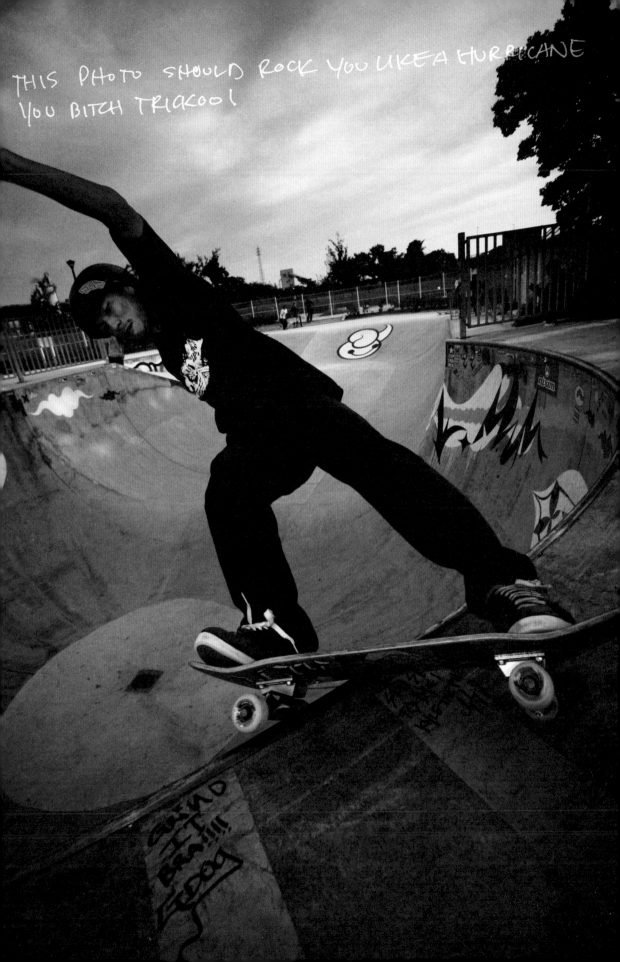

THIS PHOTO SHOULD ROCK YOU LIKE A HURRICANE
YOU BITCH TRIAKOOL

2 TRAINS to get out oF Tokyo.
Headed to ~~Tsukuba~~. SAKAI-Machi,
Ibaraki. This was the Home oF
Felem & my good Friend Tsuyoshi.
Tsuyoshi & his team have been coming
to HAWAii FoR a Few years — They
are genuine people. Felem is A
Skatepark / skateshop / Distributor.
They distribute the DRIVEN (JASON Jessee's
Skate Co., thrasher & ROYAL HAWAIIAN pool
Service). These guys are The most
Hardcore skaters IN JAPAN! Their
Ramp Had Z bowls Facing each
other with hips — very challenging.
Think FasT. MeT All the locals
& HAD the best oF times.
Dinner with the Crew IN A
Neighboring city. Jokes & Heckles

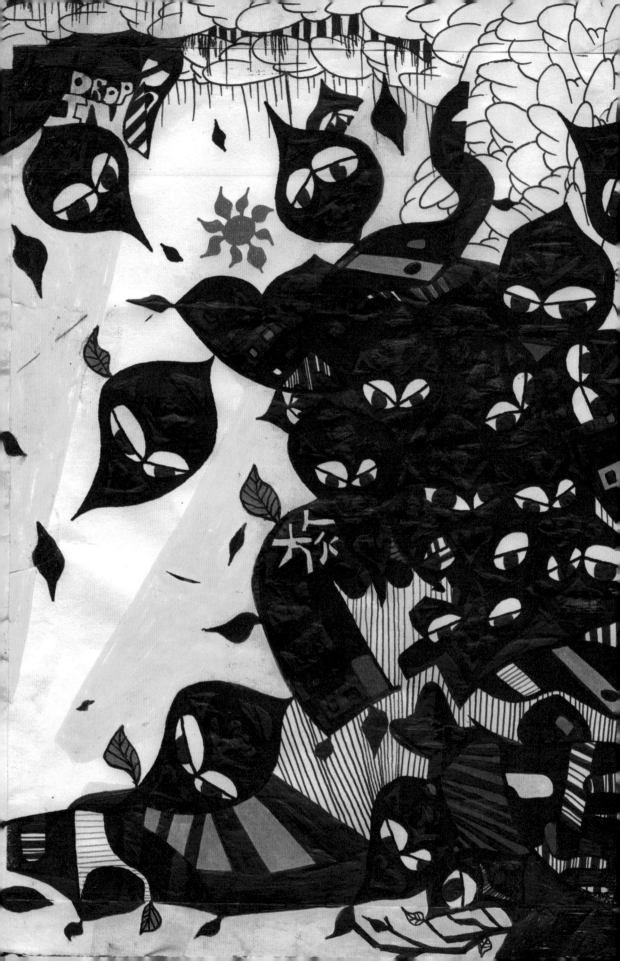

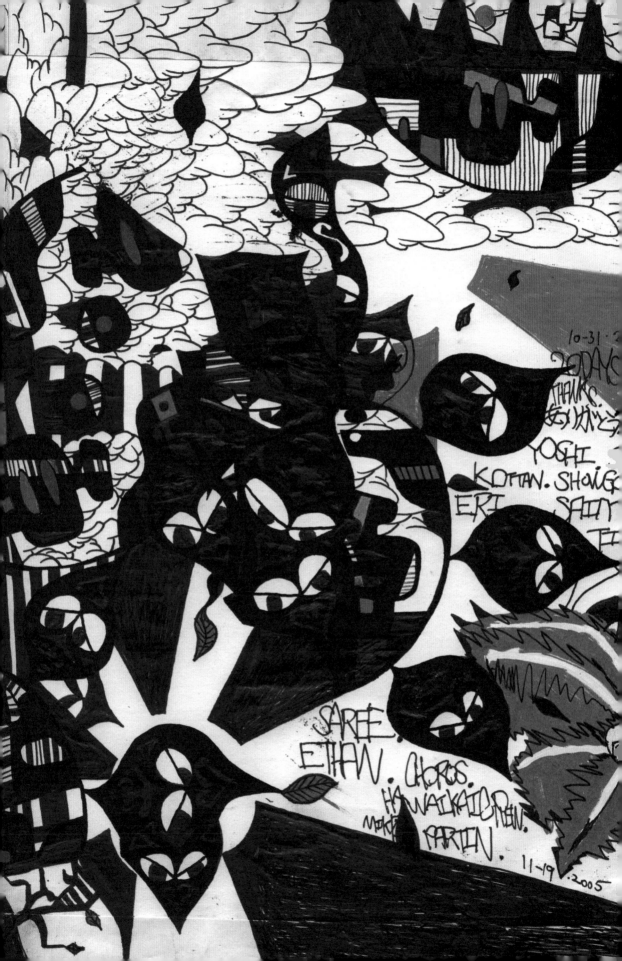

CLASS PROGRAM

NAME. *Tetsuyakino* ADDRESS. *Kyoto jp.*

SCHOOL *originalinthetwak.* CLASS. *P.M.A.*

TIME	FROM TO....	PERIOD 1	PERIOD 2	PERIOD 3	PERIOD 4	PERIOD 5	PERIOD 6	PERIOD 7	PERIOD 8
MONDAY	SUBJECT								
	ROOM								
	INSTRUCTOR								
TUESDAY	SUBJECT								
	ROOM								
	INSTRUCTOR								
WEDNESDAY	SUBJECT								
	ROOM								
	INSTRUCTOR								
THURSDAY	SUBJECT								
	ROOM								
	INSTRUCTOR								
FRIDAY	SUBJECT								
	ROOM								
	INSTRUCTOR								
SATURDAY	SUBJECT								
	ROOM								
	INSTRUCTOR								

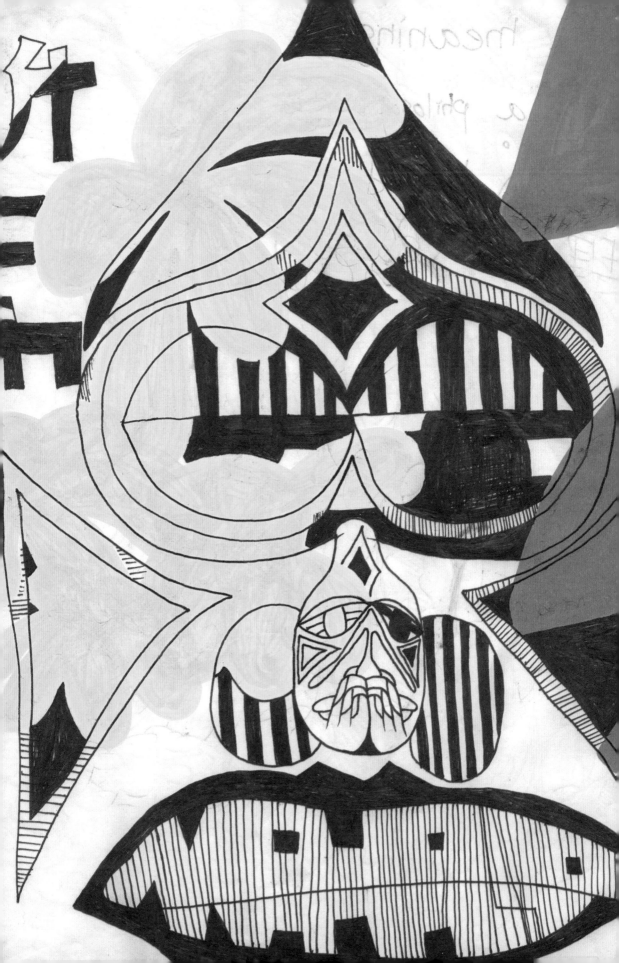

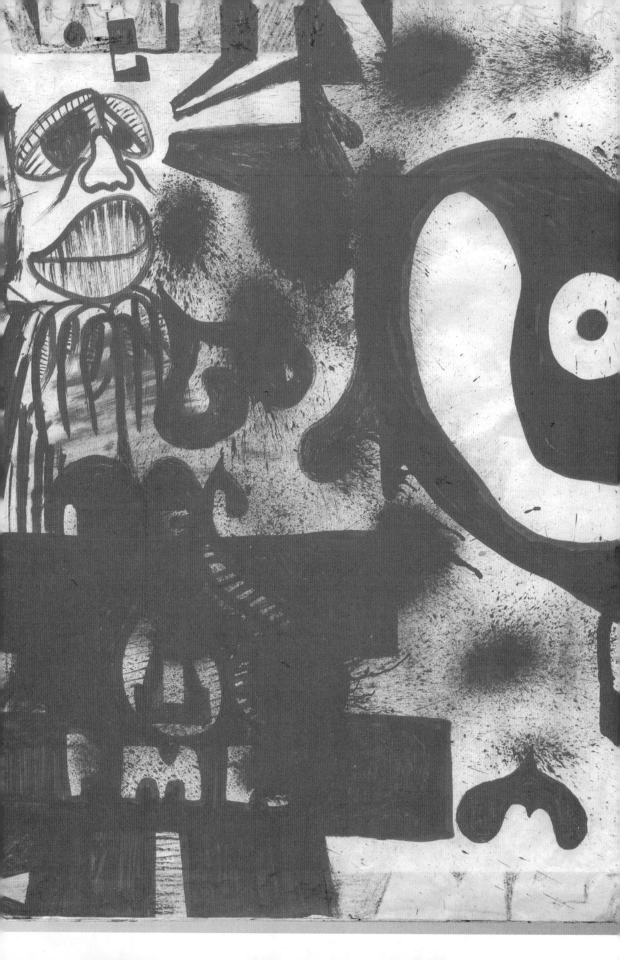

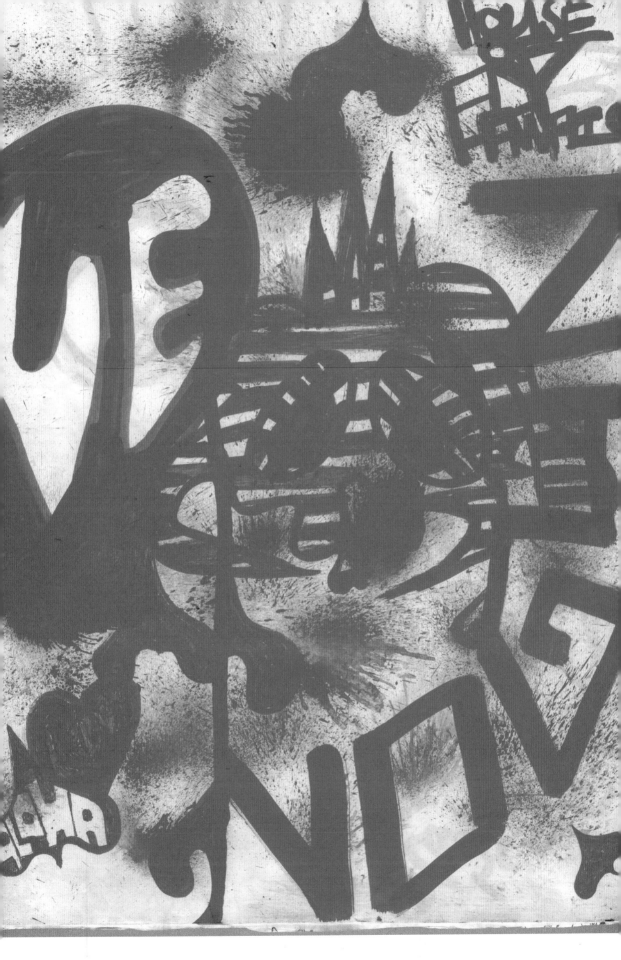

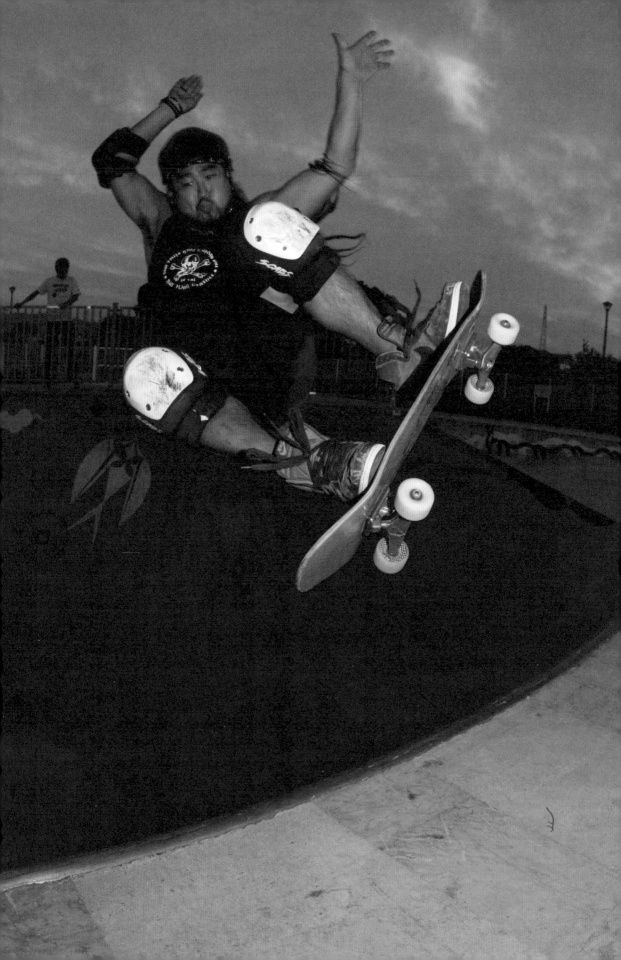

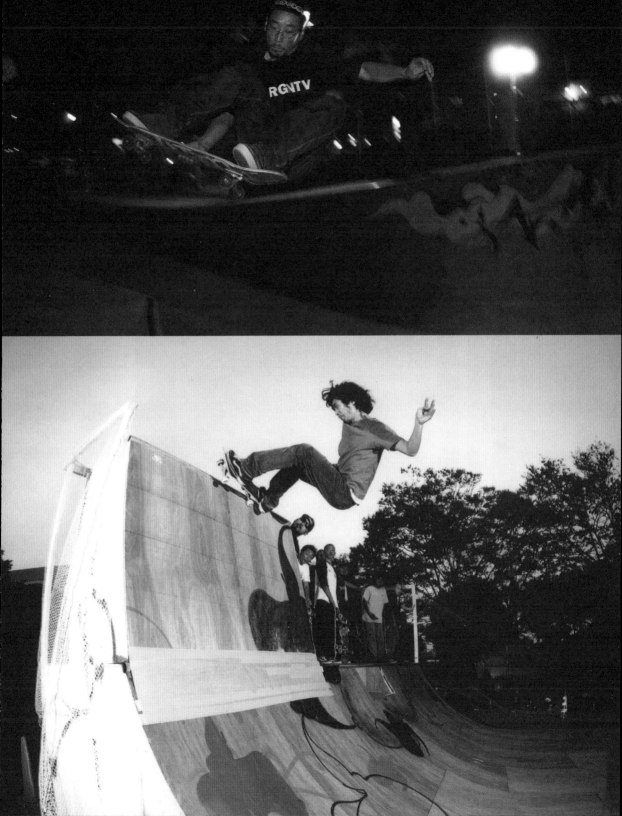

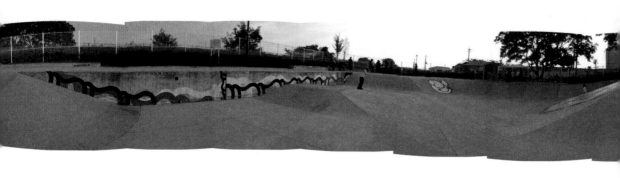

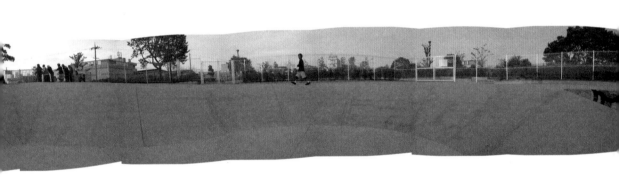

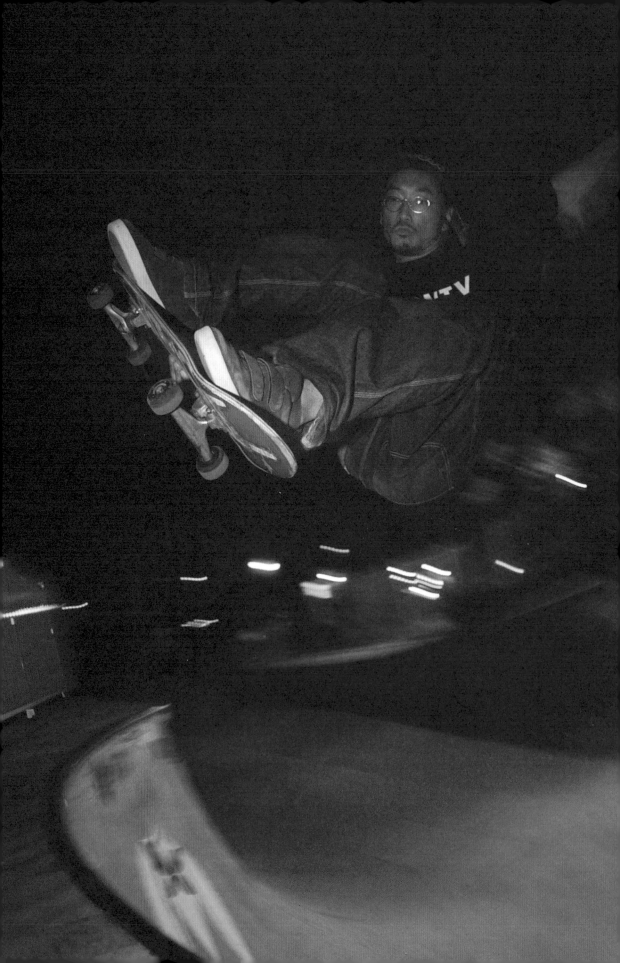

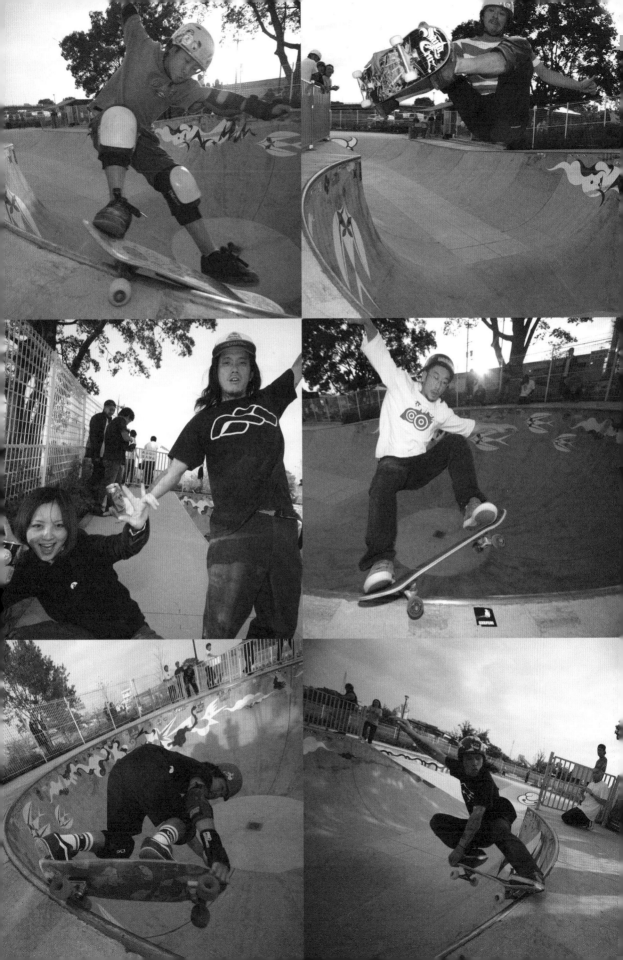

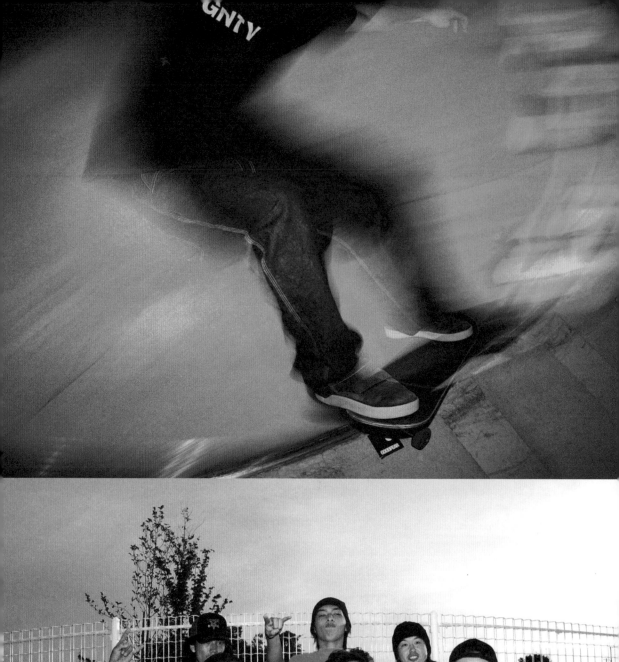

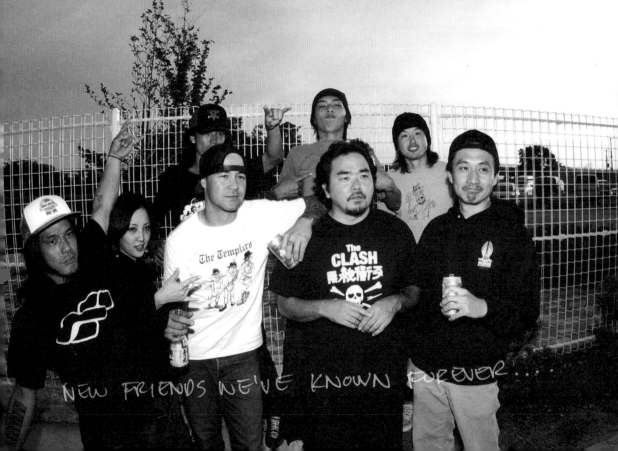

NEW FRIENDS WE'VE KNOWN FOREVER.....

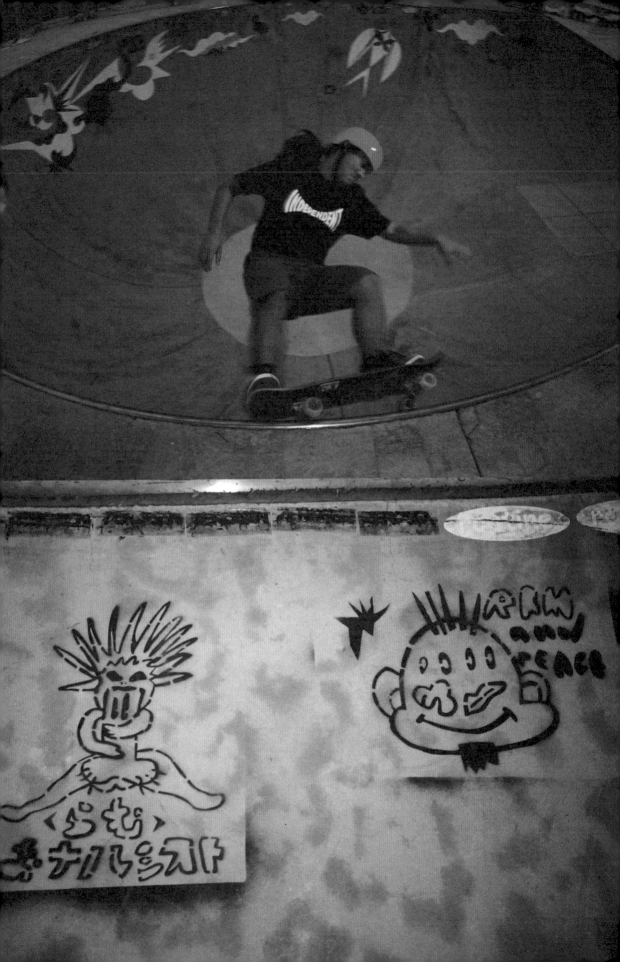

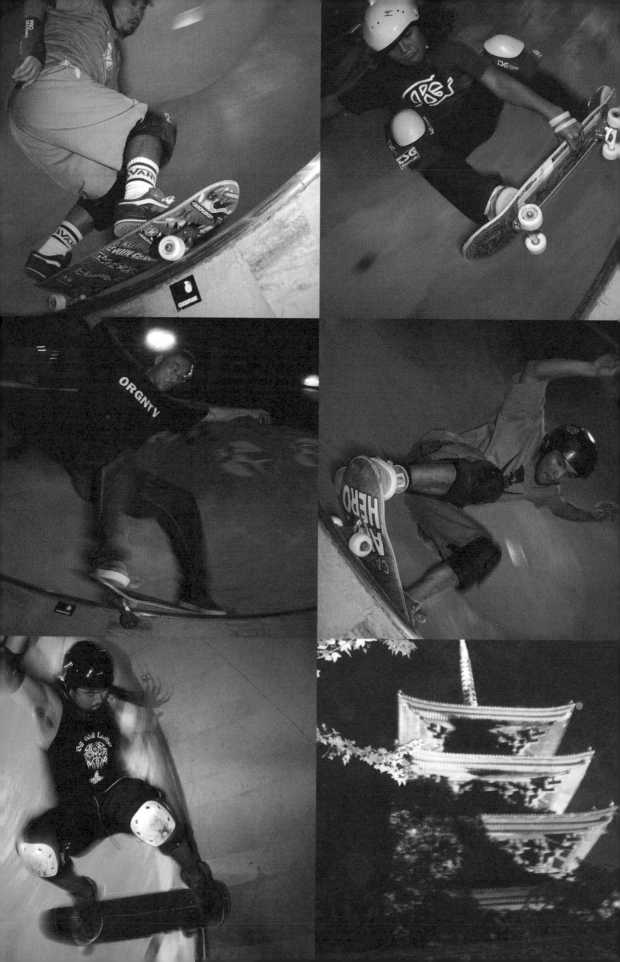

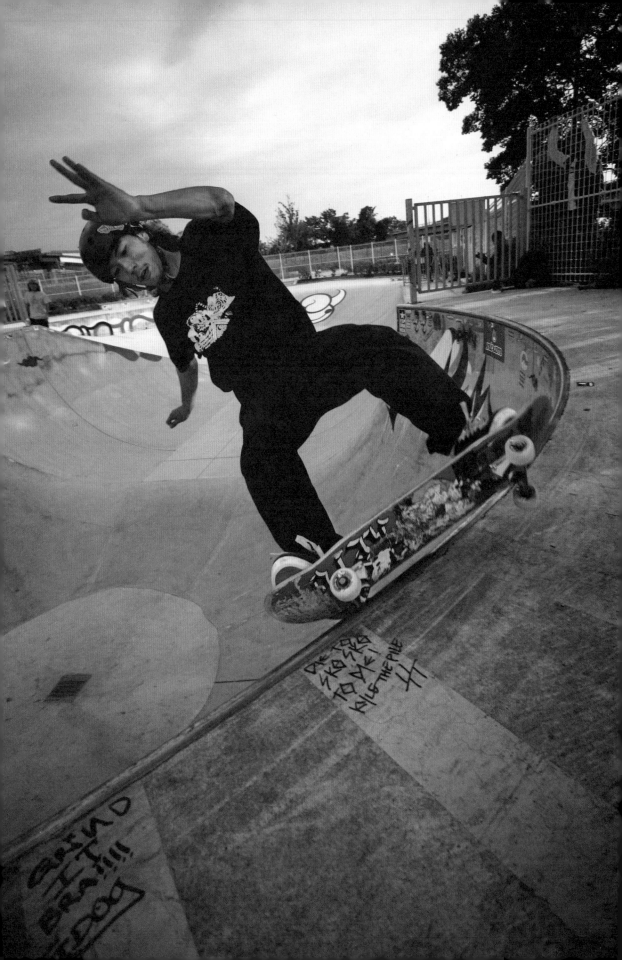

KIYOMIZU TEMPLE

音羽山 清水寺

WE leave HAKATA FUKUOKA and ~~head~~ head 3 hours North to KYOTO. We pass HIROSHIMA (the city where the ~~first~~ Atom bomb hit in WWII - this is also the city where my family the FUKUDAS are from). My Fathers Father owned land in this district. AKIRO gets off the train to visit his mom for the night. KYOTO is a very cool & historic city. Certain streets remind me of SAN FRAN. The Zitieboys pick us up & we skate the KYOTO park. It is killer a nice flow into a 9' bowl. The park is painted with excellent ART. We skate for a few hours and head for DINNER.

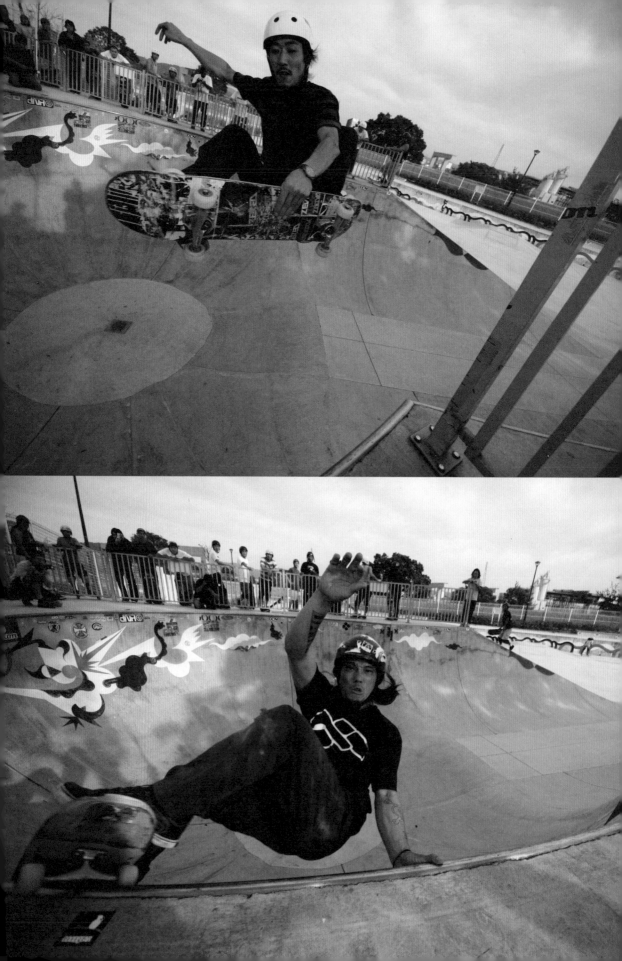

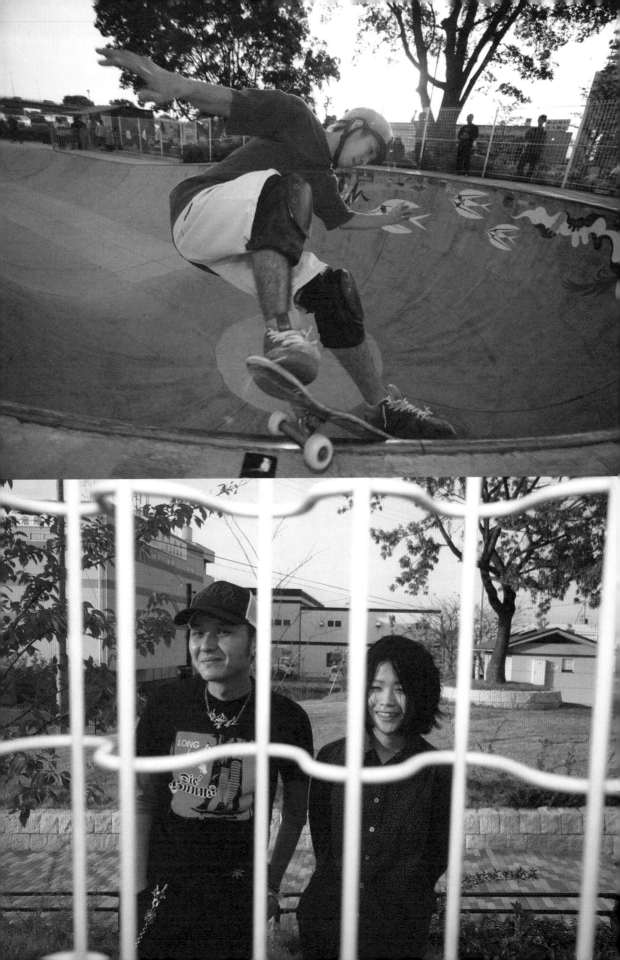

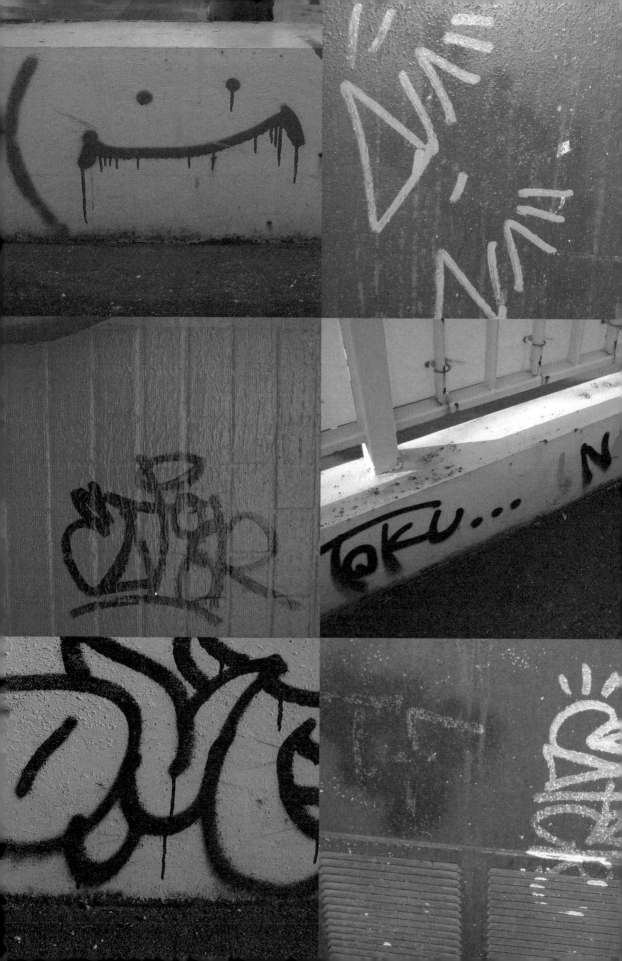

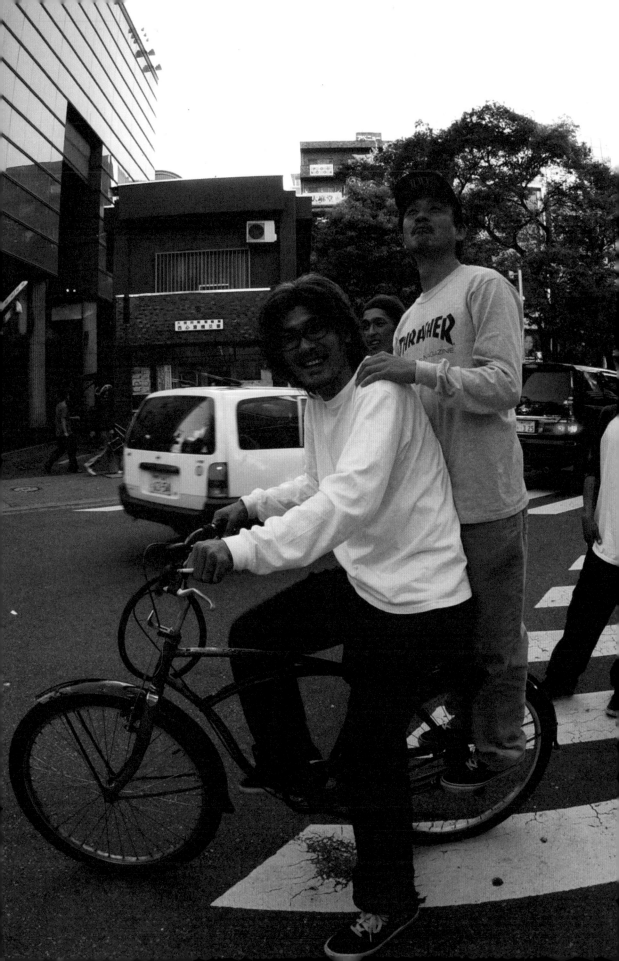

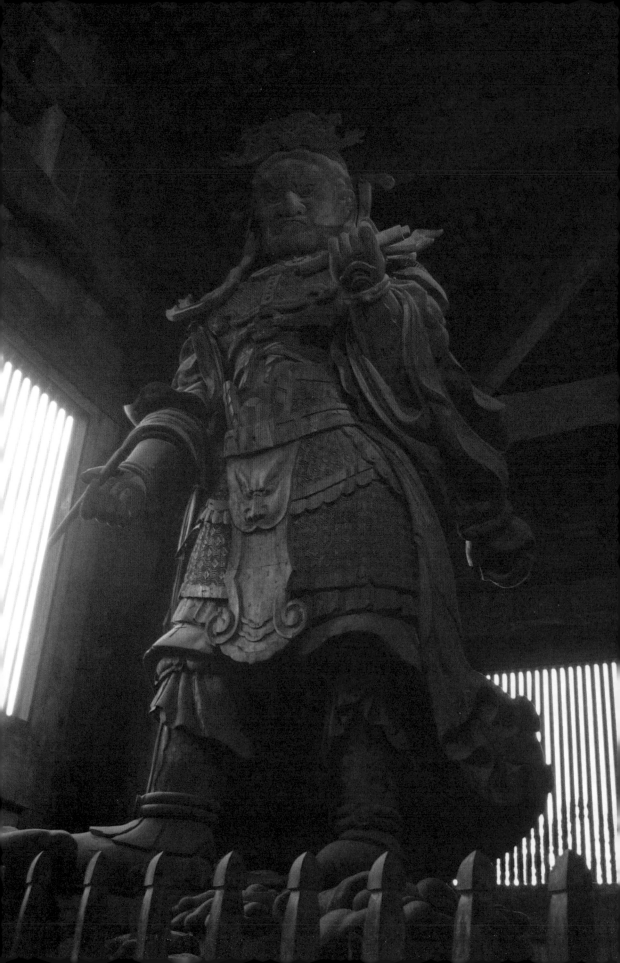

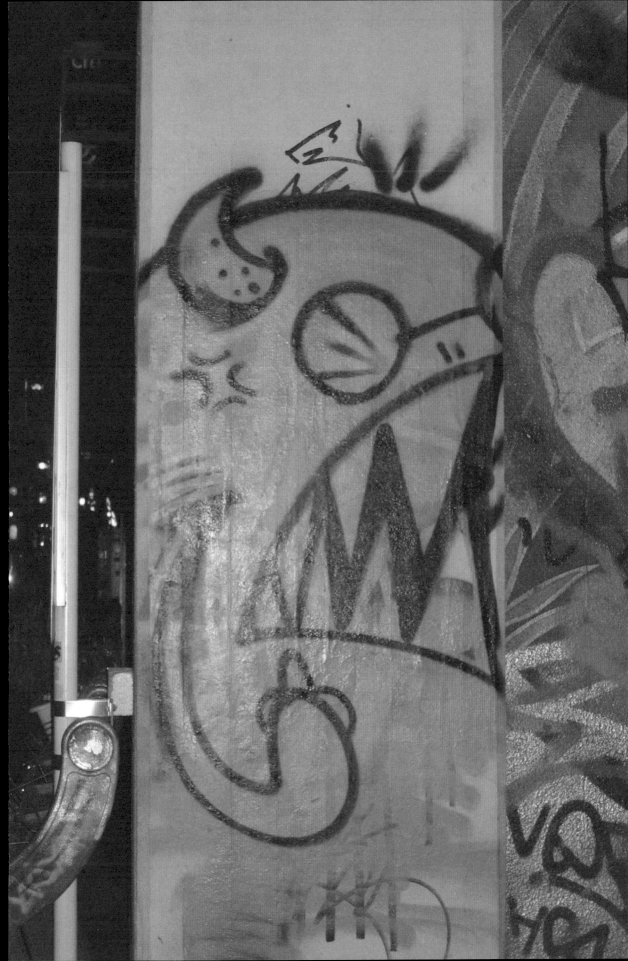

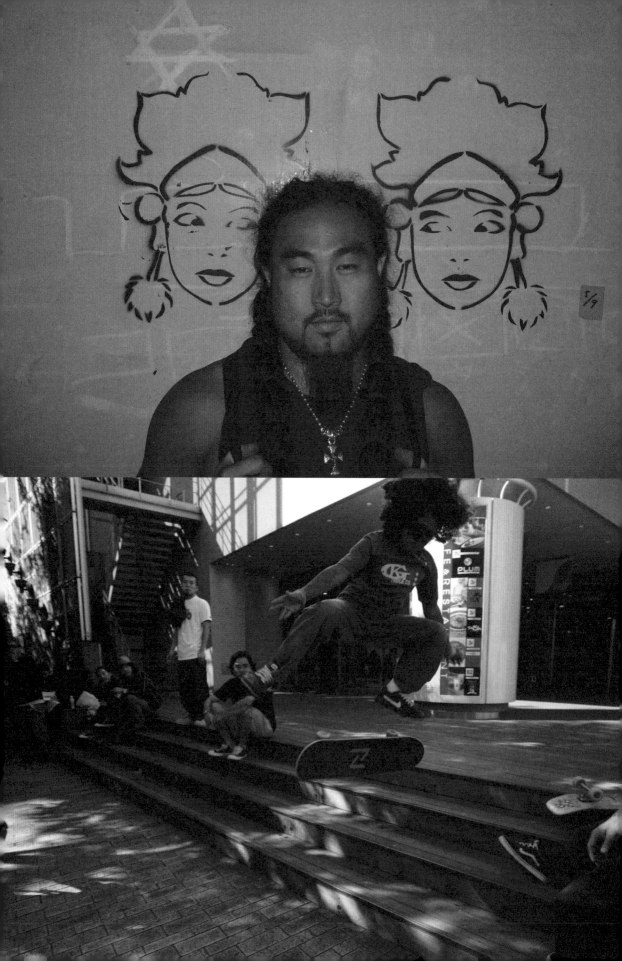

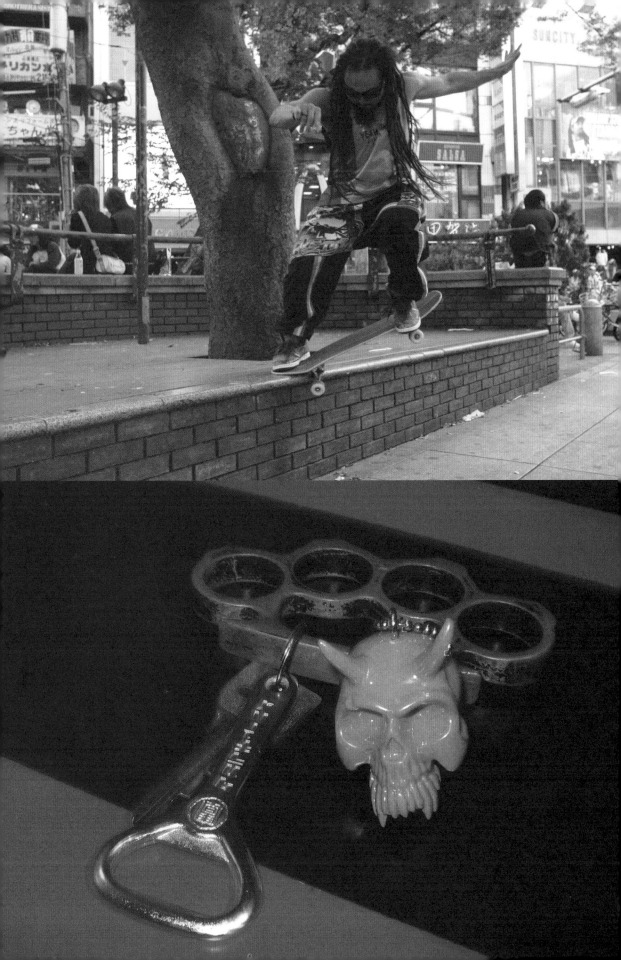

UTAO-UTAO
V6
十周年を迎えた彼ら。ドラマ「タイガー&ドラゴン」主題歌。

KISS OF LIFE
シャーデー
気品ある歌声と容姿でファンを魅了する歌姫。1992年の作品。

LIFE
デズリー
1997年のTVドラマ「to Heart〜恋して死にたい」オープニング曲

EVERYBODY

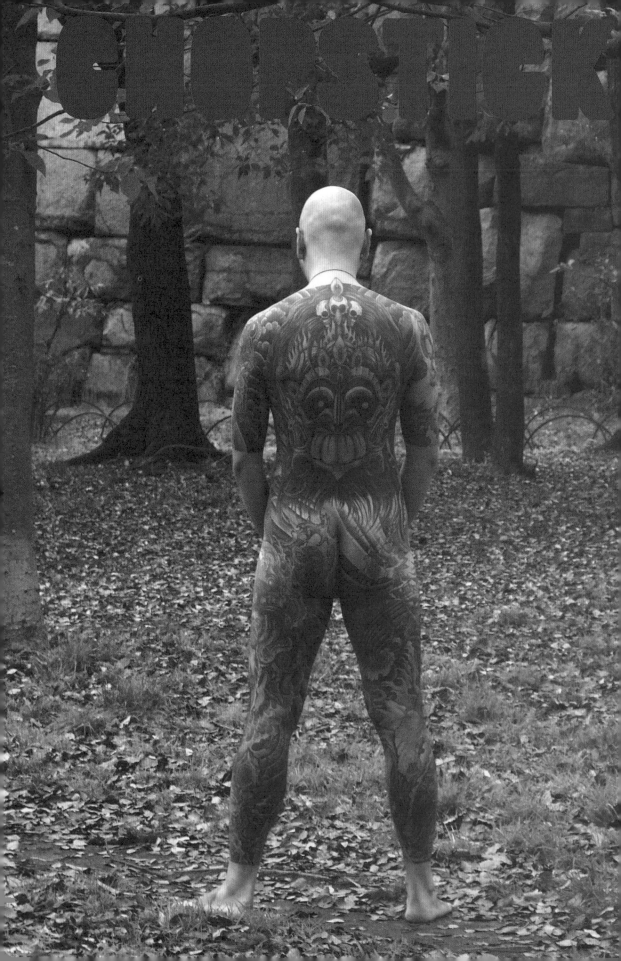

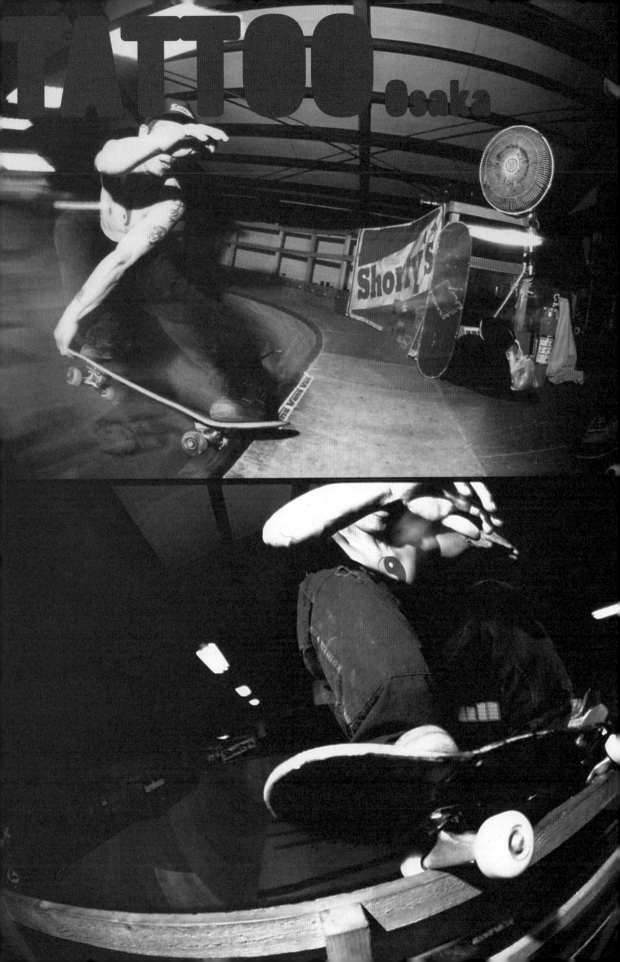

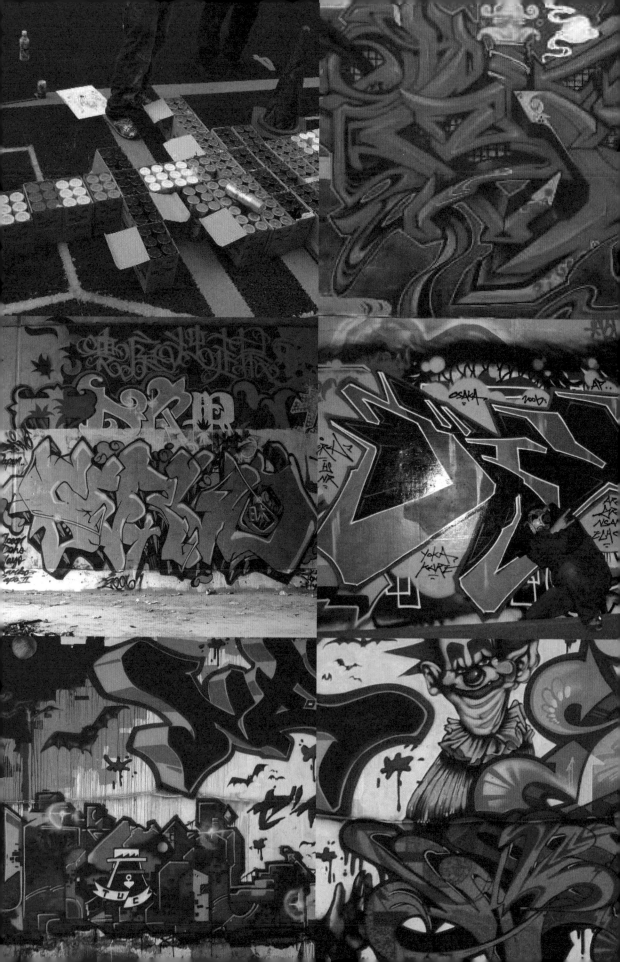

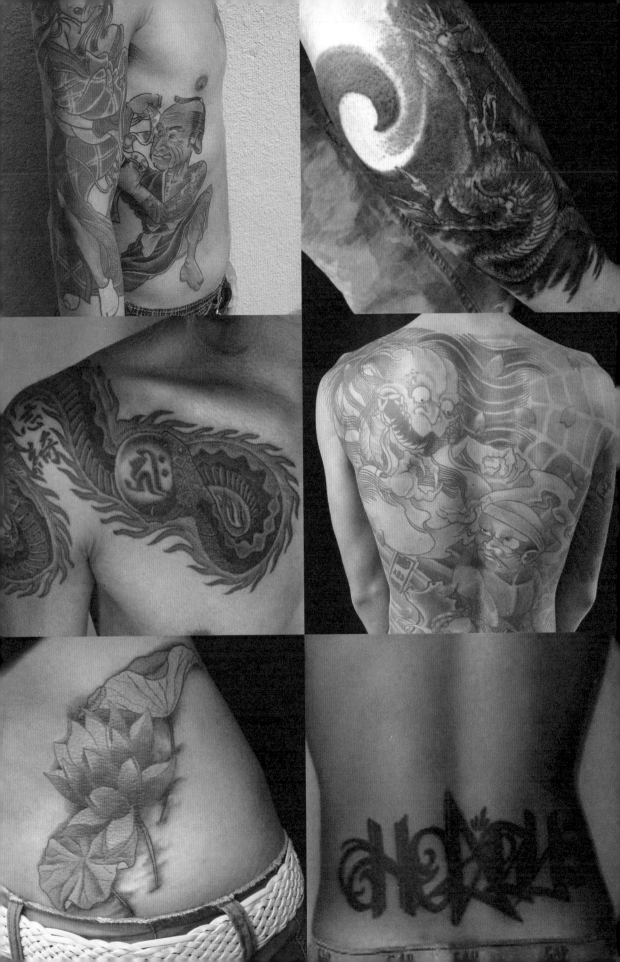

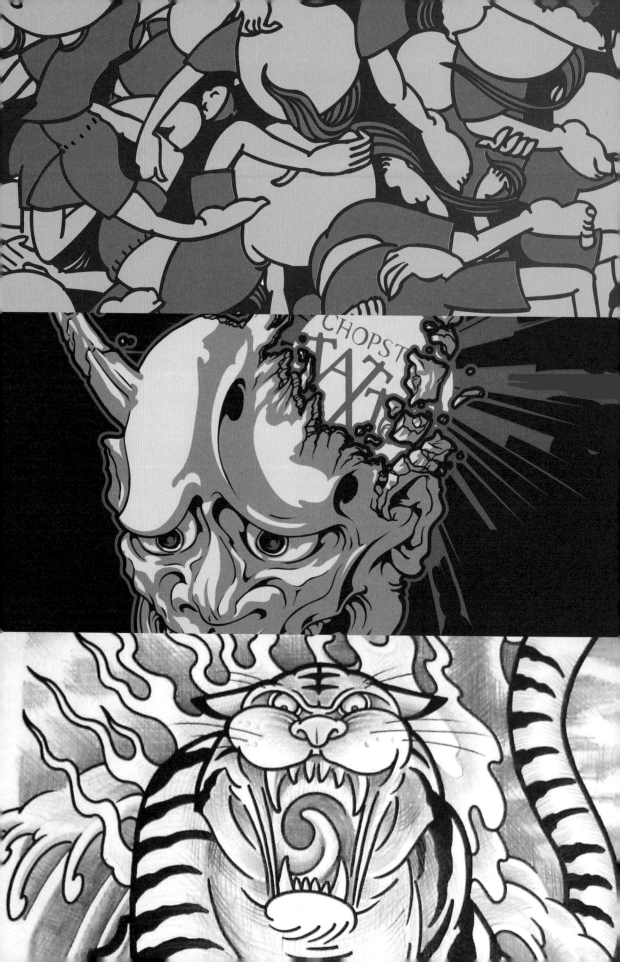

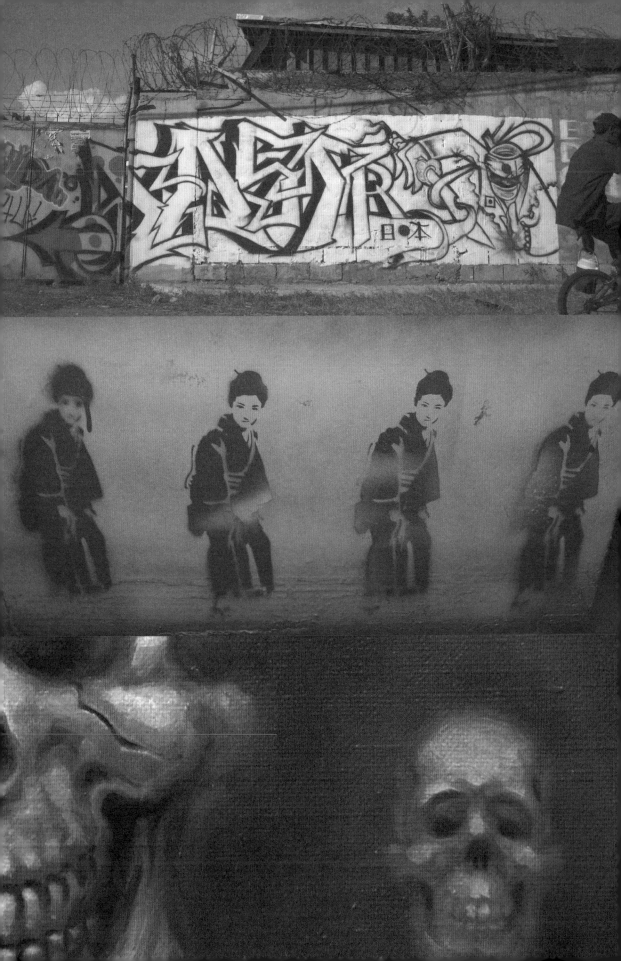

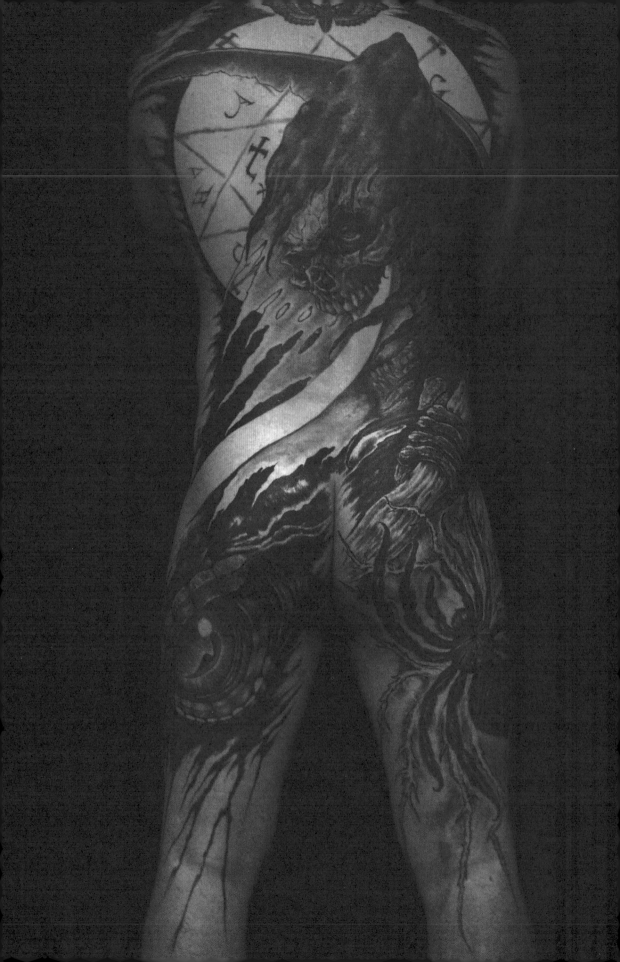

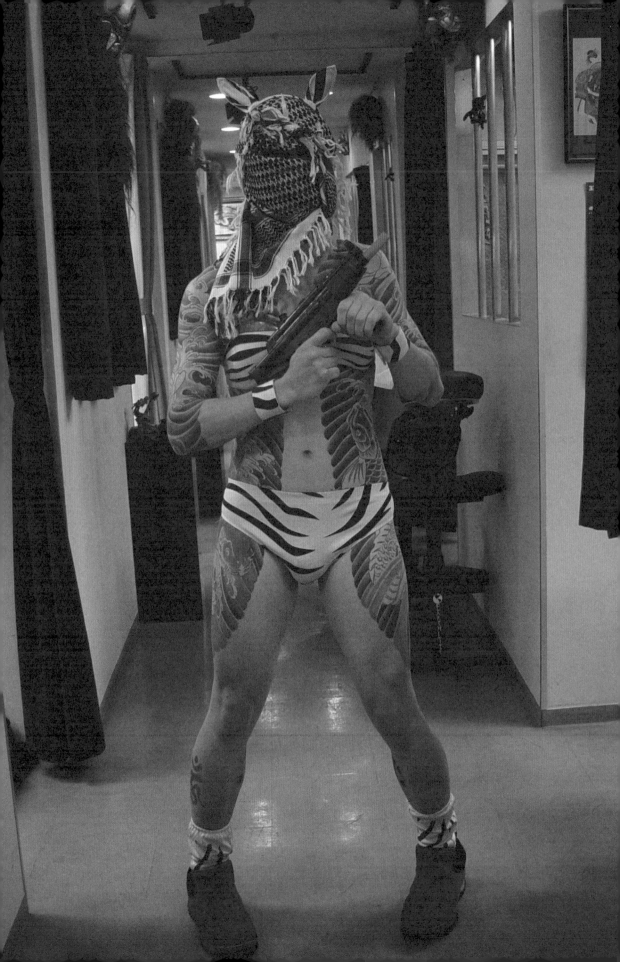

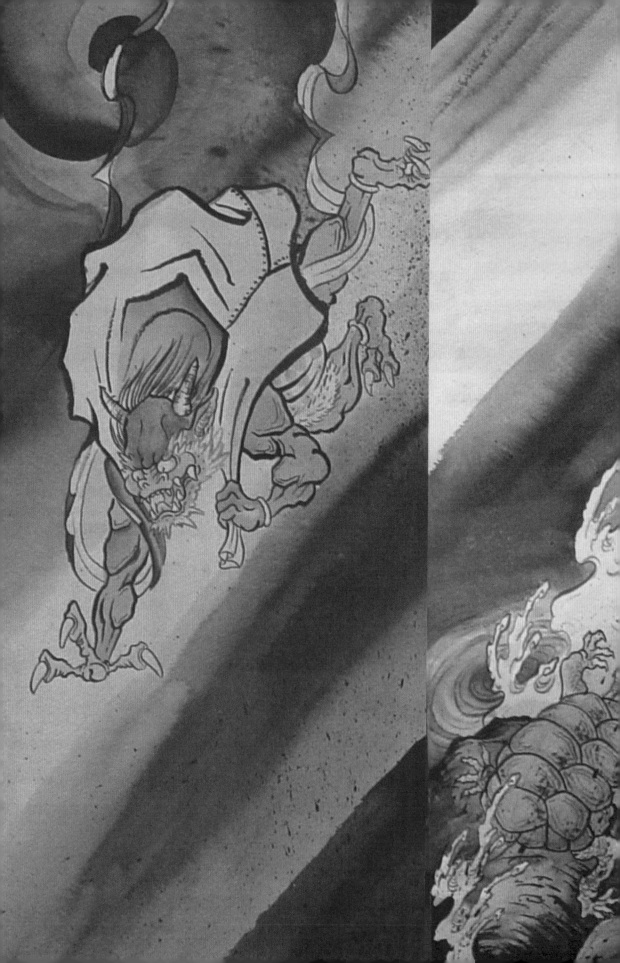

CROSSBRED CROSSBRED

Zijueboys wish to be young

BREATHLESS

団体名	
ルームNO	
602	
60.4	
60.6	
608	
609	
610	
227	

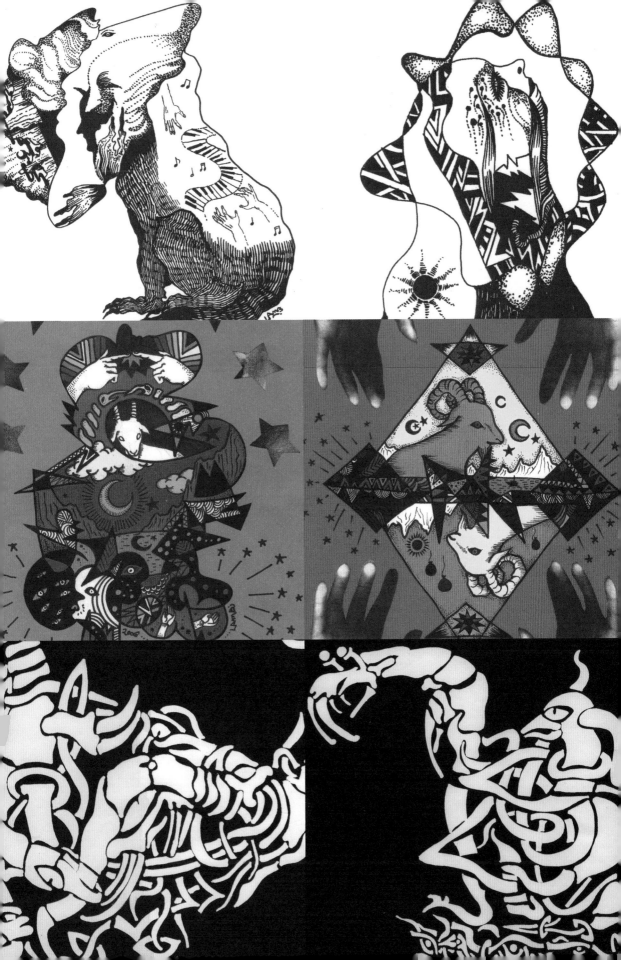

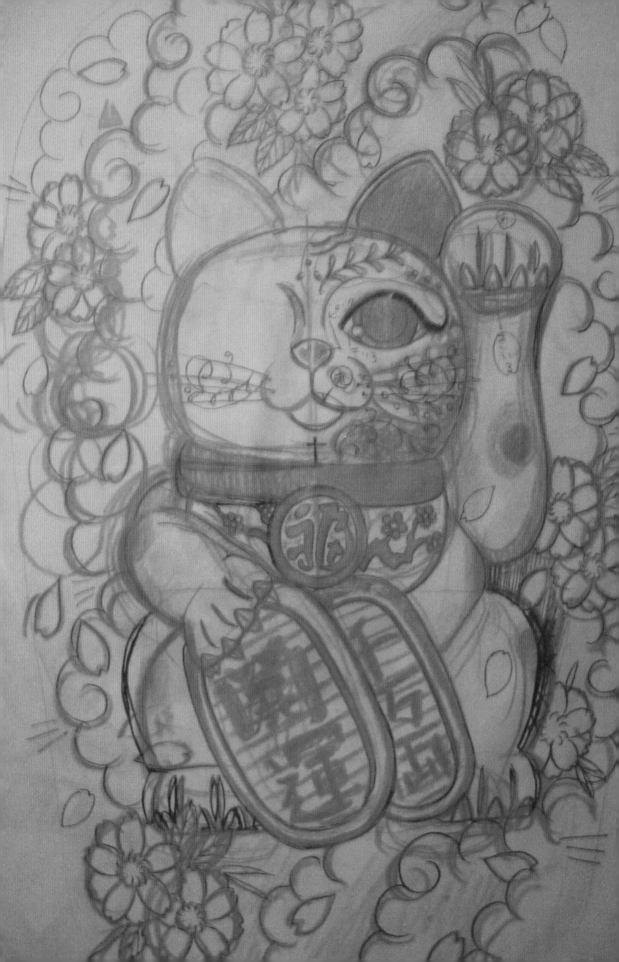

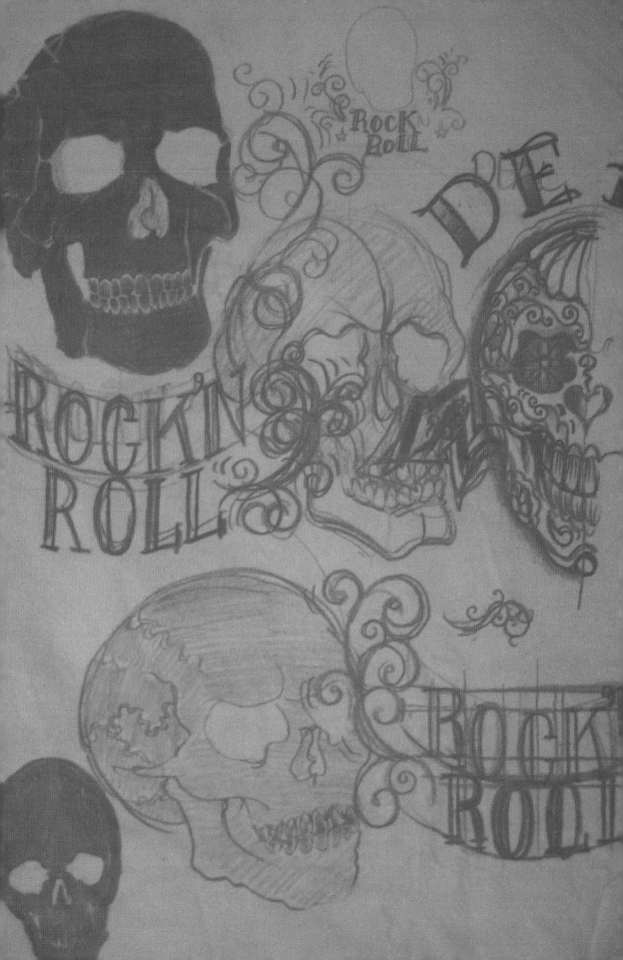

AMERICA-MURA RUBBER BAND POLE ~~JAM~~ BOUNCE TO
~~FAKIE~~ FAKIE SHOOT MIND STYLE HOE !

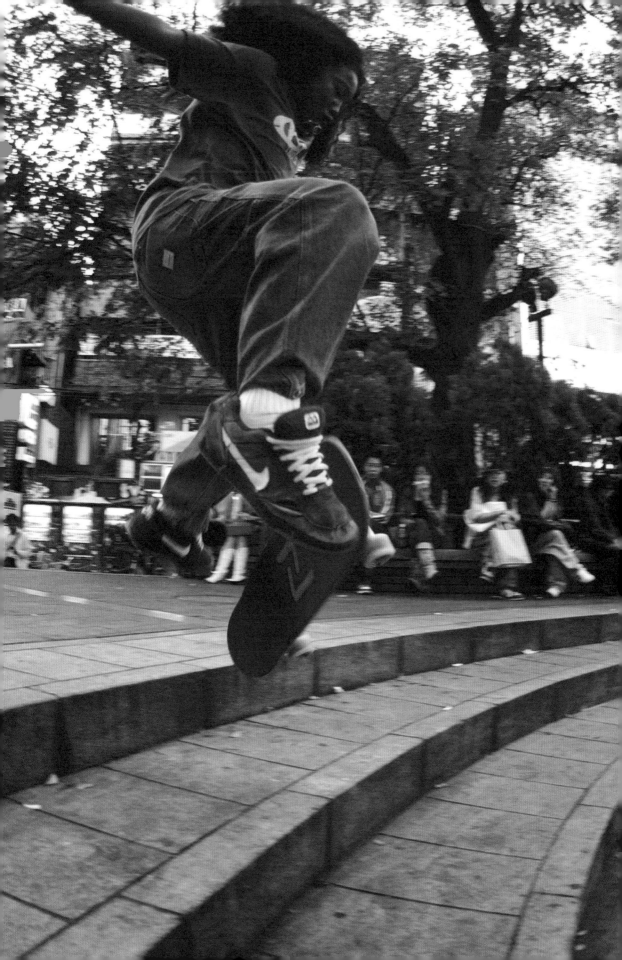

10/1

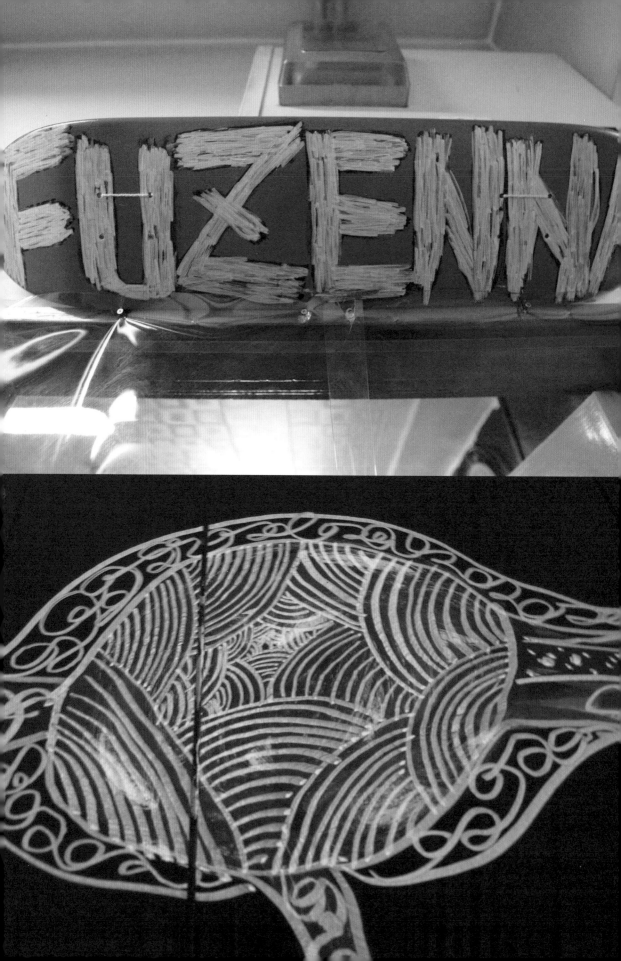

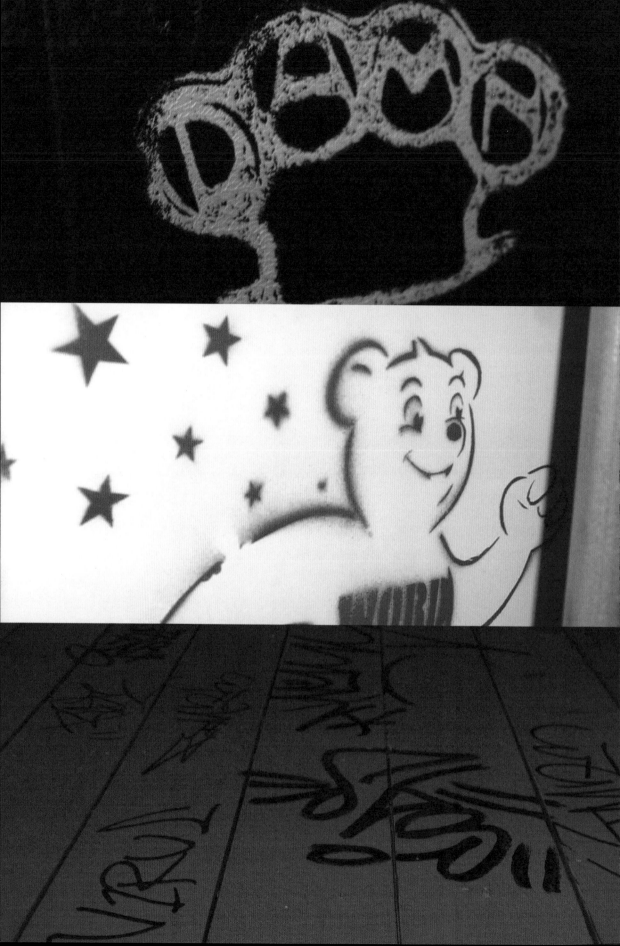

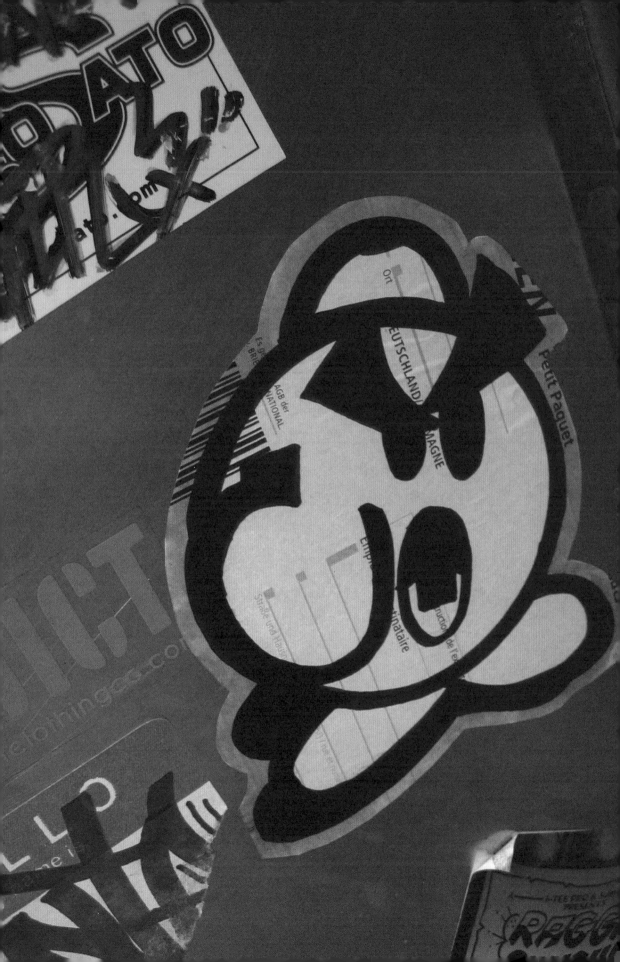

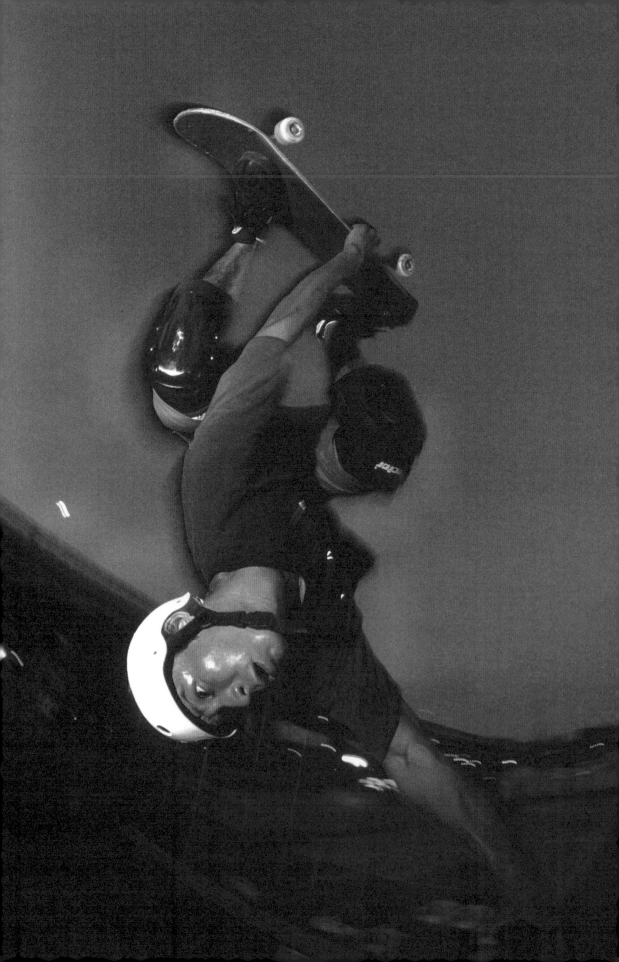

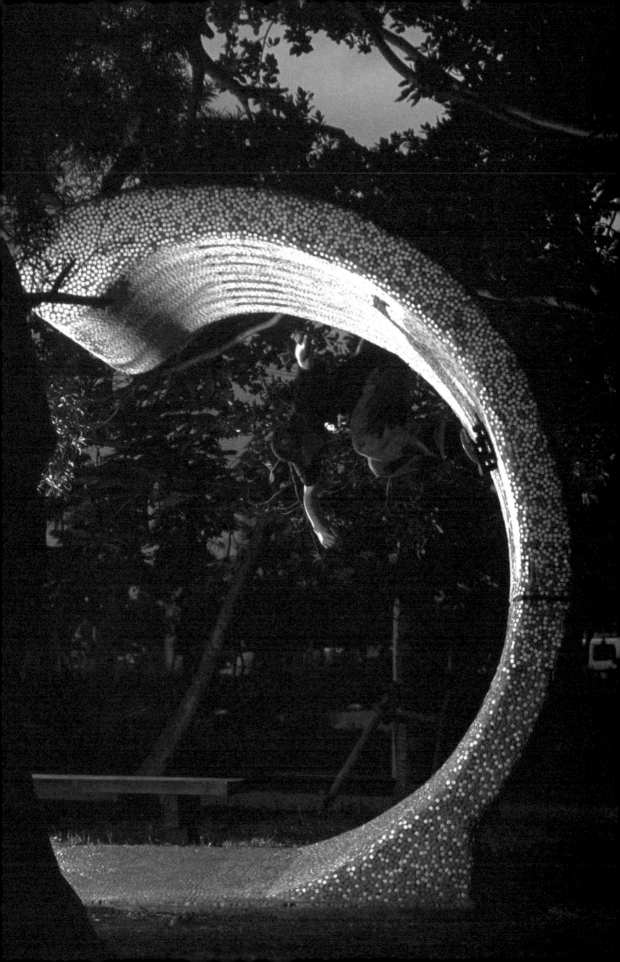

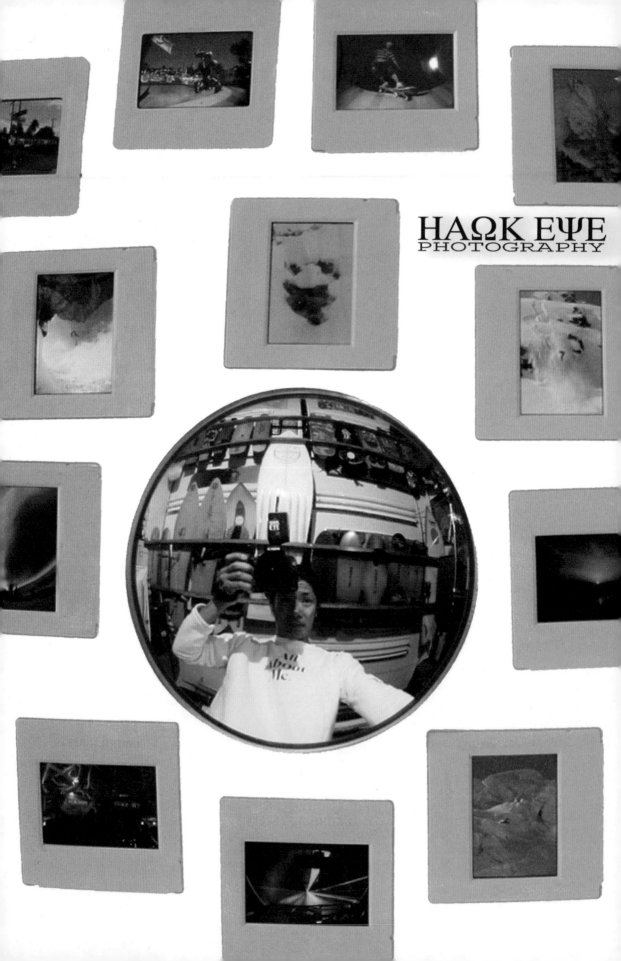

HAΩK EΨE
PHOTOGRAPHY

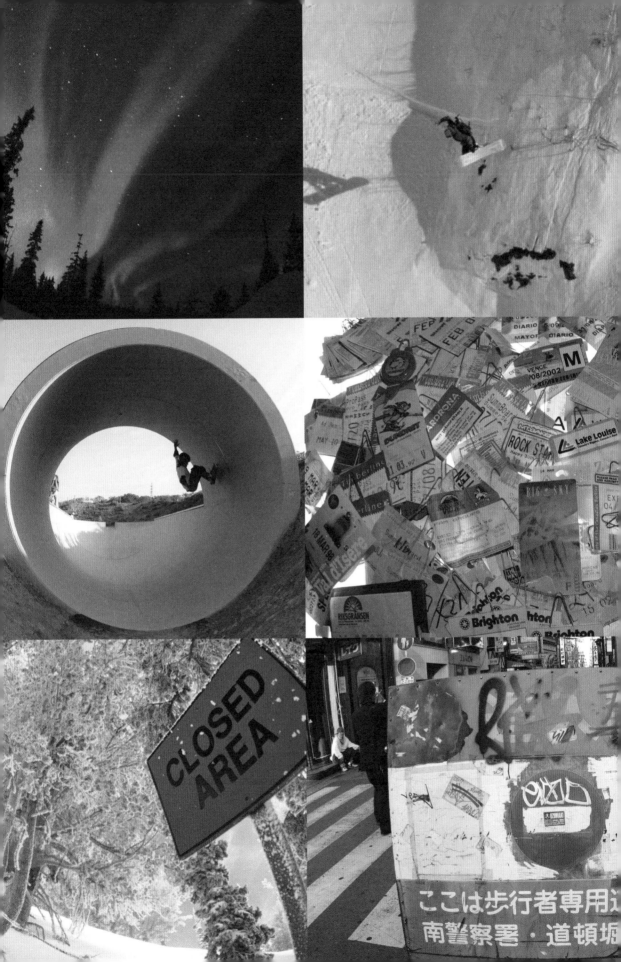

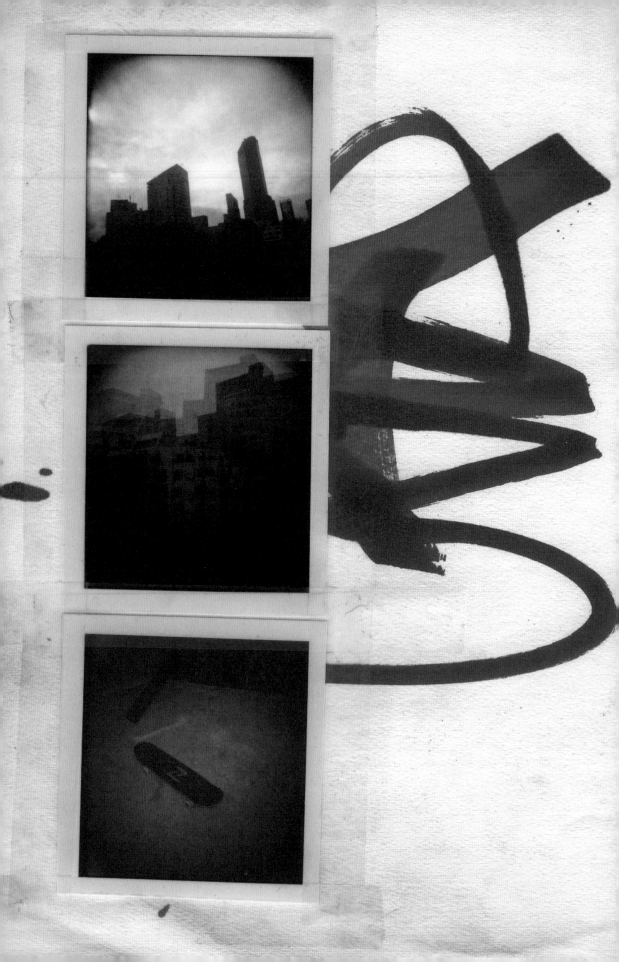

LITTLE JAPANESE DOG WILL BIT YOUR BAG OFF!

ADDITIONAL CREDITS

ADDITIONAL PHOTOGRAPHY BY

LANCE LEMOND, GENA FUKUDA, KYLE YAGIMOTO, TSUYOSHI NISHIYAMA, BANRI, YOJI, HAWKEYE, TOSHIKAZU NOZAKA, ISAM

THESE PHOTOGRAPHS WERE TAKEN IN JAPAN BETWEEN OCTOBER 8-21 2005.

D. (THE FOCUS) (THE PLAYERS)

INTRODUCE ~~MA~~ H. MATIES, BENNOT; GRAM. KYLE.

x-DEGREES of SEPARATN.

① LEAVE 4 JP. [SHIBUYA] → [x-cuttn] → [fehen] →

→ [SHIBUYA [tokyo] → [Ngma] → [FUKUOKA.] →

[KYOTO] → [OSAKA.]

JAPAN ISLANDS.

SOUTH & ISLANDS.

to SKETCHBOOK REMY. w/ RASSONS.

OSAKA — RESTARNT. RE-SHE-WA
SKATEDECK Stools

THANKS

MUCH MAHALOS FROM GRANT TO:

THE KING OF KINGS - LORD OF LORDS, MY FAMILY- LOVE YOU GUYS VERY MUCH, SHOGO & RONIN SKATES, MY BRUTHAS FROM OTHER MUTHAS- THE RISING SONZ, FRANKENFELT & KINS, FELEM, TSUYOSHI, WATARU, KENJI, SUGE, YUPA, TANUMA, YUKI, TATSUYA, OTAKI-DTS/T-19 JAPAN, TOKYO ZBOYZ, BOARD KILL, DAMN, WAKA JAH WAKA, SHIBUYA METS HOTEL-THE BEST, JESSE KAWADA-OLD SKOOL BROTHER, ART TOWER MITO, X-COLOR, NOSAKA-ASIAN WAVE SKATES, AKIRA-BLACK FLYS JAPAN, NISHIOKA-DEVILMAN, MAMI, TOYODA, HAWKEYE PHOTO, AKI AKIYAMA, FRAGILE, SHOP SAM'S, ZIJIEBOYZ, SHIKA, GYAN, YOSHI, SHINGO-THE MASTER, KYOTO BOYZ, OSAKA BOYZ, SHOOT MIND, REGGAE KERMIT, THE GOLDEN TEMPLE, THE 2 NOMAD RIPPERS WHO FOLLOWED OUR WHOLE TOUR, CHOPSTICKS, RIHAKU-WONDERING POET SAKE, ASAHI, GARY OWENS, PAT MEYERS, KIRK MUAKAMI, JASON JESSEE-HI BOND BROTHER, INDY TRUCKS, THE STONE GROOVE FAMILY, HURLEY, THE CLASH, GABBY PAHINUI, DEVO, JAY BOY ADAMS, HOLMES, VERCELLI, RASKEL, MANIFEST, VJ CREW, PADDOCK POOLS, BLUE HAVEN POOLS, THE OL'SKOOL HEAVY CHEVY'S, GANGSTER WHITEWALLS, JUANDY AKA-BIG SHITTY, DTS-Z BOYS, CHOLO, BERTLEMAN&BUTTONS, THE BACKYARD BROTHERHOOD, CHUCK TAYLOR, KTUH, SKIPPER, DOWNING FAMILY, LOWBOY, AND TO ALL THOSE WHO RIDE LOOSE TRUCKS. STAY UP AND GOD BLESS -GDOG

BENNETT WOULD LIKE TO THANK:

BIG UP ME SPONSORS DEM!!! SMA (SANTA MONICA AIRLINES), NIKE, BILL WALL LEATHER, PEP WHEELS, FLY-HI HELMETS, ROUTES, RAS NEVADA, CHILL-I-DREN PRODUCTIONS AND X-TRA LARGE UP 2 MARK FELT AND SCOTT KINSEY AND THE WHOLE RISING SONZ MASSIVE!!! THANK YOU 2 ALL OF MY FRIENDS IN JAPAN!!! TOKYO CREW!! OTAKI, NOZAKA, ALL THE SK8TERS KEEPING IT REAL IN THE CITY! KYOTO CREW!! HIDE, GIAN, SHIKA, CABA AND THE WHOLE-A-DEM RESPECT! TSUYOSHI AND FELEM CREW, BIG UP! OSAKA CREW!! SHUMAI, KENJI, Z-OKA, HASSHI, WARU, PURE NICENESS ON THE STREETZ! KYUSHU CREW!! ANGI, MEGANE, AND EVERYONE LETS GO EAT RAMEN!!! TOYODA SAN IN THE MOUNTAINS!! YOU'RE DOING IT BIG!!! 2 EVERYONE IN JAPAN, STAY JAPANESE! LOVE HAPPINESS AND POSITIVE VIBRATIONS!

MATT WOULD LIKE TO THANK:

I WOULD LIKE TO THANK MY MOM AND DAD, MARK FELT, SCOTT, SHOGO, JESSE MARTINEZ, ALL OF MY FAMILY AND FRIENDS, AND I WANT TO GIVE A SHOUT OUT TO, BENNETT, NIKE 6.0, SMA, PEP WHEELS, 9 STAR SKATE SHOP, FEZ, GRIND KING, LEVI JACKSON, SAM AND KELLY JACKSON, JORGE COMELLI, AND LOUIE LOPEZ.

IMAC
REEL 3/4

03.04.43.13 WIDE
03.04.50.25

05.12.23.14 MED.
12.28.29

0.7.44.06 CLOSE
03.08.00.03

E

36.11
42.19

REEL 5/6

05.00.34.14
05.00.45.10

05.03.41.10 KNEE
0503.44.19

05.00 12
05 24 WIDE

05.10.02.05
05.10.04.25

05.30.52.22
05.30.56.02
05.31.14.05
05.31.17.12

KYLE WOULD LIKE TO THANK:

SHOUT OUTS TO - SCOTT, MARK, GRANT FUKUDA, BENNET, MATTY, LANCE, SHOGO, TSUYOSHI (FELEM CREW), THE LOST SKATEPARK, CHEVY BOWL, SHOP SAMS CREW-OSAMU, OTAKI (T19), SHOOT MIND, OKA-Z, FUZENNA (KD), ITSUMI, CHOPSTICKS TATTOO, PIPE 69 AND THE OSAKA CREW, FUKUOKA CREW, TOYOTA AND HIS CREW, KYOTO SKATEBOARDERS, NAO, SHINSUKE (PSYCHO WHEELS), CORE MACHINE, JUN-FIN SILVER SMITH, MOCHI/HIROMI, YUTA (R.I.P) AND RIDE FOREVER, PARADISE ROAD (JUNICHI), SWINGER CLOTHING, VISE CYCLE KLOTHING, SINNERS, DEATH MACHINE, BLACK LABEL SKATES, MOM, DAD AND FAMILY, JAPANESE BEER AND FOOD, OH AND EVERYBODY I FORGOT, THANKS!!!

SCOTT WOULD LIKE TO THANK:

FIRST AND FOREMOST MY FAMILY, THANK YOU FOR EVERYTHING, WITHOUT YOUR SUPPORT NONE OF THIS WOULD HAVE BEEN POSSIBLE. KELLY, JAX & LOGAN, YOU ARE MY INSPIRATION AND WITH YOUR LOVE, SENSE OF HUMOR AND STRENGTH YOU HELPED ME TO REALIZE THIS PROJECT. TO MY DAD FOR GIVING ME MY FIRST CAMERA AND EXPOSING ME TO ART AND DESIGN. MARK FELT THANKS FOR ALL OF YOUR SUPPORT AND SHARING IN THE DREAM. CLAUDE GRUNITZKY, YOU ARE A GREAT FRIEND AND A GREAT INSPIRATION. ALL OF MY FRIENDS YOU KNOW WHO YOU ARE. BENNETT, GRANT, KYLE MATT, AND LANCE IT HAS BEEN AN HONOR TO ROLL WITH YOU. TOSHIKAZU NOZAKA, WAKA JAH WAKA, HAWKEYE, TSUYOSHI NISHIYAMA, TOYODA, SHOGO, SHINGO, SHIKA, ZIJIEBOYZ, OTAKI, KOZYNDAN, SAM, KELLY AND LEVI, ENDOSAN, JEF HARTSEL, STEVIE DREAD, JESSE MARTINEZ, ANDY JENKINS, AARON "FINGERS" MURRAY (THANKS FOR THE INK!), UPRISE! CHICAGO, NEVER THE SAME.

MARK FELT WOULD LIKE TO THANK:

MY MOM FOR ALWAYS BEING THERE!! MY BROTHER AND ALL OF MY FAMILY...YOU ALL RULE! MY DAD FOR INFECTING ME WITH SKATEBOARDING, SURFING AND PHOTOGRAPHY (YOUR SPIRIT LIVES ON!!), SCOTT KINSEY AND FAMILY, JEF & ERI HARTSEL, KOZYNDAN, ELIZABETH AI, ENDOSAN, RUNJESSYRUN, REBECCA AUSTGEN AND ADDISON, OSSUR FOR CTI KNEE BRACES, THE THOMAS FAMILY, THE JACKSON FAMILY, JESSE MARTINEZ AND THE VENICE Z-BOYS, AARON MURRAY KOPING KILLER, COOK-Z, TREVELEN SUPERCO CUSTOMS, MIKE LOHRMAN, NEW BEACH ALLIANCE, TOM VADAKAN, JASON JESSEE, CHRISTIAN HOSOI, STEVE OLSON, PAT NGOHO, BART SARIC, KB, ALL MY GOOD FRIENDS. KYLE, GRANT, BENNETT AND MATTY, LANCE LEMOND, MAY THERE BE MANY MORE TIMES LIKE THESE! SHOGO FOR ALL THAT HE DID, I SO APPRECIATE IT ALL. TOSHIKAZU NOZAKA, WAKA JAH WAKA, HAWKEYE, TSUYOSHI, KENZI, WATARU, SUGE AND ALL THE FELEM CREW, TOYODA, GIAN, SHINGO, SHIKA, ZIJIEBOYZ, OTAKI, AKIRA AND BLACK FLYS JAPAN, RIE, CHOPSTICKS TATTOO, RIP, DAIKON, AND ALL THE OTHER INSPIRATIONAL JAPANESE WE MET!!

WE ALL WOULD LIKE TO THANK:

CLAUDE GRUNITZKY AND THE TRACE FAMILY, EDWARD BOOTH-CLIBBORN, TSUYOSHI, THE FELEM CREW, SHOGO, OTAKIN HIROSHI / T-19, ASIAN WAVE SKATES, BLACK FLYS JAPAN, X-COLOR, ART TOWER MITO, WAKA JAH WAKA, ROYAL HAWAIIAN POOL SERVICE, GOODFEAR, SMA, KOPING KILLERS SKATEBOARDS, RASKEL, THE ORIGIONAL Z-BOYS, JESSE MARTINEZ, WES HUMPSTON, GLENN E. FRIEDMAN, CRAIG R. STECYK III, AARON ROSE, JASON JESSE, DID WE MENTION SAM AND KELLY JACKSON? THE FINE PEOPLE AT SAPPORO, KIRIN, ASAHI AND ORION BREWING COMPANIES, CHOPSTICKS TATTOO OSAKA, CASPER, VERY, DISE, DEPAS, ESOW, ZYS, OP, KRESS, KAMI, SECT, MAKE, FATE, KE, DASTE, KANE, BELX2, RYU, SHOOT-MIND, OKA-Z, 2SAN, KENJI, WATARU, BEN, TON, KOZURU, MAGOSHI, YASUO, NATTSU, NISSAKO, GAKKIN, ITSUMI, MOCHIKO, JEFF GROSSO, MIKE LOHRMAN AND EVERYONE ELSE.

WWW.ASIANWAVESKATES.COM
WWW.FELEN.COM
DAMINZINE.COO.NE.JP
WWW.FUZENNA.COM
WWW.ATENMAG.COM/HAWKEYE/INDEX.HTM
WWW.ARTTOWERMITO.OR.JP/XCODE/XCODEJ.HTML
WWW.COOLFEAR.COM
WWW.JWSC-SNOW.COM
WWW.SMASKATEBOARDS.COM
WWW.CHOPSTICKTATTOO.JP
WWW.KOPINGKILLERSKATEBOARDS.COM
WWW.KSKA.NET/P-BOX/IL.HTML
WWW.AUTONODOWN.COM
WWW.DEATHMACHINECORPSE.COM
WWW.ROYALHAWAIIANPOOLSERVICE.COM
WWW.VENICESKATES.COM
WWW.VENICEORIGINALS.COM

WWW.BULLDOGSKATES.COM
WWW.SKATERMADE.COM

WWW.B-ARTWORK.COM

WWW.VENICESKATEPARK.COM

WWW.MYSPACE.COM/THESTITCHES

WWW.BBINWORKSDIST.COM

WWW.POETREEMOVEMENT.COM
WWW.UPRISINGSONZ.COM

TS40771(04.12 ②HITACHI ⑤M

7I2 LAX/JL 08OCT
JL857255
AN AIRLINES

JL061

NRT
TOKYO/NARITA

TO 08OCT

131 JL 857255

Love 'em All !